KATE WHITEFORD
LAND DRAWINGS / INSTALLATIONS / EXCAVATIONS

RICHARD CORK

RICHARD NIGHTINGALE

COLIN RENFREW

KATE WHITEFORD

JOHN PHIBBS

YVES ABRIOUX

black dog
publishing
london uk

CONTENTS

SUBVERSIVE INCISIONS

RICHARD CORK **SUBVERSIVE INCISIONS**

Many artists would have been daunted by the prospect of making work on a site as commanding and freighted with associations as Calton Hill. Positioned near the heart of Edinburgh, with an overwhelming view over the proud array of squares, monuments and streets far below, it symbolises Scotland's long infatuation with Athenian magnificence. Nowhere more openly than in the National Monument, an unfinished homage to the Parthenon reigning over the capital city below.

But in 1987, when Kate Whiteford was given the opportunity to work in this grand and brooding location, she did not feel at all inhibited. On the contrary: the artist responded with inventiveness and verve. The invitation came from an audacious nationwide venture called *TSWA 3D*, whose organisers defied the timidity of so much site-specific work by choosing locations that were, in their own words, "more expansive and more demanding". Although the risks were clear, they favoured settings "already alive with the associations of history (cultural, industrial and political) and memory, but also places whose stature or symbolic status, whose very lack of neutrality, may have discouraged the idea that they were available for art".[1]

The negotiations involved in securing such places proved delicate, particularly when permission to use cherished national landmarks was requested. But the temerity paid off. A remarkable array of spaces was found for the project, and some 15 young artists invited to participate, on the strength of the proposals they submitted.[2] Whiteford's was among the most daring of these initiatives. If she had tried to take her cue from the assertive architecture already in position on Calton Hill, the work she produced might easily have been crushed by its classical forerunners. So Whiteford decided instead to undermine the dominant ideology of the buildings. With admirable daring, she cut a sequence of colossal images directly into the turf itself, as a witty riposte to the architectural setting.

Rather than competing with the grandeur of the edifices erected on Calton Hill, she refrained from interfering with their nineteenth century bulk. The only way to view Whiteford's immense excavations in their entirety was to climb the 143 steps of Nelson's Monument, which takes the form of an upturned telescope, and survey her work from its vertiginous summit. Looking down, I realised at the time that the forms she had made were no longer as fragmented or mysterious as they seemed at ground level.[3] Instead, their distinct and separate identities as a spiral, a set of ring

PREVIOUS PAGES:
Black Contour Drawing, 1987
152 x 115cm. Emulsion and charcoal on paper.

OPPOSITE TOP:
Sculpture for Calton Hill, Edinburgh, 1987
Excavated trenches with crushed Skye marble infill. View from the top of Nelson's Monument.

OPPOSITE BOTTOM:
Sculpture for Calton Hill, Edinburgh, 1987
View at ground level, looking towards the National Monument.

The land drawings, with their reference to an indigenous culture, were intended as a witty riposte to the classical solemnity of the architectural setting. The three symbols were designed to be seen from the top of the Nelson's Monument, and even today their shadows can be seen like an archaeological trace in the landscape.

8

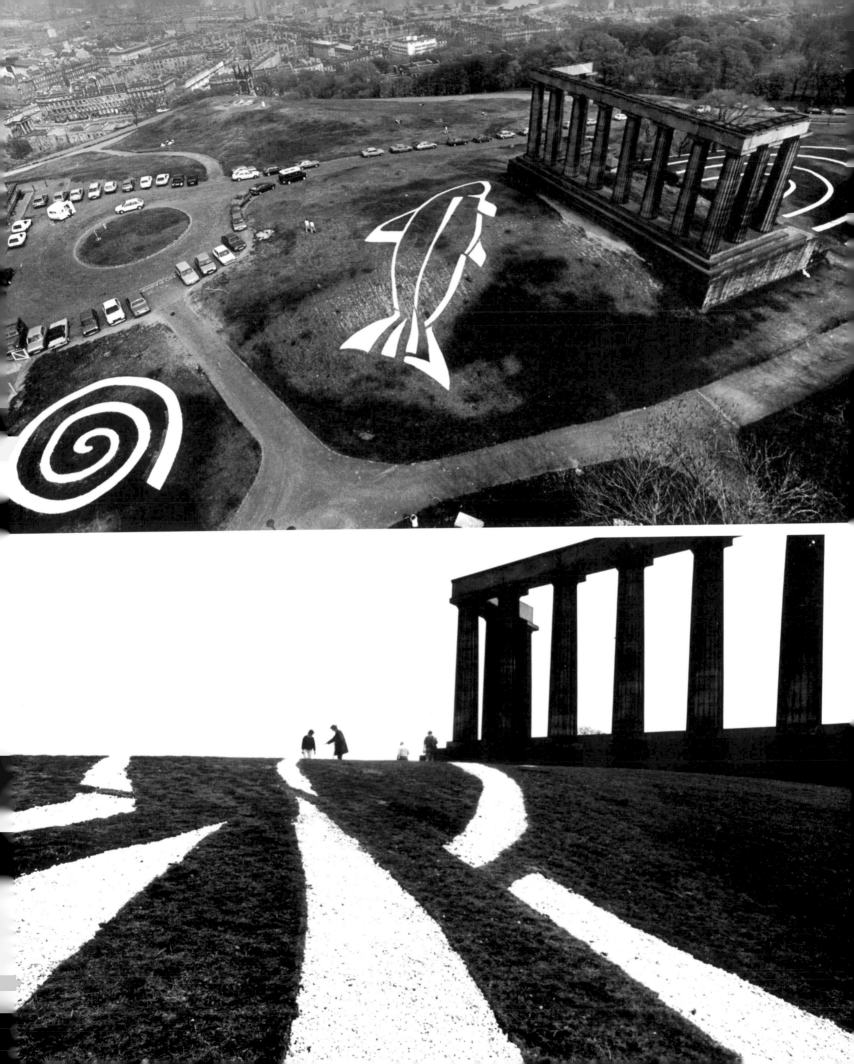

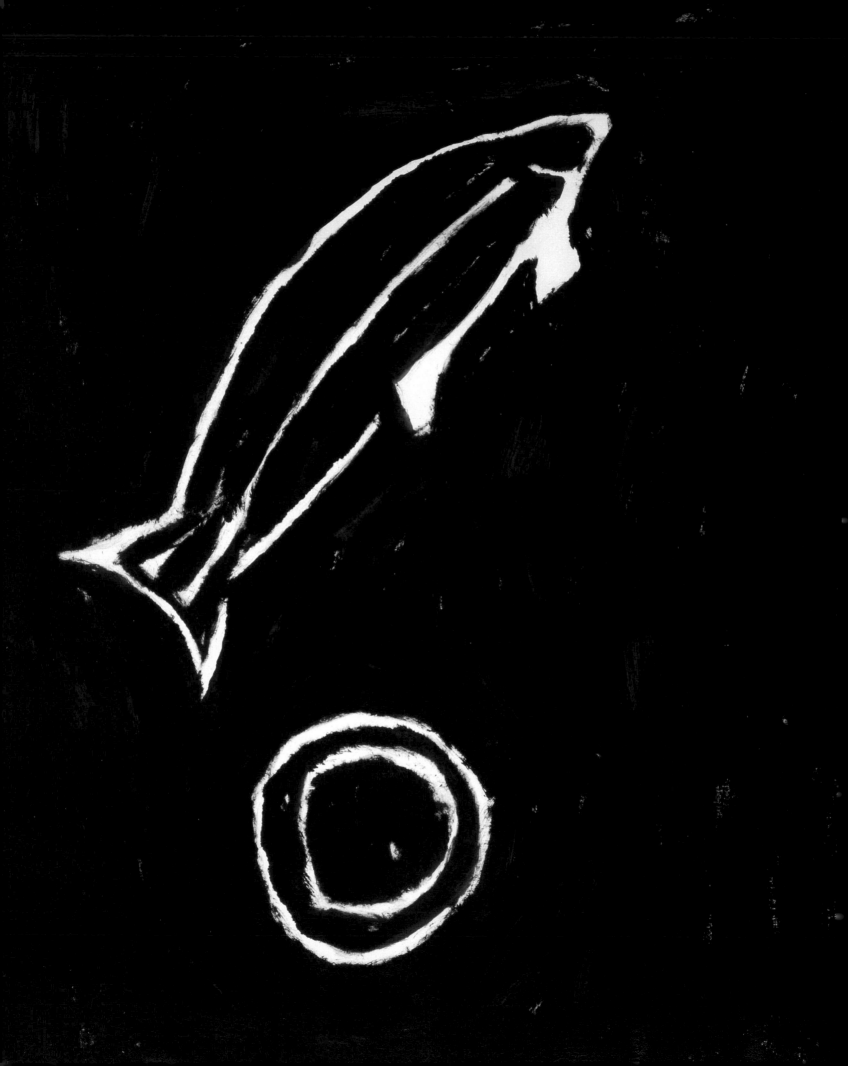

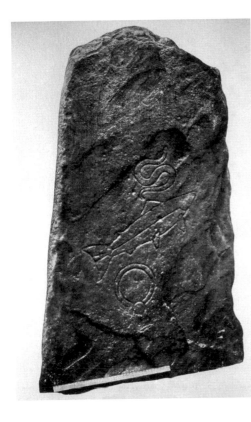

markings and a leaping fish became fully revealed. They were derived in part from a far earlier, less rational and more hidden period of Scottish history. Signifying the mysterious 'other', it has been largely erased apart from carvings on stones associated with a matriarchal society.

Unlike the Scottish Enlightenment celebrated so openly on Calton Hill, the Pictish era was instinctively in touch with the natural world. The energy of Whiteford's spiral seemed to trigger the dynamism of the fish as it leapt over the hill, apparently poised to dive deep into the waters of the Forth Estuary before reaching the Kingdom of Fife beyond — the terrain where Pictish Symbol Stones were discovered. Whiteford's ring markings undulated outwards, like ripples caused by the fish's splash. And her entire work injected a bracing new vitality into this sombre, not to say portentous site, riddled with references to Edinburgh as the 'Athens of the North'. Whiteford's subversive incisions were able, in form and technique alike, to direct our imaginations in the direction of an alternative culture, far more directly attuned to the environment than the Hellenism and military triumphalism normally associated with Calton Hill.

In this respect, she claimed for her art an archaeological and almost revelatory role. "The physical removal of the turf and topsoil to make the drawings can be read as a metaphorical reflection on the layering processes of history and culture", Whiteford declared, before explaining that "certain images echo across time, across culture and across belief. Culture overlaps culture, belief over belief; assimilating, changing and re-arranging sign, symbol and images which are deeply ingrained within our psyche."[4]

With hindsight, we can now see that the Calton Hill sculpture was an enormously liberating experience for Whiteford. Before then, she had been exhibiting within galleries, learning how to make use of all the available space and often painting *in situ*. Now, suddenly and quite unexpectedly, the chance to work on an outdoor site of epic proportions became a reality. It was almost a logical extension of her work inside galleries, but the challenge was still immense: Whiteford had to learn how to work with a surveyor, as early as seven in the morning, combating mists while she drew on site and carved into the sea-turf. It was, she recalled, "a mega-operation, and at the time I thought it was a one-off".[5] Far from remaining the spectacular exception in her career, though, Calton Hill proved a decisive moment. It became the catalyst for a whole series of ambitious and innovative extra-gallery ventures over the years ahead.

The attraction of working on a large scale is evident at the very beginning of her career. Soon after leaving the School of Art in 1973, she began making large colour-field paintings like *Hoarding*, all reflecting her urban surroundings with peeling billboards or torn wallpapers still surviving on derelict tenements in Glasgow. The interest in layering, which would later prove so fruitful for Whiteford's mature art, can be traced back to this

II

OPPOSITE:
Symbol Stone, 1984
152 x 114cm. Acrylic emulsion on paper.

ABOVE:
Pictish symbol stone,
Glamis Manse, Angus.

youthful period. So can the urge to think on an architectural scale. Working now as a member of the Glasgow League of Artists, she became involved with an idealistic attempt to make paintings on exposed gable-ends throughout the city. Tim Armstrong, who had taught her at the School of Art, designed two award-winning gable-end paintings based on complex geometric prints reflecting the toughness of this socialist city and its shipyards.[6]

She was permanently affected by the realisation that work could be made out on the street as well as inside a gallery. Her contemporaneous course in art history at the University of Glasgow reinforced this interest. Encouraged by her genial Professor, Andrew McClaren Young, she visited Italy and was impressed, above all, by the Giotto Chapel at Padua and all the other settings transformed by paintings made specifically for them. Whether in Florence, Assisi or Rome, where Whiteford particularly admired Caravaggio's *Calling of Saint Matthew* in the Contarelli Chapel, works made *in situ* for a particular sites impressed her profoundly.

After winning a British Council Scholarship to Italy in 1977, she worked alongside field archaeologists for the first time while staying at the British School in Rome. They showed her hidden, recently excavated sites, often in underground locations only viewable with the aid of torches. Whiteford was so stimulated by these revelatory settings that she made drawings, not only of Roman digs but also at the lost cities of Pompeii and Herculaneum. They generated a sequence of *Archive* monotypes taking as a springboard the transparent overlay employed by illustrators to place diagrammatic reconstructions on photographs of sites ruined by volcanic eruption. But Whiteford, as her subsequent large paintings *Isidis* and *ERCOLANO* reveal, was more engaged with the unpredictable interplay between Roman reality and our own contemporary concerns.

Just such a priority informed the work of Ian Hamilton Finlay, whose remarkable garden became familiar to Whiteford after returning to Scotland. Occupying a studio in the Tweed Valley, she found nearby Stonypath a potent source of inspiration. Whiteford discovered that the perpetual cross-currents running through Finlay's work enabled historical references and conceptual innovation to be held in illuminating coexistence at every turn. His central idea of interacting with historical events and ideologies had an immense influence on her development.

12

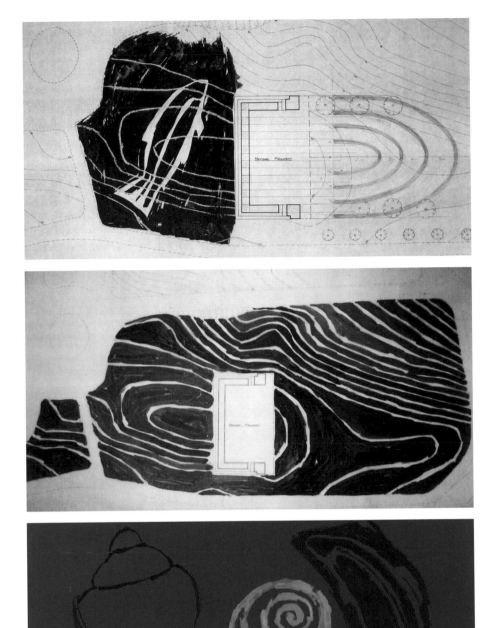

TOP TO BOTTOM:
Drawing for Sculpture for Calton Hill, Edinburgh, 1987
69 x 89cm (detail). Pencil, crayon and gouache on Ordnance Survey map.

Drawing for Sculpture for Calton Hill, Edinburgh, 1987
69 x 89cm (detail). Pencil and gouache on Ordnance Survey map.

Concerning the Spiral, 1986
200 x 260cm (detail). Oil on gesso on canvas and wood frame.

OVERLEAF:
Sculpture for Calton Hill, Edinburgh, 1987
Aerial view showing the relationship of the land drawing to Nelson's Monument and the Royal Observatory.

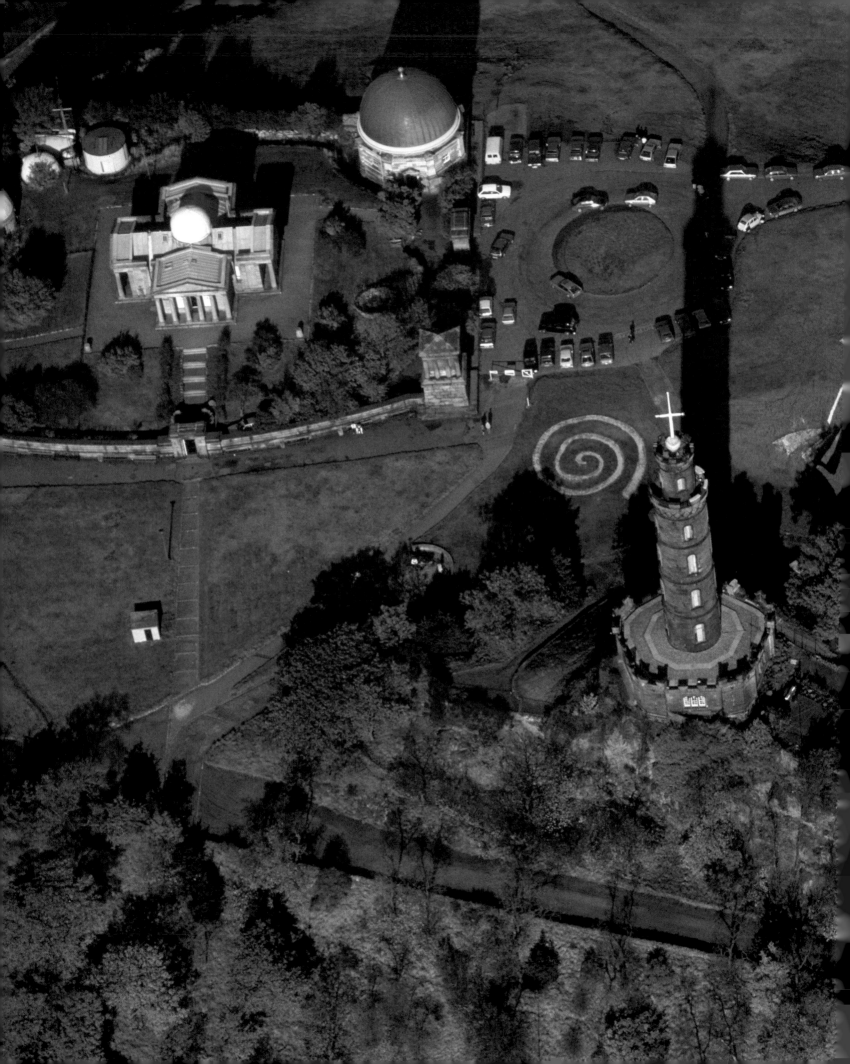

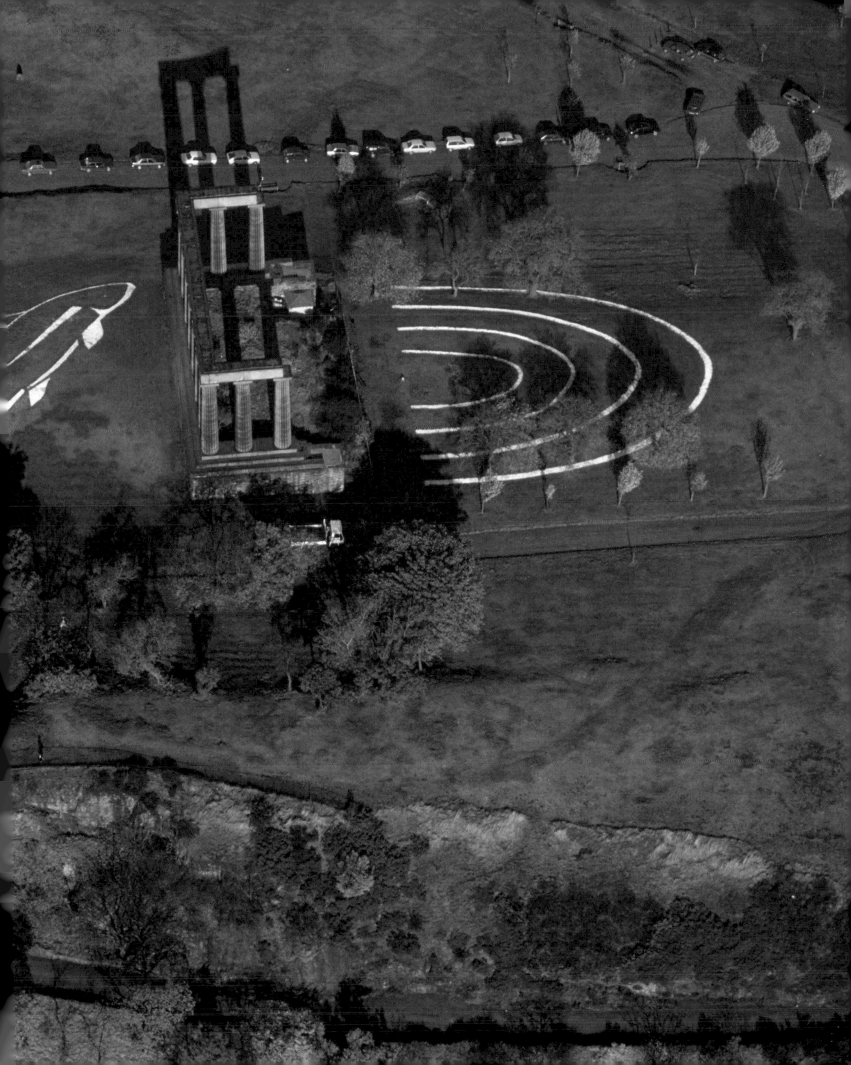

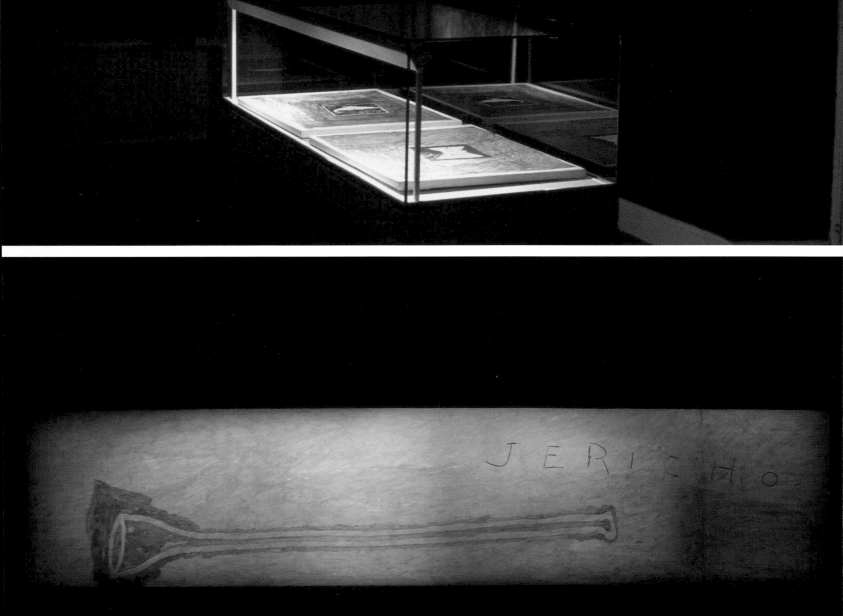

A comparably wide-ranging involvement with past and present fed Whiteford's imagination during the 1980s. At first, working in a modest London studio on Acre Lane in Brixton, she found herself occupying the same premises (a former meat-pie factory) as emergent sculptors like Richard Deacon, Antony Gormley and Bill Woodrow. The artists ran a small gallery there, and Whiteford showed her *Archive* images derived from Italian sources. It was a stimulating period: the *New Spirit in Painting* exhibition at the Royal Academy in 1981 announced a widespread desire among young painters to re-examine the past, while New British Sculptors including Tony Cragg and Woodrow explored the possibilities inherent in even the most overlooked detritus scavenged from metropolitan skips and waste-lots. Whiteford, likewise, employed the idea of unearthing objects, but in her case they were vessels discovered on archeological sites. Martin Kemp, who had taught her at Glasgow University, pointed out how "Whiteford sensed that the instincts of *will to form* and *will to meaning* in the making of ritual artefacts were shared at the most fundamental level by different human societies."[7]

This concern intensified when Kemp, now Professor of Art History at St Andrews University, invited her to be Artist in Residence at the Crawford Centre there. She soon discovered, in the University Library, Romily Allen and Joseph Anderson's comprehensive publication *The Early Christian Monuments of Scotland*. The authors listed an impressive range of Pictish Symbol Stones, still at that time occupying their original sites.[8] Whiteford spent almost a year visiting them in these landscape settings, and their survival contrasted with the loss of artworks so painfully evident in St Andrews Cathedral, a tragic victim of Calvinist destruction. She decided to use her residency to create a body of work that would engage with the intellectual life of the University and respond to its cultural setting as the seat of the Reformation.

She also scrutinised, in the Archaeology Museum, a small exhibition of finds from a University excavation at Jericho. Whiteford responded by painting a gesso frieze on panels running round a darkened room at the Crawford Centre in 1983. Most of her images were inspired by the finds, yet she also included a severely simplified trumpet — the instrument that caused Jericho's walls to collapse and precipitated its downfall. Whiteford described in the exhibition catalogue how "the archaeological finds, themselves, combined with the poetry and beauty of the story of the Walls of Jericho, gave me the idea of making a piece which had something of the quality of an ancient site, something of the mystery of discovering ancient paintings; and in this instance the frieze includes several of the finds which actually exist in the Museum and several which do not, notably the trumpet."[9] This adroit use of a playful conceit would become a recurring feature of Whiteford's work.

17

On a more profound level, though, the apocalyptic obliteration of Jericho, along with so many of the other civilisations she sought to explore, provided her Crawford Centre show with an elegiac undertow. More of an installation than a conventional exhibition, it enveloped the viewer in a small, darkened chamber. The fundamental mood was defined by Cordelia Oliver, who described it in her *Guardian* review as "a gentle, cumulative kind of drama that compels one to silence, rather as though one had unexpectedly entered into an underground tomb, newly excavated and containing, in a few gold objects and vessels of red earthenware, the very essence of an archaic culture".[10]

The idea of a burial passage persisted when Whiteford produced her *Graven Images* installation at the ICA in London. Using the narrowness of the corridor gallery to eloquent effect, she filled one side with images of Symbol Stones reflecting her exploration of sites in Scotland. But on the other side, large monochrome paintings executed on the wall-surface interwove single iconic images in each of the large bays. Dimmed lighting enhanced the theatrical effect and the experience of passing from one state to another. Whiteford had no intention of producing an academic art focused solely on accurate historical reconstruction. Instead, she aimed at creating a resonant fictional archaeology.

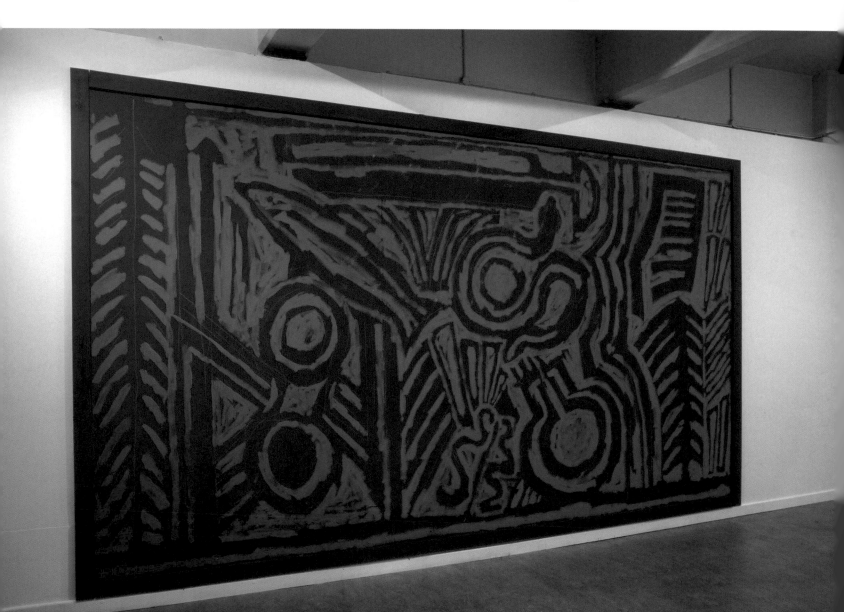

By the time her monumental painting *Rites of Passage* was displayed, in a show of the same name at Glasgow's Third Eye Centre in 1984, she felt able to fuse formal concerns and theatrical presentation in a single overwhelming image of carvings from a passage grave. Its dark presence, enhanced by a pool of light in front of the piece, managed to hold the immense gallery space. For the catalogue, which contained a full-page photograph of emptied-out stone tombs at St Andrews Cathedral, Michael Archer wrote an essay identifying as Whiteford's foremost theme the "notion of a passing from one state to another". The transformative potential inherent in death energised much of her work at the time. As Archer went on to point out, "Whiteford is interested in flux, in a certain configuration giving way to something new, perhaps in a potential being realised, in a coming to fruition giving a sense of wholeness."[11]

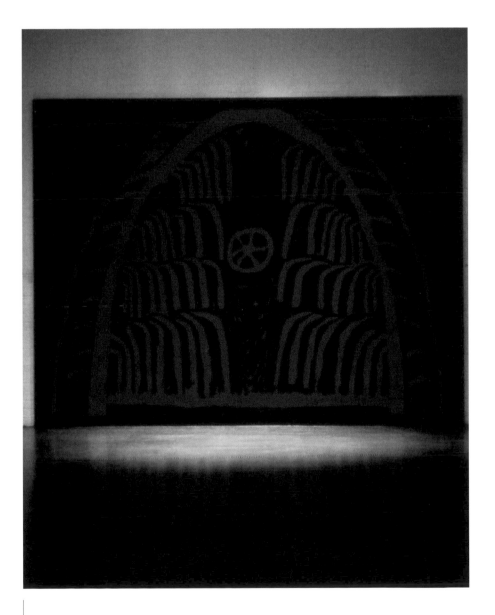

OPPOSITE:
Gavrinis, 1985
304 x 600cm. Wall painting. Ikon Gallery, Birmingham.

RIGHT:
Rites of Passage, 1984
304 x 426cm. Acrylic emulsion on paper and wood frame. Third Eye Centre, Glasgow.

Often displayed in darkened spaces illuminated by pools of light, these two works reference the carvings found in subterranean excavations at Gavrinis, and Locmariquer in Brittany.

That is why she found so much stimulus in her 1985 visit to Nepal, where the sense of historical distance encountered elsewhere on her travels was broken down. Since even the most ancient rituals and artefacts retained their power in this society, Whiteford realised that "to visit the country now is almost to experience another sense of time, another reality, and it was this sense of a displacement of time — of past and present being so startlingly mixed — that was so striking".[12] Hence, perhaps, her decision to carve the image of a leaping fish, the Celtic "salmon of wisdom", in the sea-turf on Calton Hill. Defiantly countering the neo-classical rationality of the Scottish Enlightenment with a more intuitive symbol belonging to a far older era, this fish was caught in just such a moment of becoming.

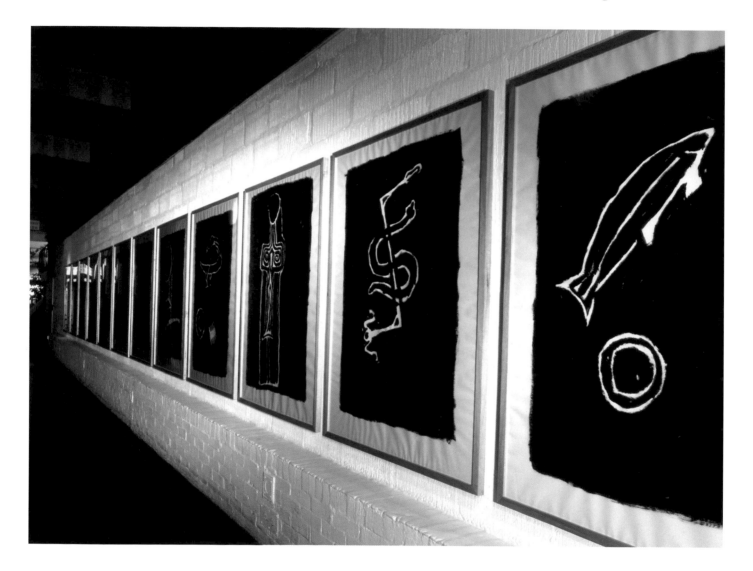

ABOVE:
Graven Images, 1983
Installation of five wall paintings and 12 works on paper. Concourse Gallery, ICA, London.

OPPOSITE:
Symbol Stones, 1983
Each 152 x 114cm. Acrylic emulsion on paper. From the installation *Graven Images*, 1983.

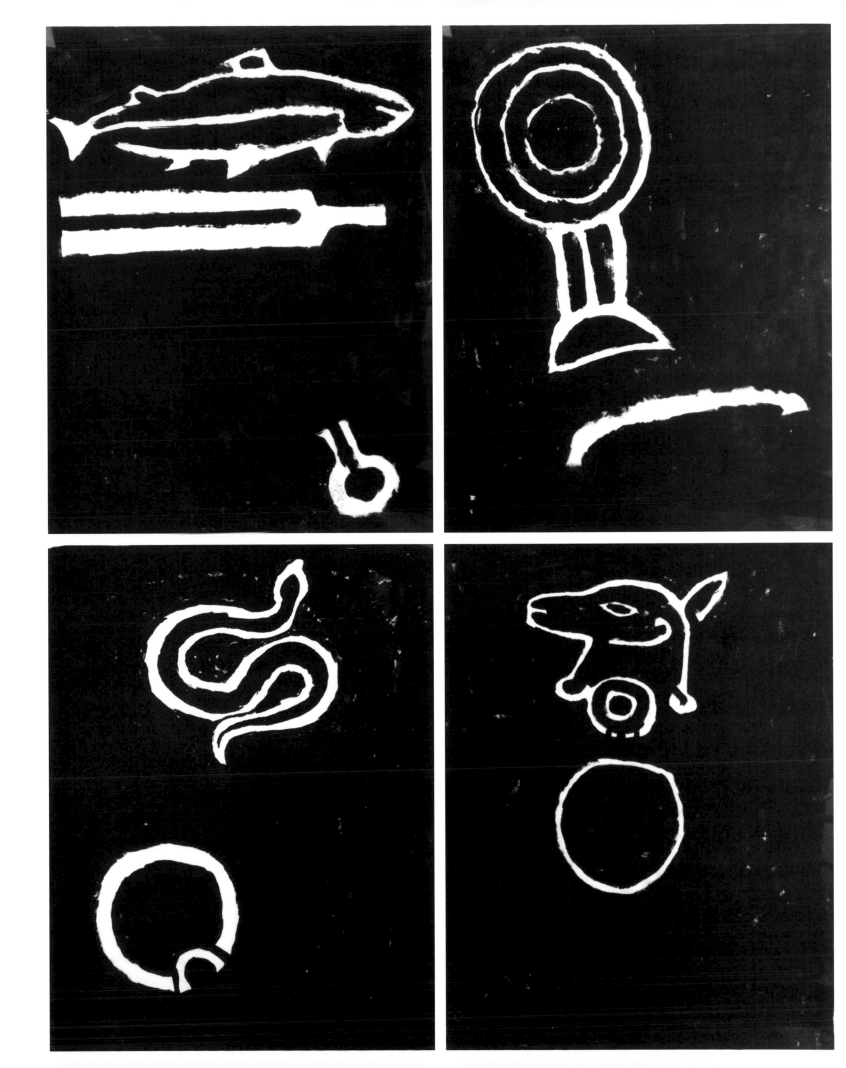

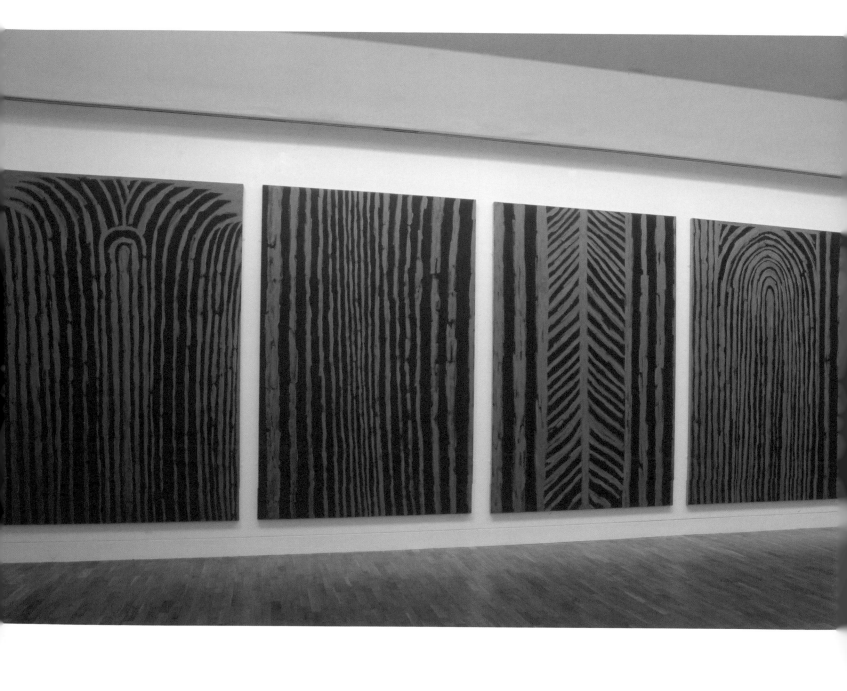

Calton Hill can now be seen as such a decisive turning point in Whiteford's work. Everything came together on this extraordinary, multi-layered site, and the work she produced there threw up so many resonances. And the Calton Hill breakthrough made her eager, from that point onwards, to go beyond the limits of conventional exhibitions.

During the late 1980s she did not turn down invitations to show her work in spaces as sympathetic as the Scottish National Gallery of Modern Art in Edinburgh, or at the Whitechapel Art Gallery in London. But the paintings Whiteford placed there attempted to fight against the tradition of static wall-displays. In Edinburgh she transformed the room at her disposal with an arresting installation called *Echo*, using complementary hues of red and green acrylic to initiate a powerful optical vibration. Both colours seemed to float free from their surfaces, like titanic pieces of prehistoric decoration leaving the places where they had once been incised. The same spatial hovering occurred in the *Quartet* from the *Echo Series*, painted this time in oil on brilliantly white gesso grounds. Ranged in a lofty row at the Whitechapel, they evoked the magisterial scale and arched rhythms of great cathedral interiors.

Emboldened by her Calton Hill revelation, Whiteford was now clearly ready to take on projects in locations far removed from the galleries' territorial boundaries. She responded with alacrity at the end of the 1980s when I commissioned her, along with five other artists, to make a large print for distribution to NHS hospitals.[13] The outcome, a dynamic image called *Double Chevron and Spiral*, still galvanises the many different spaces where it hangs, doing much to alleviate the bleakness of medical buildings throughout Britain.

23

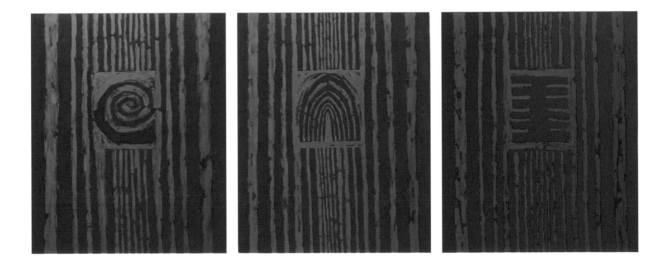

OPPOSITE:
Quartet, 1988
213 x 152cm. Oil and gesso on linen.
Whitechapel Art Gallery.

ABOVE:
Between the Lines, 1989
80 x 60cm. Oil on gesso on linen.
Three of five sections.

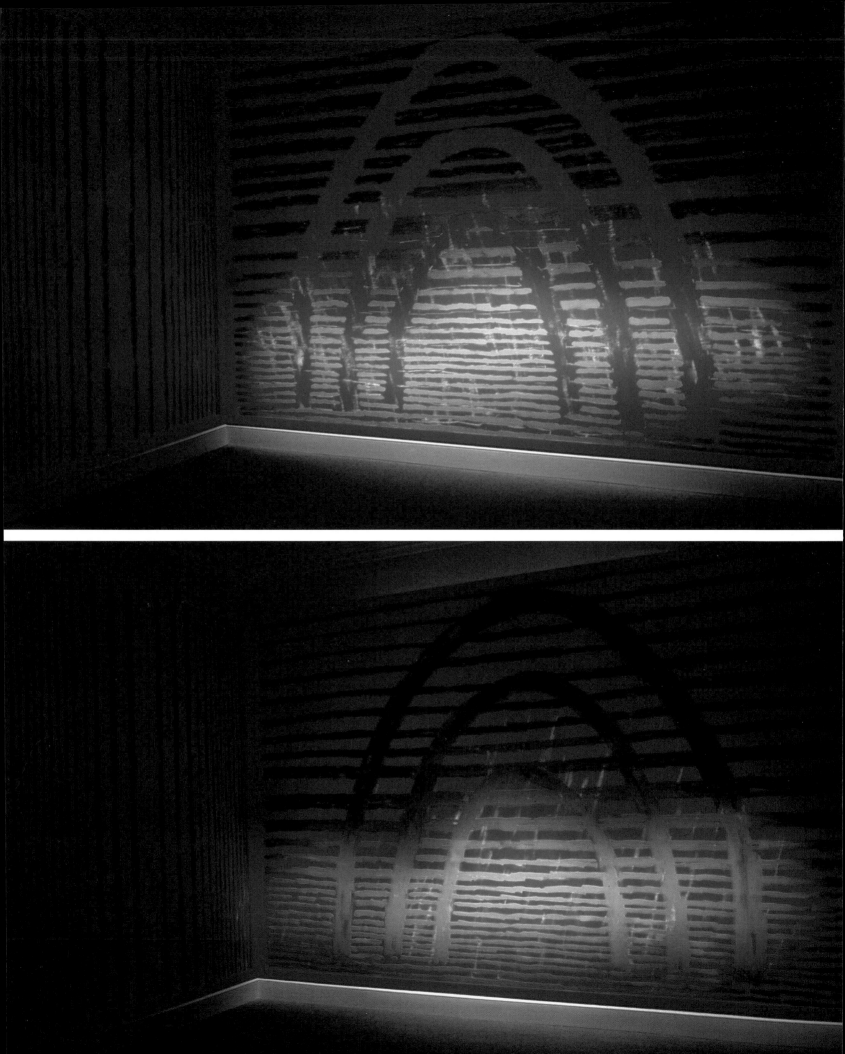

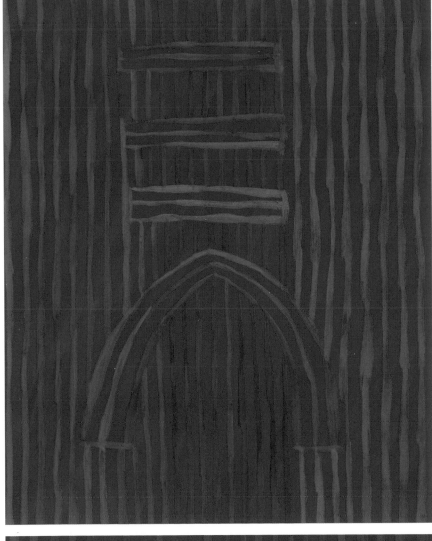

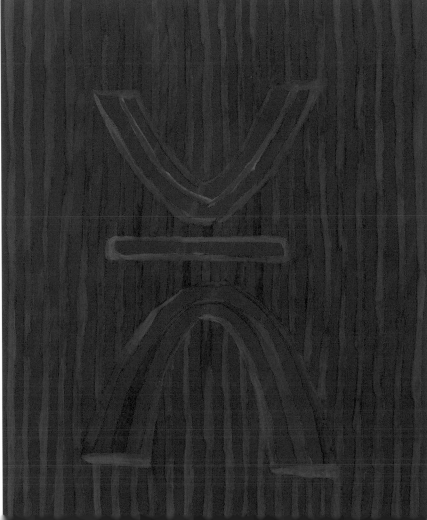

OPPOSITE TOP AND BOTTOM:
Echo, 1987
Wall painting on canvas stretched
over walls. Scottish National Gallery
of Modern Art, Edinburgh.

TOP AND BOTTOM:
Signature, 1990
Each 39 x 29cm. Diptych.
Gouache on paper.

The advent of the 1990s was marked by a flurry of adventurous projects, each highly distinctive and challenging Whiteford to work in open-air, indoor and even underwater settings. For the Rambert Dance Company, she collaborated with choreographer Siobhan Davies on the set and costumes for *Signature*. The composer, Kevin Volans, was a former pupil and assistant of Karlheinz Stockhausen and Mauricio Kagel. He had been conducting field recording trips in southern Africa, where the regular rhythmic lines and patterns of textiles impressed him greatly. So Whiteford responded immediately to *Chevron*, the score he wrote for the Rambert dance work. Volans' interest in archetypal forms corresponded with her own, and Siobhan Davies turned out to be a highly stimulating collaborator.

Whiteford's small maquette was sent to the vast painting workshop at Sadlers Wells, where her eye-bending red backdrop and two translucent gauzes were painted with the help of lifts and a long gantry. By hanging the gauzes in front of each other, and linking them with painted images on the floor of the stage, she was able to spatially liberate the complementary interplay between red and green. With a double chevron on the gauze nearest the audience, and a colossal arch stretching across the floor, *Signature* was given a commanding amount of visual drama. Peter Mumford's lighting further enhanced the dynamism of the work. And Siobhan Davies made sure that the dancers responded to the optical vibrations, activating Whiteford's paintings with the vivacity and precision of their bodies. She attached particular importance to keeping a sense of movement in the brushmarks, each one released into space like a departing breath. At the very end, a pair of dancers slowly formed their limbs in inverted V-shapes beneath the final gauze, which Whiteford had painted with a related form.

OPPOSITE AND OVERLEAF:
Signature, 1990
Set and costume designs for *Signature*, in collaboration with choreographer Siobhan Davies and composer Kevin Volans. Rambert Dance Company.

This was the first time Whiteford had worked with the choreographer Siobhan Davies. She was intrigued to discover that Siobhan's choreographic notations bore a uncanny resemblance to some of the symbols in her own work. This led to a close interaction between the movements of the dancers and the painted gauze in the final scene of the dance.

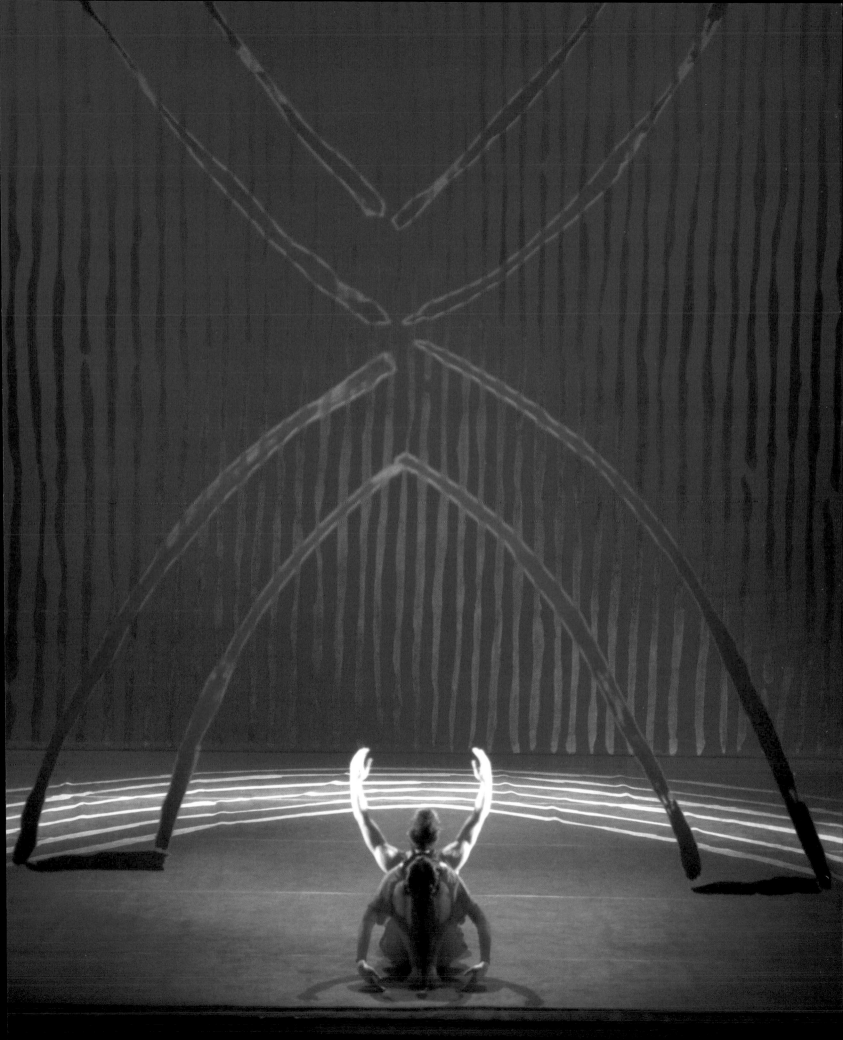

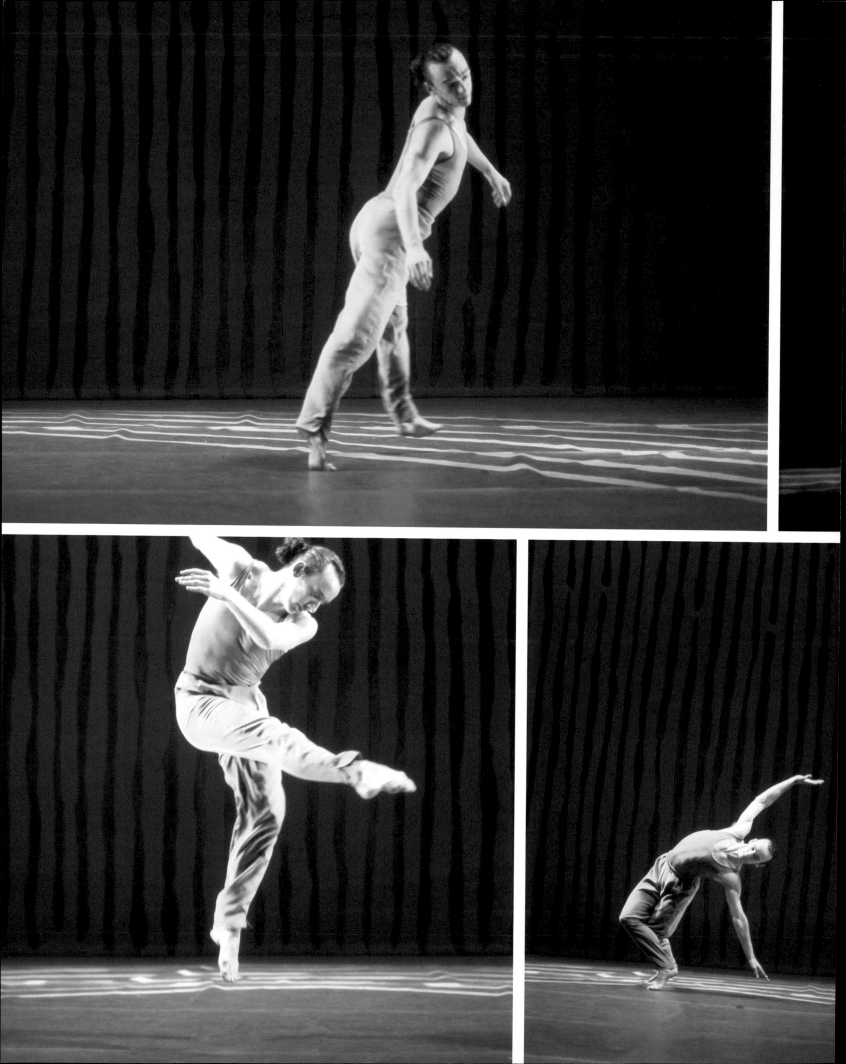

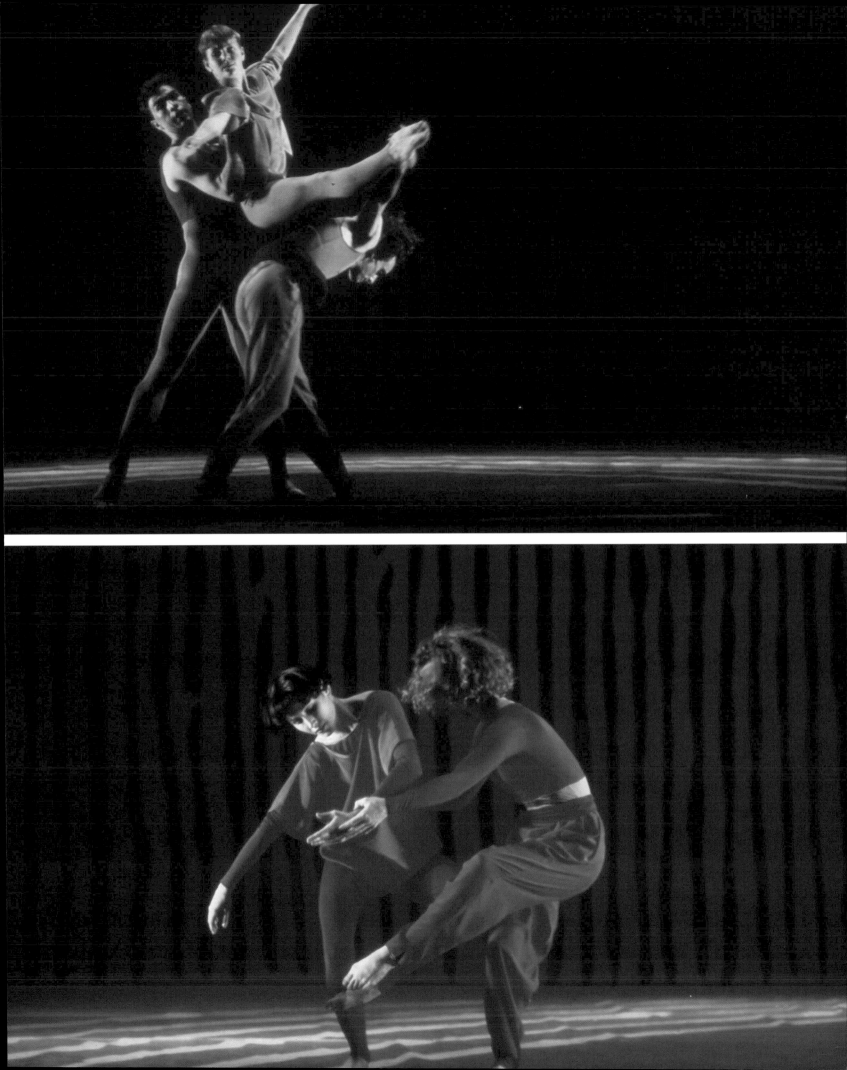

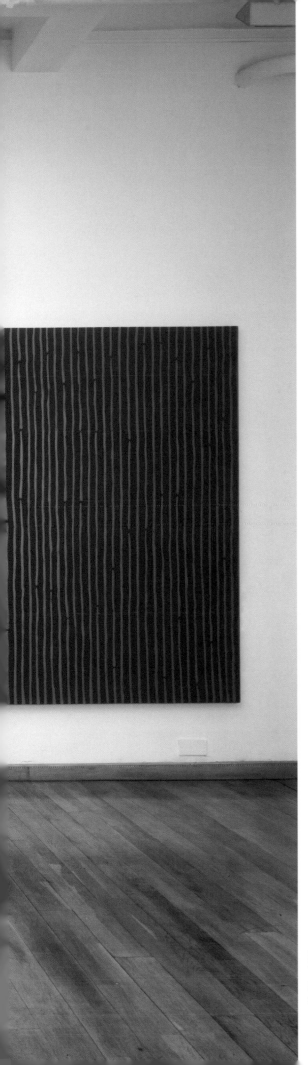

LEFT:
Torii Gate, 1991
Each 200 x 300cm. Diptych.
Oil on gesso on linen.

The *Torii Gate* diptych was painted after a visit to Japan;
six metres long, it was the culmination of several years'
work on optical red and green paintings.

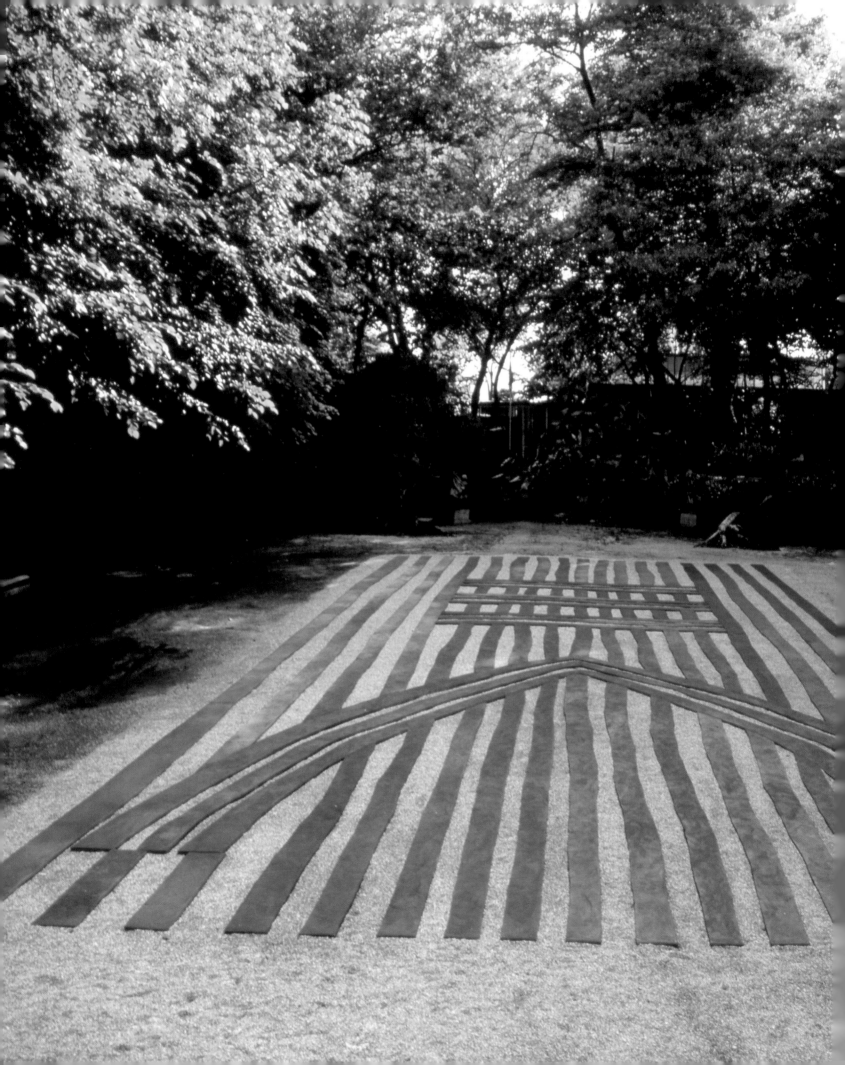

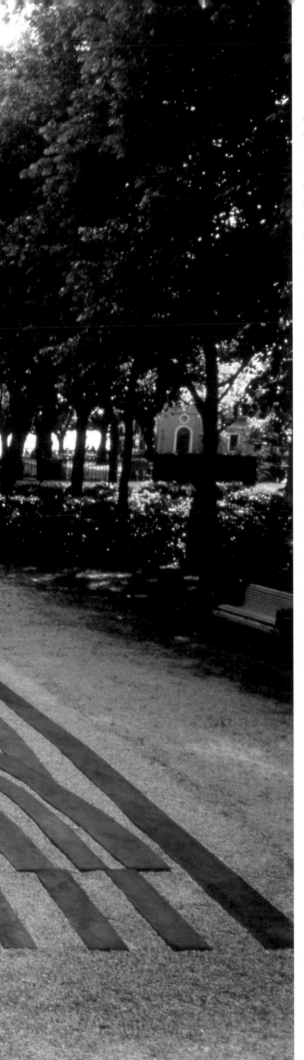

Working on *Signature* prevented Whiteford from attending the opening of *Sitelines*, her ambitious land drawing at the 1990 Venice Biennale. It was a historic occasion: the first independent exhibition of Scottish art at the Biennale since it began in 1895.[14] An ample outdoor location called the Escedra, at the centre of the Giardini where the main national pavilions can be found, provided space for a land sculpture on the grand scale. Unlike at Calton Hill, though, here Whiteford was forbidden to cut directly into the ground. The mass of cables laid under Venice's shallow earth cannot be disturbed, and the tall trees enclosing the Escedra also meant that *Sitelines* could only be encountered close-to. Whiteford had a chance to view her sculpture from above while scaffolding was erected on site. But the tower was taken down once the work had been completed, so visitors were not given a privileged aerial vantage like Nelson's Tower on Calton Hill. Instead, *Sitelines* would be read from a number of positions at ground level alone, and Whiteford realised that she must take this limitation fully into account when planning her sculpture.

As well as responding to the specific character of the Escedra, she became fascinated by Venetian pavements. While staying in a Grand Canal apartment owned by Tudi Sammartini, who was publishing a book on *The Secret Gardens of Venice*, Whiteford walked round the city with her hostess looking at decorated pavements and piazzas.[15] So the drawing for the work developed over a period of months, and when complete it was laid out with lengths of string on site. Then she pegged out the string lines to make a metal formwork for casting *in situ*. And the parallel stripes of black pigmented concrete, which dried dark grey with a mottled surface, were installed in shallow relief on the Escedra ground. They reflected Whiteford's omnivorous interest in the Venetian pavements, encouraging the viewer to move in the direction of insistent spatial thrusts. At the same time, they were countered by bars running across the stripes, inviting visitors to pause and assess their position as they responded to the forcefulness of *Sitelines*. Clare Henry described how Whiteford's work "plays on the tensions between positive and negative, dark and light, embossed and engraved lines which influence our perception of the site. These have to be 'discovered' under one's feet, beckoning, as it were, an invitation to follow the rippling curves and bands which echo each other and the topography of the Escedra."[16]

33

Sitelines, Venice, 1990
Black pigmented concrete cast *in situ* with quartz infill. Venice Biennale, 1990.

This site is set within the Biennale Escedra and close to the Lagoon. Created at exactly the same time as the sets for Rambert Dance Company, it was as if this piece marked out movement patterns on the ground as well as making reference to the pavements of Venice.

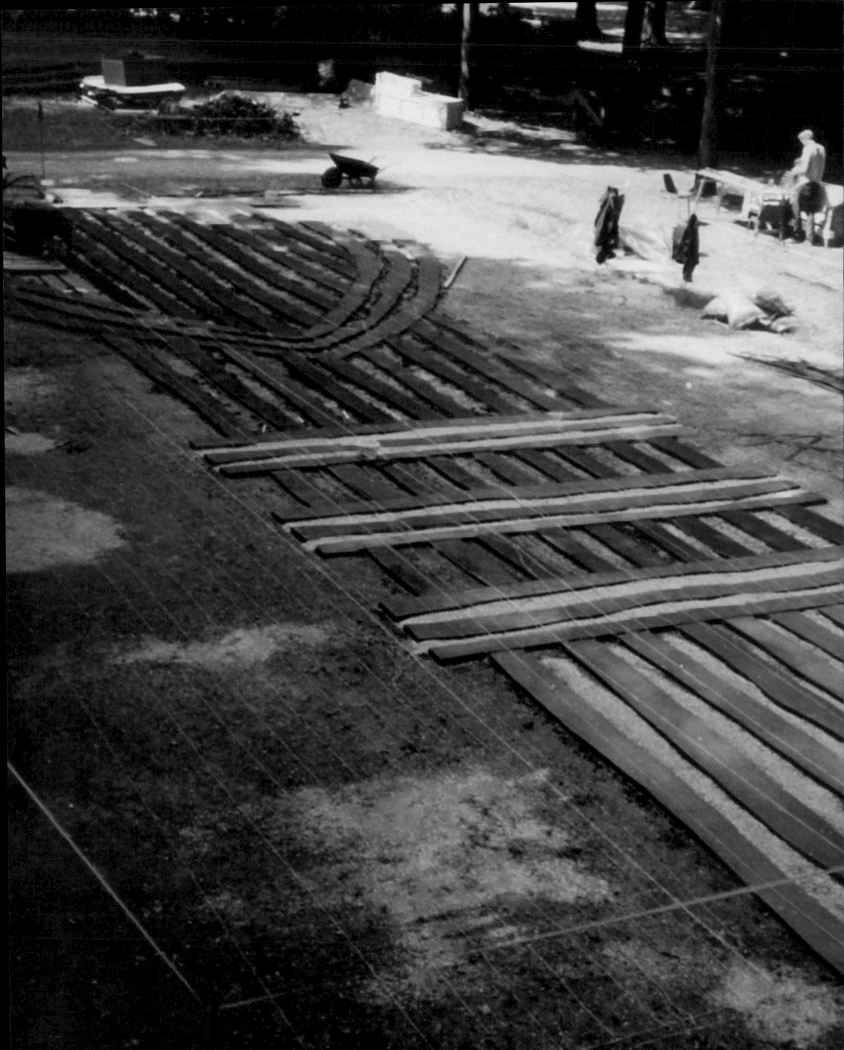

While working on *Sitelines*, Whiteford grew very aware of the dappled light in this shady locale — as well as the waters of the lagoon just visible through the surrounding trees. She wanted her grey lines to echo the character of the site by always appearing slightly in motion themselves. But a very different set of conditions prevailed on the large estate where she executed her next land drawing. In the chill of a Swedish spring, she travelled to Wanås where the estate's owners stage an international exhibition of invited contemporary artists each year. Although trees have been planted there in formal arrangements, with particular attention paid to distant vistas, they do not provide the kind of enveloping shade Whiteford experienced in Venice. She eventually chose a place where the lie of the land exerted a strong appeal. Even though a path ran across the grass, Whiteford had no hesitation in cutting right through it — as if to emphasise that she was responding to a far older and more elemental aspect of the terrain.

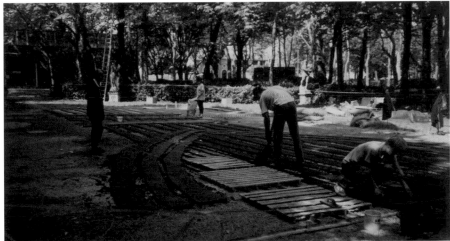

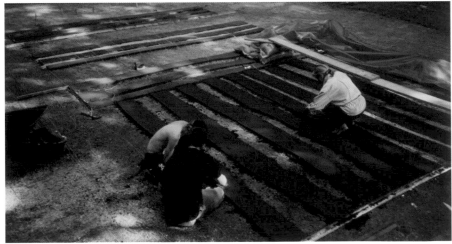

LEFT AND ABOVE:
Sitelines, Venice, 1990
Work in progress,
Venice Biennale, 1990.

It is illegal to cut into the ground of Venice, so the drawing was cast in shallow relief, rather than excavated. The use of pigmented concrete produced a dappled effect almost like watercolour, which gave the work an added sense of movement.

37

Black Line Drawings, 1992
Each 194 x 96cm. Triptych. Charcoal and
emulsion on paper.

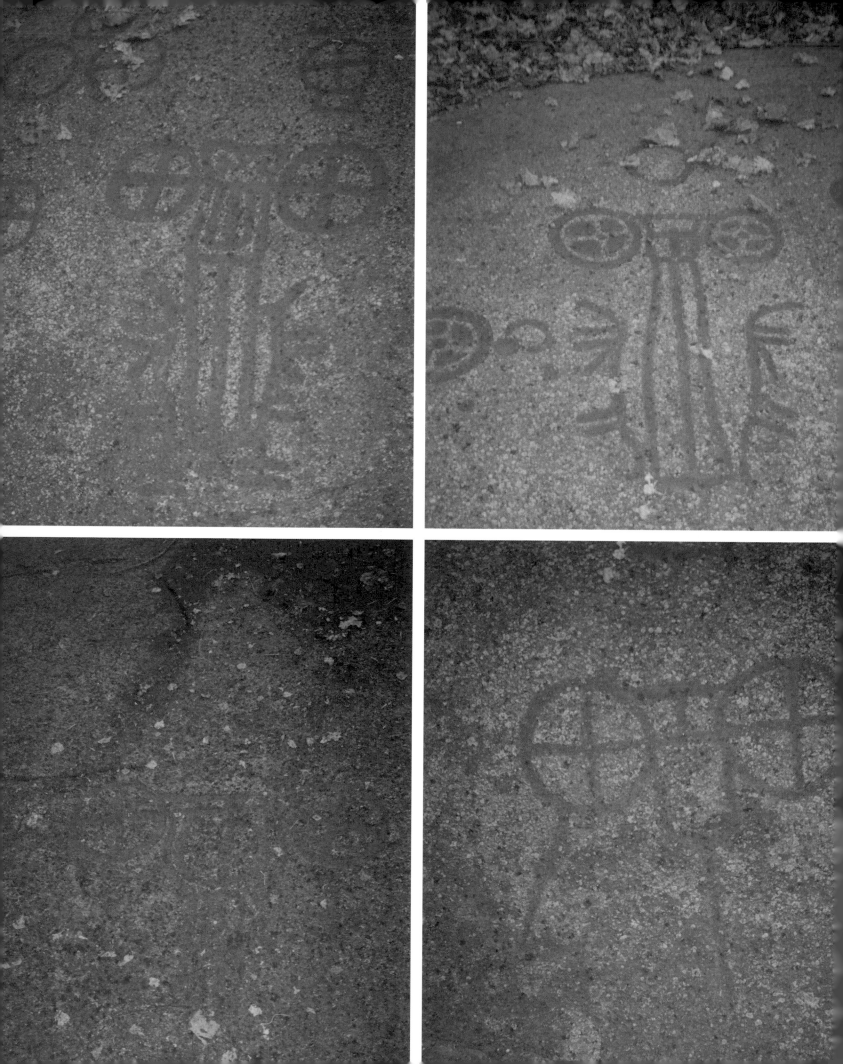

Her awareness of this historic dimension quickened when she discovered, on the neighbouring Bronze Age site of Frannarp, a cluster of large exposed rocks in the ground. Each one bore prehistoric carvings of mysterious images, all linear and some akin to wheels. Ignored by local residents, they nevertheless reminded Whiteford of the Pictish Stones she had sought out in Scotland nearly a decade earlier. And the Swedish carvings were smeared with red earth pigment, a resonant colour which also caught her eye on the tiled roofs of the Wanås estate buildings.

She decided, for her land drawing, to use 20 tons of warm red shale — the kind normally employed in *en-tous-cas* tennis courts. Inlaid in the turf, it was set against the lawns and thereby created a complementary green red frisson without indulging in the full optical assault carried out on the set of *Signature* or some of her earlier paintings. An aggressive retinal impact would have been inappropriate in this sequestered Scandinavian context.

Even so, the forthright strength of the three giant red bands stamped on the grass at Wanås should not be underestimated. Each one was almost one metre thick, and they travelled across the site with an unmistakable sense of decisiveness. Refusing to be deflected by the white path, they forged on towards a pair of curved stripes at the far end. The rounded rhythms of these two bands suggested that Whiteford had attentively responded to the contours of the lakes on the estate. For all the reticence of its secluded pastoral setting, *Marklinjer* demonstrated that she had lost none of her boldness when tackling an epic stretch of the earth's surface.

39

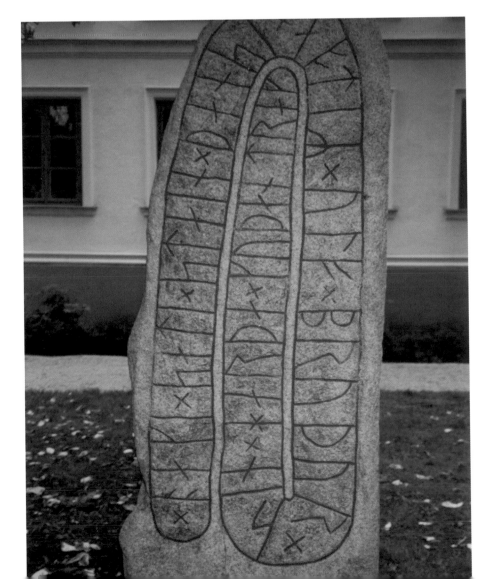

OPPOSITE:
Bronze Age rock drawings, Frannarp, Sweden.

RIGHT:
Stone with inscriptions, Lund, Sweden.

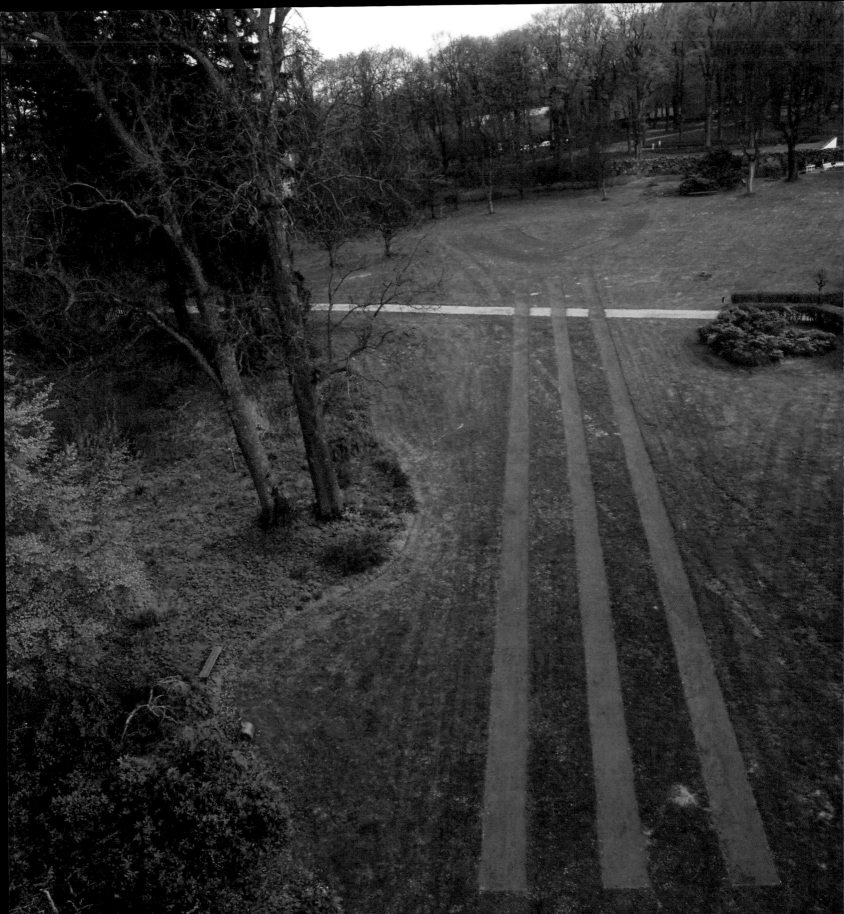

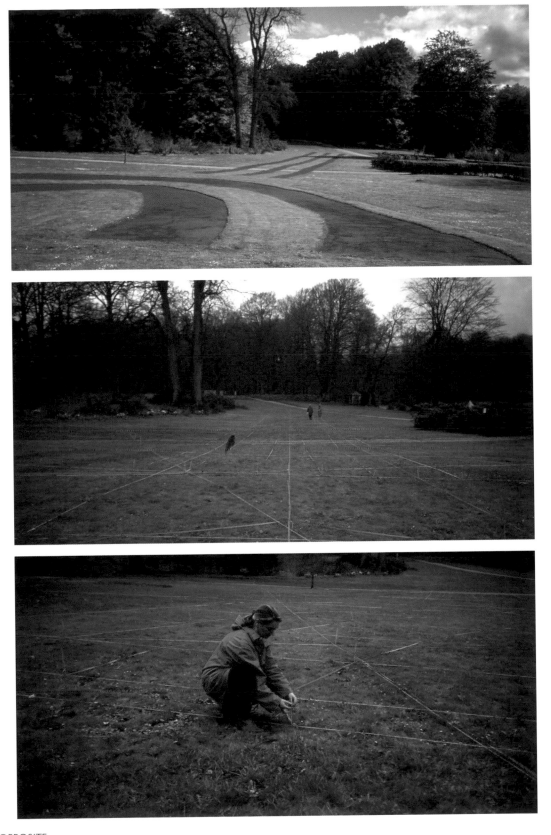

OPPOSITE:
Marklinjer, 1991
Excavated trenches with *en-tous-cas* infill. Wanås Foundation, Knislinge, Sweden.

ABOVE:
Setting out on site.

The choice of material for this land drawing — red *en-tous-cas* — makes reference to the red-painted stone carvings at the Bronze Age site of Frannarp, which lies within the Wanås estate.

A similarly daring and incisive approach characterised the work Whiteford produced for the Greenwich Foot Tunnel in 1992. At first, the prospect of making site-specific art beneath the Thames must have seemed very far removed from the outdoor projects she had recently undertaken. Perhaps that is why her initial idea for the Greenwich venture, commissioned in association with the Whitechapel Art Gallery, centred on putting a lazer across the river. Since it was deemed too dangerous for shipping, this plan was abandoned. So Whiteford directed her attention under the water, where a tunnel had for many years enabled pedestrians to walk from one side of the Thames to the other.

It was a more enclosed and fiercely directional location than any she had dealt with before. But Whiteford was already fired by Greenwich's historic role as a focus for the meridian line, maritime exploration and astronomical discovery. Up on the hill, the Greenwich Observatory had long been a power-house for stellar research. And close by, the National Maritime Museum housed a spellbinding collection of navigational and astronomical instruments. Whiteford was impressed by the astrolabes, crafted and embellished with an opulence reflecting their prodigious ability to navigate by measuring the altitude of stars.

Her response lay in throwing a line right down the middle of the tunnel floor. Above it, on the curved walls, a multitude of existing tiles already sent other lines plunging deep into space. But Whiteford's band was made of brilliantly coloured red and green tape. It emblazoned the pathway as they coursed through the tunnel, terminating at both ends in circles round the entrance buildings. Enhanced by powerful lighting, they vibrated all along the quarter-mile length of the twisting floor, and the strips' optical shift left an after-image burning on the retina of everyone who saw it. *Azimuth* is the term used for an arc described by the celestial great circle, from zenith to horizon. Whiteford, immersed in Greenwich's association with the meridian, wanted her line to make onlookers think in terms of astronomical mapping. Later the same year, she published an artist's book called *Azimuth* full of geometrical lines connected with the astrolabe, overlaid on images derived from navigational charts. It testifies, as Martin Kemp argued, to her "immensely ambitious quest for a language that will inspire contemplation of the universal and enduring behind the particular and the immediate".[17]

OPPOSITE TOP:
Azimuth, 1992
South Dome, with red line.
Greenwich Foot Tunnel, London.

OPPOSITE BOTTOM:
Azimuth, 1992
Red and green line underneath the River Thames. Greenwich Foot Tunnel, London.

The word "azimuth" is derived from the Arabic *as-sumut* which means "the ways". It is a term used in astronomy and for centuries was one of the two co-ordinates used in celestial navigation. The domes marking each end of the Tunnel, one each side of the river, become metaphors for the northern and southern hemispheres.

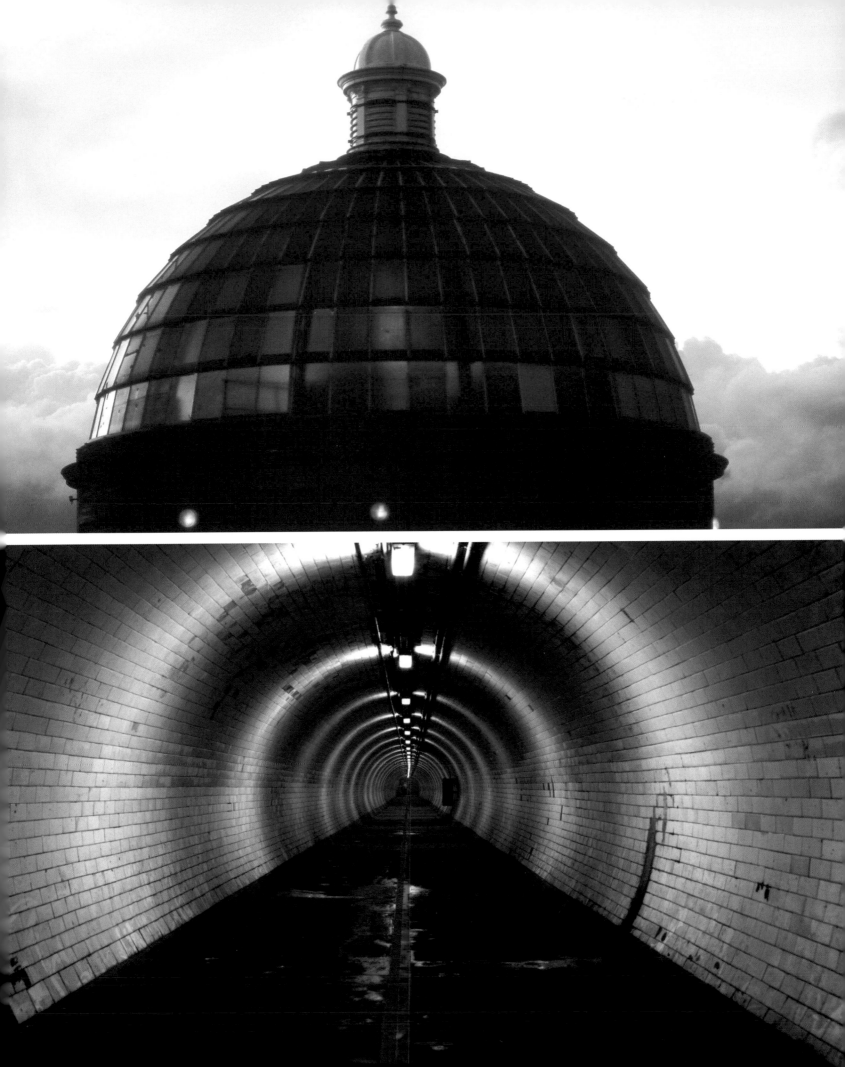

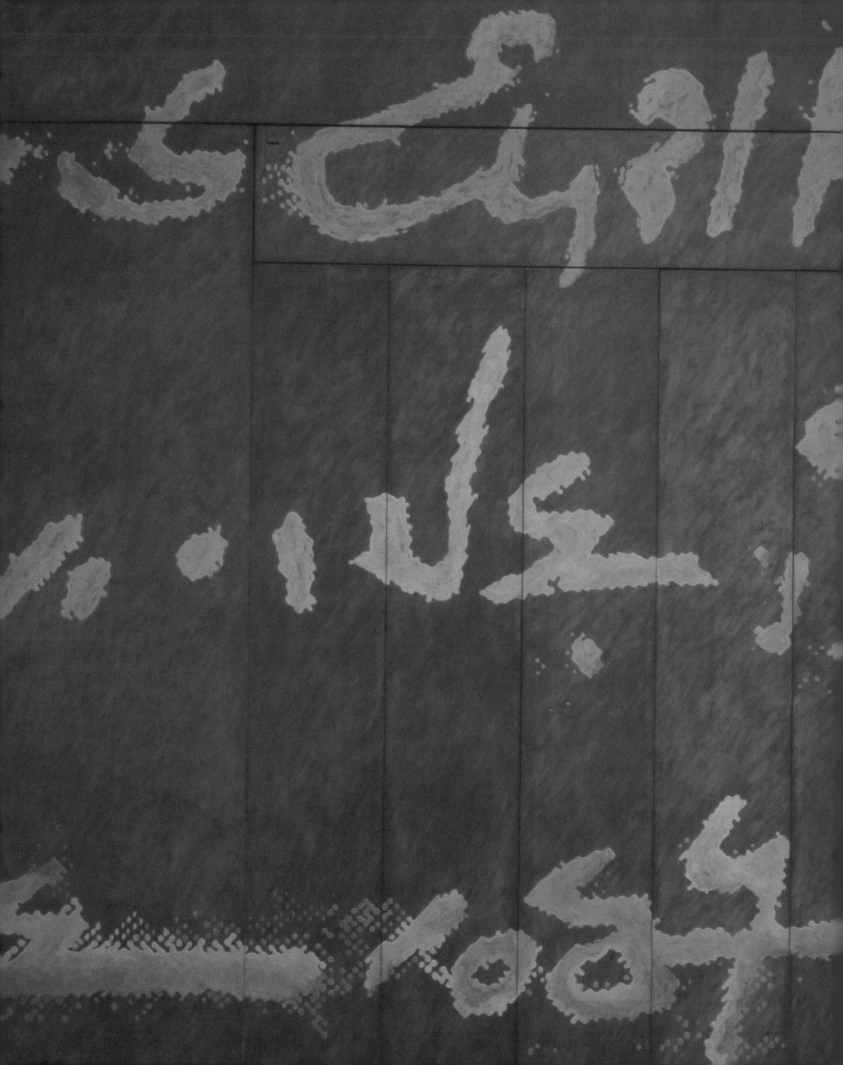

LEFT:
False Door, 1994 (detail)
305 x 400cm. Wall painting and
canvas in nine sections.

ABOVE:
Detail of demotic script.

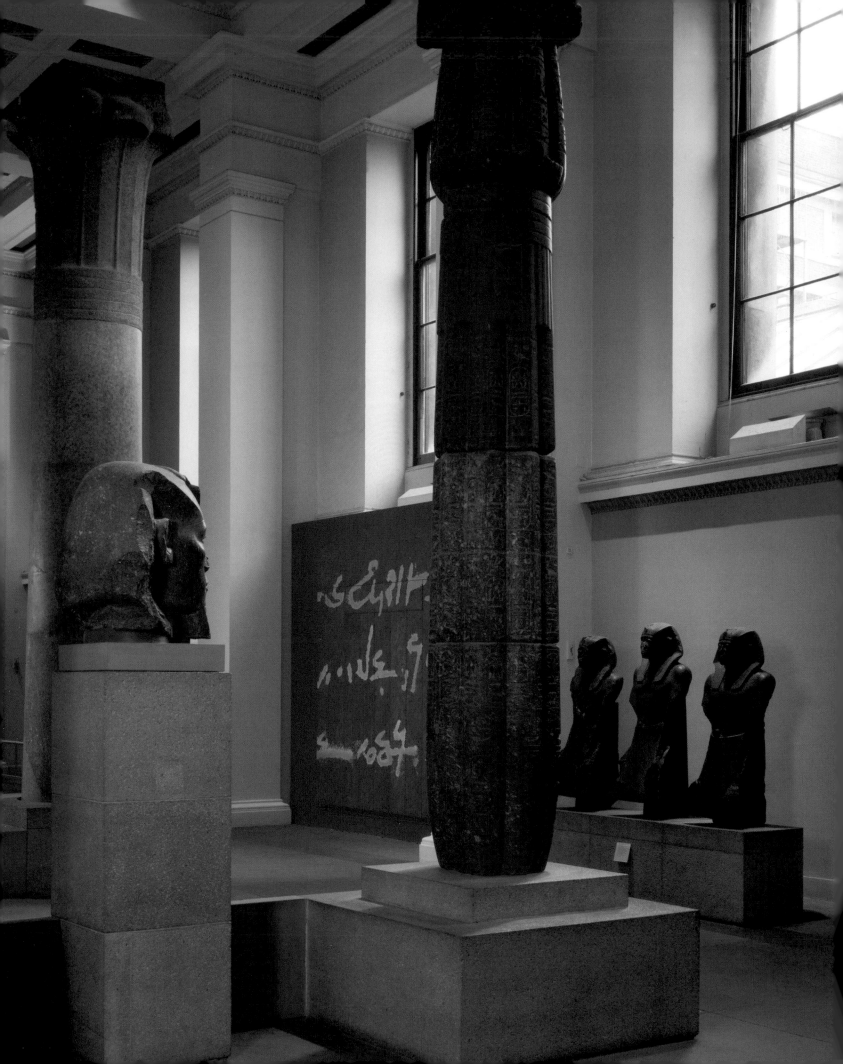

That is why Whiteford was an ideal choice for an audacious and illuminating exhibition at The British Museum. As its title suggested, *Time Machine* set out in 1994 to reveal the continuing links between the art of ancient Egypt and contemporary practitioners. 12 artists were invited to participate, among them Stephen Cox, Andy Goldsworthy and Marc Quinn. They all responded to different aspects of the outstanding Egyptian artefacts in The British Museum. From the time of Jacob Epstein and Henry Moore, twentieth century sculptors responded with profound excitement to this collection. The Keeper of Egyptian Antiquities at the Museum, W Vivian Davies, was right to assert that "the creative link between the past and the present, so well exemplified in some of Moore's sculptures, is as strong and vital as ever".[18]

Apart from sculpture, the selected artists contributed paintings, photographs and installations in a wide variety of media. Produced specially for the exhibition, they were displayed among the Egyptian works that helped to bring them into being. And James Putnam, the show's curator, explained that he had invited artists who "would not simply draw directly on Egyptian images but would explore the concept in a more thematic and evocative way".[19] Whiteford must have felt immediately in sympathy with the aims of a curator who emphasised that "to the ancient Egyptians, art was a magical means of harnessing the energy they observed in nature's great cycle of birth, death and rebirth".[20]

47

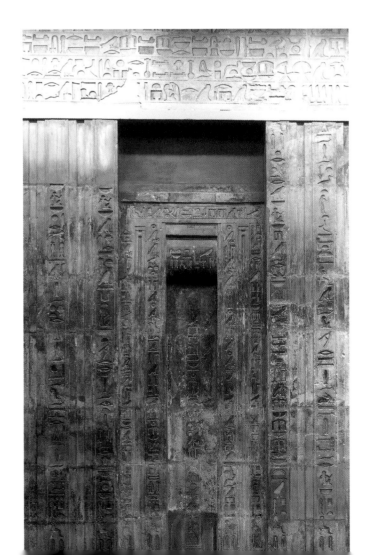

OPPOSITE:
False Door, 1994
300 x 400cm. Wall painting and canvas in nine sections. Installation view, The British Museum.

LEFT:
The False Door of Ptahshepses
C. 2450 BC, from Saqqara, Egypt. Limestone, c. 3.66m. The British Museum.

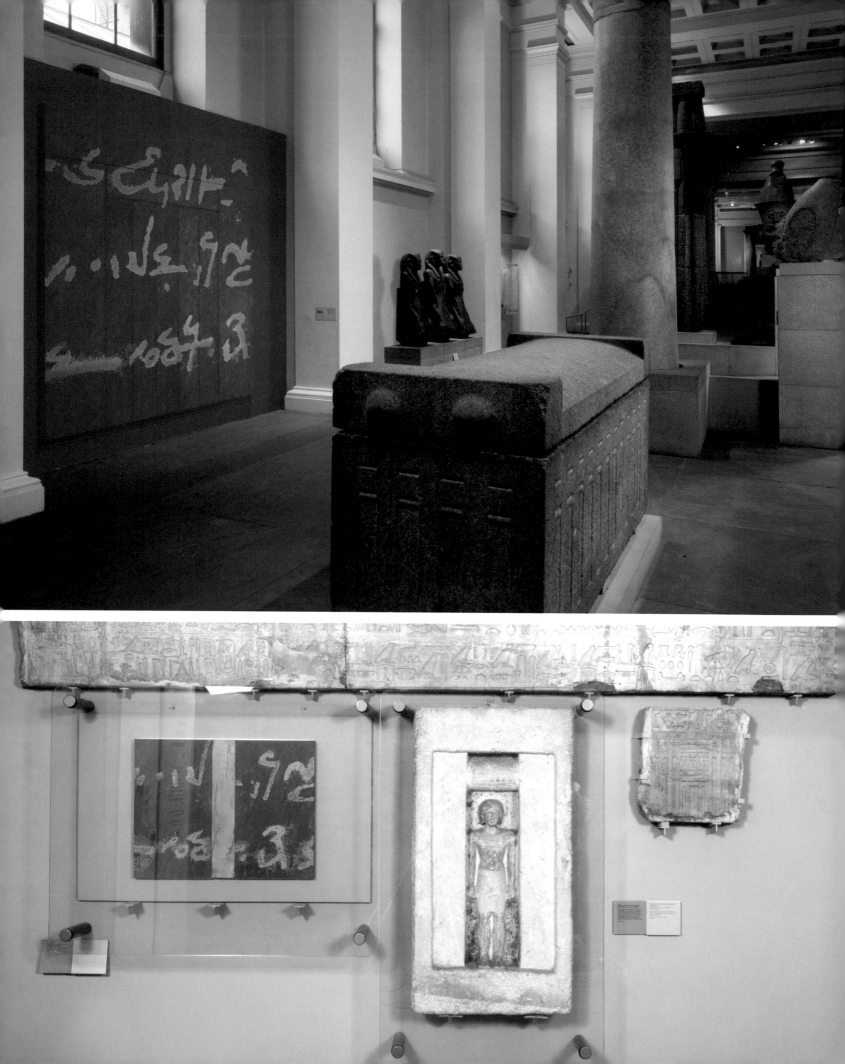

She was intrigued above all by the *False Door of Ptahshepses*, made in limestone at Saqqara around 2450 BC. This imposing and elaborately incised structure, surging to a height of 3.66 metres, was regarded as the most important element in an Egyptian tomb-chapel. Despite its undoubted sculptural solidity, the False Door was believed to possess magic powers. The spirit of the dead person would be able to pass through this aperture and gain renewal in the afterlife.

The pertinence of such an idea for Whiteford is evident at once. Immediately drawn to the concept of a transition point between one state of being and another, she felt an immediate rapport with the Ptahshepses door. On a purely visual level, too, the entire stone structure had for her an extraordinary presence. "This is due partly to its architectural quality", she explained, "and also to its incised hieroglyphs, which still retain traces of earth-red and green pigment."[21] The carvings on the door, executed with great intricacy and yet capable of holding the viewer's attention in a mesmeric manner, seemed to Whiteford intensely evocative of the next world. But she also carried out a great deal of research into demotic texts, finding in the everyday writing of ancient Egyptians an admirable concern with the transition between language and symbol.

Determined this time to use red and green at maximum strength, so that they would honour the Egyptians' belief in something other than what you see, she set to work on a large multi-sectional canvas. Her preparatory studies had explored the possibilities of a red border enclosing a sequence of magisterial vertical stripes. She also experimented with an alternative image, shifting the stripes to the edges and filling the heart of the work with far more freewheeling, hieroglyphic brushmarks. In the end, she opted for a painting dominated by vertical strokes ranged in ten mighty blocks across the canvas. Redolent at once of an architectural opening, they honoured the stern, upright forcefulness of the *False Door* itself. But her image was dominated by calligraphic marks, inspired by demotic texts, that seemed to float in front of the painting's surface. Whiteford completed the work *in situ* at The British Museum, giving herself the eerie experience of working there at night among the silent exhibits. She ensured that her Egyptian sources were in no sense copied. Although Whiteford wanted her displayed painting to draw attention to the Ptahshepses stone block nearby, she avoided pastiche entirely. Her exhibit had an independent life of its own, even while capturing in contemporary terms what Henry Moore once described as Egyptian art's "stillness of waiting, not of death".[22]

49

OPPOSITE TOP:
False Door, 1994
300 x 400cm. Wall painting and canvas in nine sections *in situ* in the Egyptian Galleries. Time Machine, The British Museum.

OPPOSITE BOTTOM:
Incantation, 1994
60 x 85cm. Diptych. Oil on canvas with blue macauba marble inset. Installed within the permanent collection in the Egyptian Galleries. Time Machine, The British Museum.

The painting is made in multiple sections, echoing the construction of the False Door of Ptahshepses, standing exactly opposite. The False Door is inscribed with hieroglyphics, the formal language of Ancient Egypt, whereas demotic text was used on the painting. Both 'doors' use red and green, faded on the original but at full intensity on the canvas, to create an optical shift.

Back in her native country, another architectural setting provided her with a different kind of challenge altogether. Approached by the National Museum of Scotland, she was asked to design an enormous tapestry for the entrance of the new Edinburgh building designed by Benson + Forsyth. The Museum's Director, Mark Jones, was in favour of commissioning contemporary art for the interior. It was a controversial innovation, and for her part Whiteford had no previous experience of working in tapestry. But she felt intrigued enough to attend a meeting in the old Dovecot Studios, a purpose-built headquarters reflecting its Arts and Crafts origins.

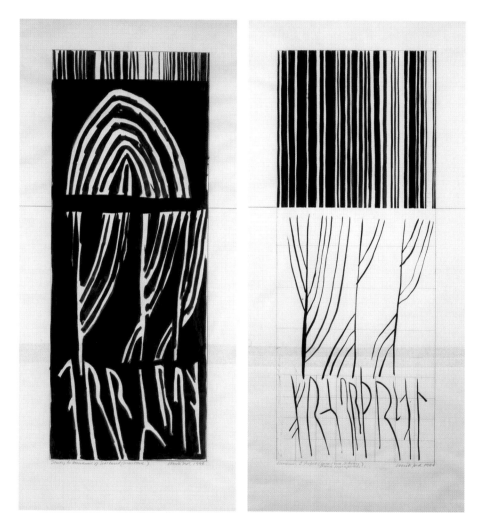

50

LEFT AND RIGHT:
Corryvrechan Tapestry, 1997
Studies. 150 x 50cm. Black ink on graph paper.

OPPOSITE:
The Corryvrechan Tapestry, 1997
800 x 400cm. In association with the Edinburgh Tapestry Workshop. Museum of Scotland.

The design of the tapestry was conceived as a series of strata, reflecting the different periods covered by the Museum, from runic inscriptions to barcode-like vertical bands at the top.

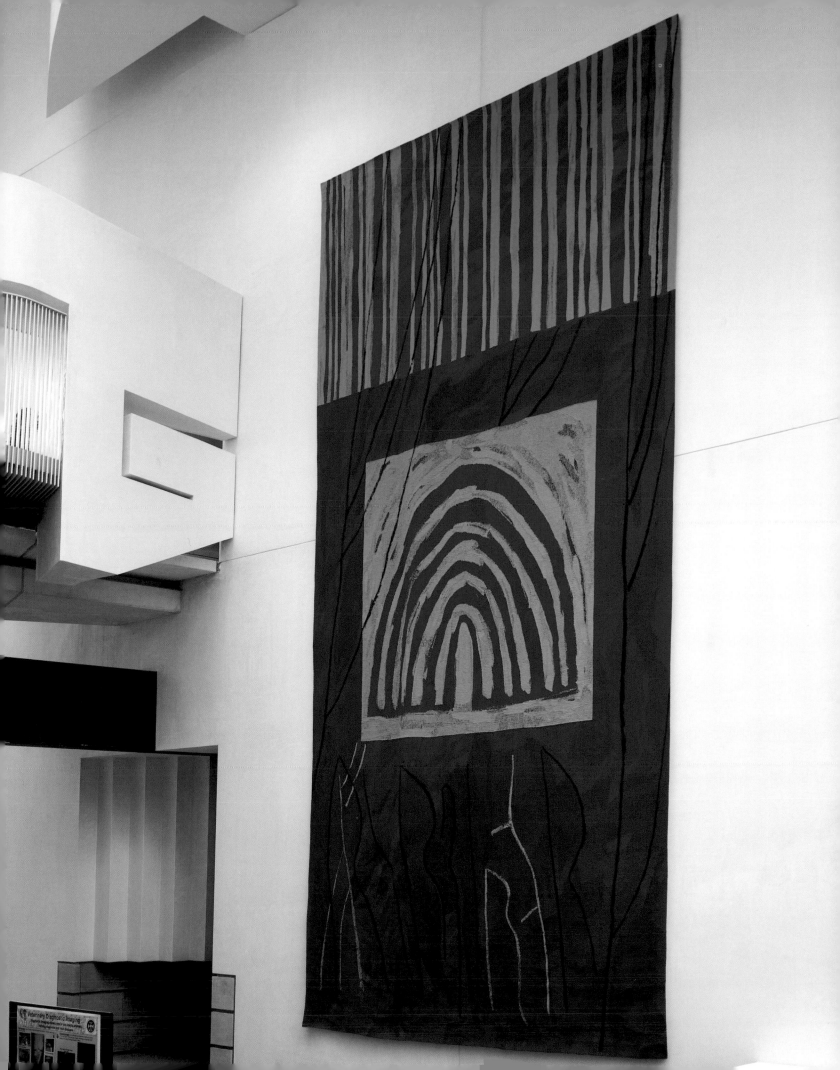

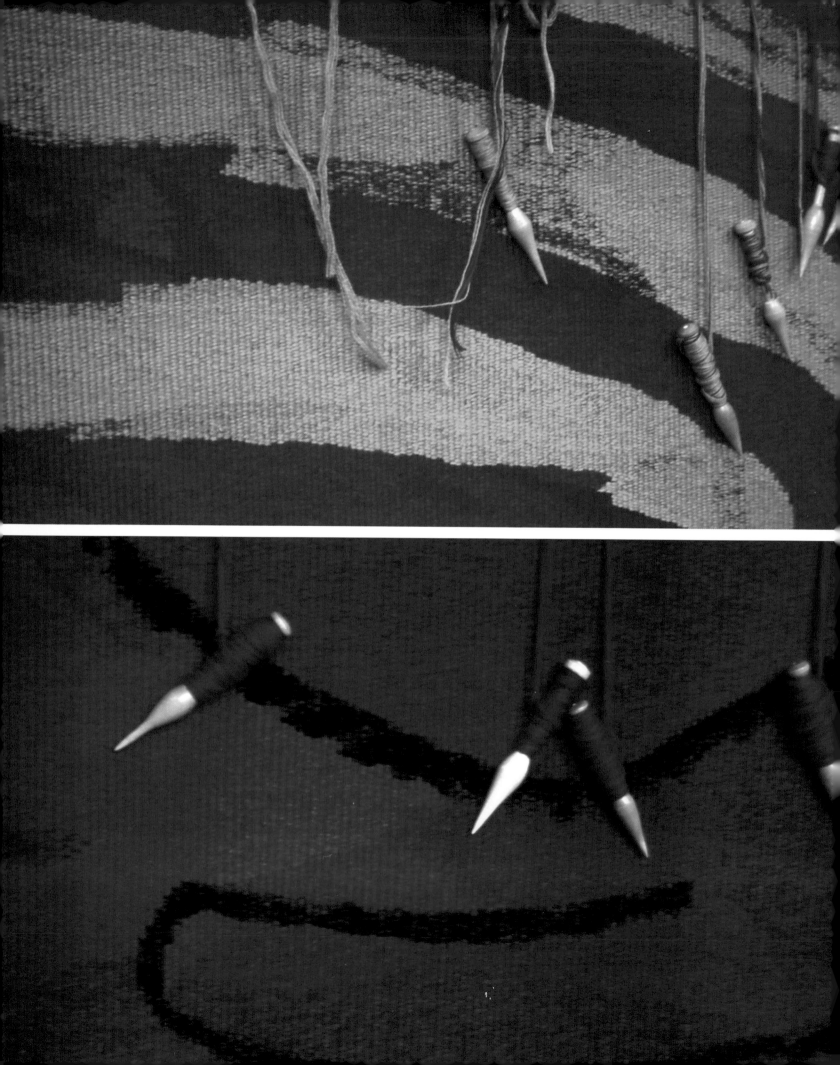

In more recent decades the Dovecot Studios had worked with artists as various as Alan Davie, Eduardo Paolozzi and Tom Phillips, so she found that everyone involved in the Museum of Scotland venture approached it with a reassuringly open attitude. During a subsequent discussion, the architect Gordon Benson became very enthusiastic about the concept she proposed: to reflect the various layers of the Museum's collection in a design linking the chronological changes on each floor. At this stage, Benson wanted the tapestry to plunge down through the entrance hall floor into pre-history as well. But the building programme was too far advanced to let such an idea be realised, and soon after the finished tapestry's formal unveiling in December 1998 it was moved into the main hall — a better location, where it is easier for visitors to read.

53

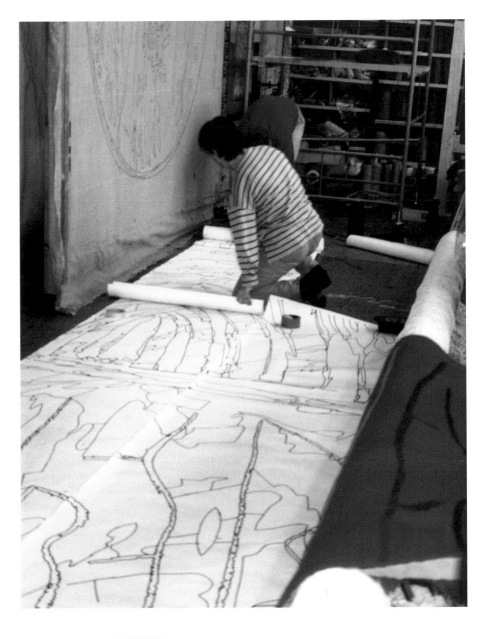

OPPOSITE, TOP AND BOTTOM:
**The Corryvrechan Tapestry,
1997** (detail)
Work in progress. Edinburgh
Tapestry Workshop.

ABOVE:
Preparation of the tapestry cartoon.
Edinburgh Tapestry Workshop.

TOP AND BOTTOM:
Inscription I
Inscription II
52 x 164cm each. Diptych. Liquid
watercolour on parchment paper.

Whiteford's thinking about the design was dominated by a startling and ambiguous idea: a contained symbol of prodigious energy or destruction. She called it the *Corryvrechan* tapestry, after an infamous whirlpool in a strait off the coast of the Isle of Jura. Unexpectedly, the vortex there is very dark yet still. Whiteford wanted her work to convey the dynamism of the ancient and modern cross-currents in the Museum and contemporary society beyond its walls. But she also aimed at playing with perception in the images of 'tree' runes (Maes Howe Orkney) running the entire length of the tapestry, transmitting their vitality through the timeline to the present day.

55

ABOVE:
Detail of runic inscription from Maes Howe, Orkney. Museum of Scotland.

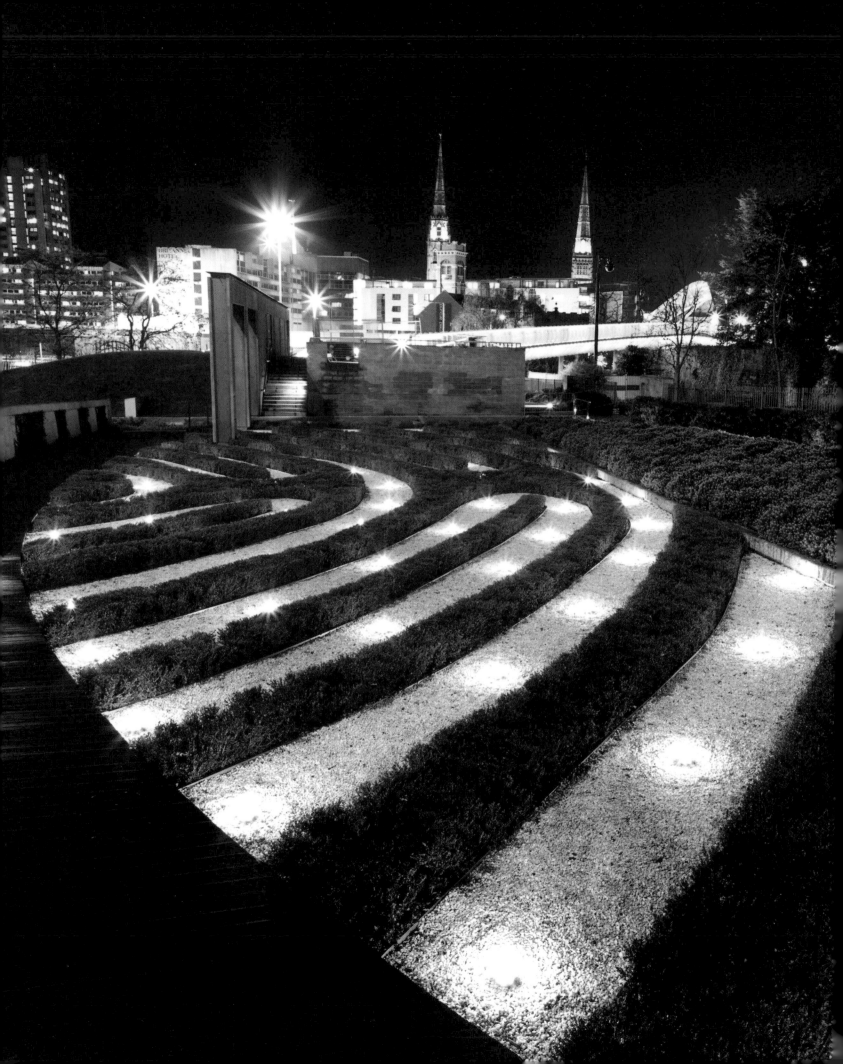

Outside the sheltered confines of a museum, artists often undertake urban projects at their peril. However impressive the work may be, it can easily become compromised or even crushed by an alien cityscape on every side. The challenge is daunting, and Whiteford would normally shy away from involving herself in a location shadowed by a motorway or underpass. At Coventry, though, she overrode her usual misgivings. The site offered to her felt uncomfortably close to the concrete inner ring road ensnaring the city's heart. But Whiteford was invited by Vivien Lovell to create a sunken garden there, and it formed part of an enlightened regeneration scheme masterminded by the architects MacCormac Jamieson Prichard (MJP) with Rummey Design Associates.[23] The £50 million Phoenix Initiative, commissioned in 1997 by Coventry City Council, was dedicated to redeeming a city blitzed by Nazi bombers, blighted by neglect and then hideously disfigured by mediocre structures erected during the most dismal era of twentieth century architecture.

Whiteford would have been quick to notice, on exploratory visits to this scarred urban centre, that the history of destruction went back to a far earlier period. The once-resplendent Cathedral of St Mary, completed by the Benedictines around 1220, was ranked among the most outstanding Romanesque buildings of the time. Yet Henry VIII obliterated most of it during his iconoclastic attack on Catholic art and architecture, just as the Gothic magnificence of St Michael's church was reduced to ruins during a nine hour assault by the Luftwaffe in 1940. Some of the city's multiple wounds were healed when Basil Spence, with the help of Jacob Epstein, John Piper and Graham Sutherland, created a new cathedral in 1962. But much remained to be done, and the Phoenix initiative succeeded in regenerating the extensively damaged area beyond the boundaries of Coventry Cathedral.

At every stage in this far-seeing scheme, artists were invited to play an integral part. Far from being treated as 'add-on' embellishers long after the new buildings had been erected, they were able to enter into a collaboration with the architects and designers. Richard MacCormac and Vivien Lovell explained that they wanted "artists to make a new place — or series of linked places — redeeming a fragmented site. Through artists' interventions, disparate areas could be given identity, not by some grand formal gesture, rather by way of an episodic journey through a series of places, highly contemporary yet informed by history, and unique to Coventry."[24]

Whiteford took as her starting point images of the Great Maze at Chartres Cathedral, using it as a poetic metaphor to indicate Coventry's centuries-old links with other great European cultural centres. Boldly, Whiteford wanted her *Priory Maze* to look as if it had just been unearthed from the urban highway placed in such uncomfortable proximity to the Garden. She aimed at implying that her maze once extended beneath the flyover.

57

Priory Maze, 2000
Excavated trenches with *Buxus sempervirens* and nordic spar infill. The Garden of International Friendship, Coventry. Night view looking towards the glass bridge and Coventry Cathedral and St Mary's.

This was a derelict inner city site, bounded by the ring road on one side, and covered in 1960s concrete. Records show this was the former orchard of the Priory of St Mary's, which pre-dates Coventry Cathedral. The work 'recovers' the memory of a great maze which runs underneath the flyover.

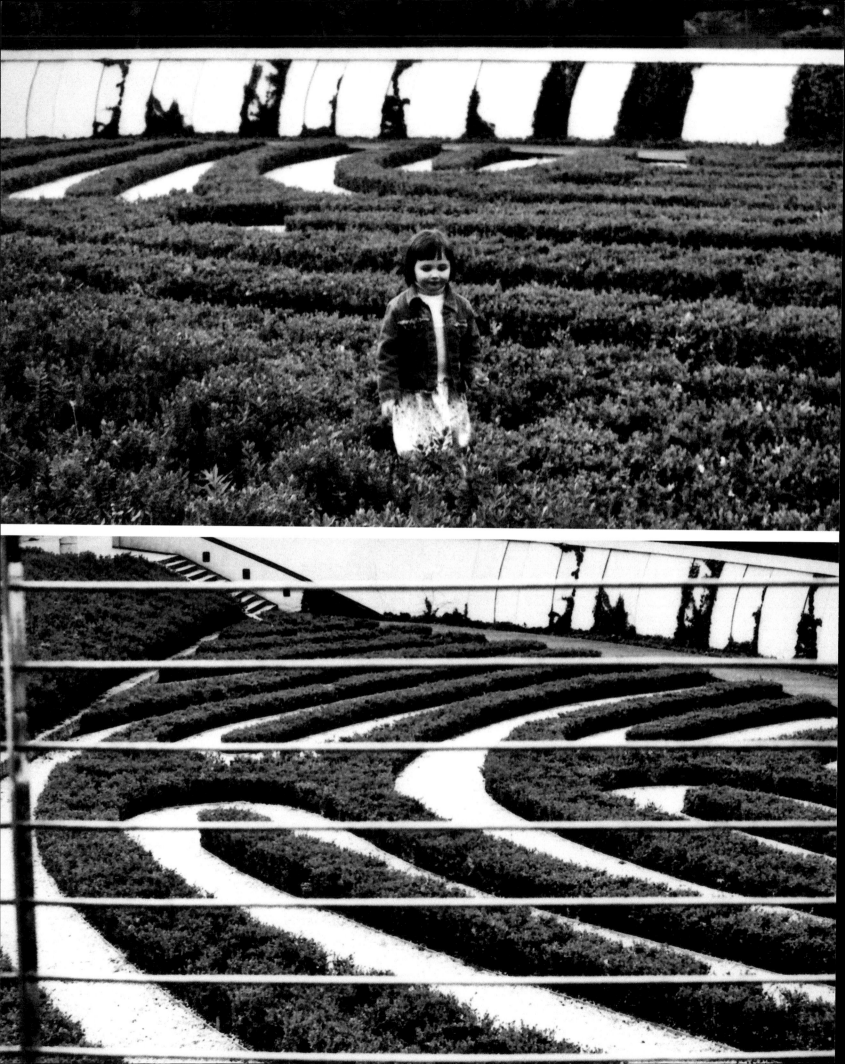

Rather than being defeated by the dual carriageway brutally cutting off Coventry's centre from the rest of the city beyond, *Priory Maze* exerts a redemptive power. The pared-down clarity of its form is reminiscent of the spiral on Calton Hill, and yet this sunken garden at the same time honours Coventry's history. "The twists and turns of the maze", she explained, "echo the many ropeworks that were part of a once-significant industry in the area."[25] But Whiteford ultimately wanted the Garden to serve a contrasting range of functions, providing on the one hand a playful interactive space for children and on the other "a place for reflection, to encourage visitors to remember the wider history of the area — not only the terrible devastation of the Second World War and its aftermath, but also the peaceful contemplative life of its monastic past".[26]

Finally, running round the curved retaining wall of the Garden is an embedded text selected by the artist and the poet David Morley from the Coventry Mystery Plays, performed for many centuries by processions of local people around the city's perimeter. One passage in particular seems to speak for Whiteford's hope that *Priory Maze* would transcend its urban setting and evoke a far larger vision of the world beyond:

> Owt of deserte, from the hard stone
> I exorte you all
> That in this place assembulde be
> With sun, mone and staris
> Erthe, sky and wattur
> And al for the sustenance of owre humayne nature
> With fysche, fowle, beast
> And cyuere othur thyng vnder us
> To have the naturall course and beyng [27]

59

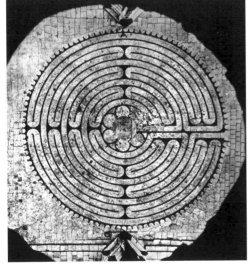

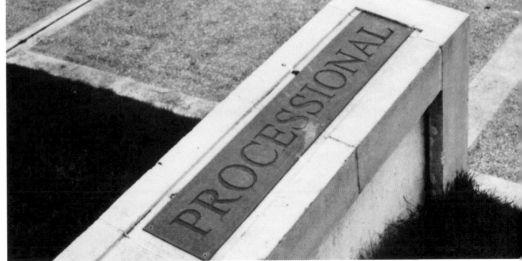

OPPOSITE, TOP AND BOTTOM:
Priory Maze, 2000
The Garden of International
Friendship, Coventry.

LEFT:
Le Labyrinthe de Chartres,
thirteenth century inlaid stone
floor. Chartres Cathedral, France.

RIGHT:
Procession, 2000
55m in length. *Cento* from the
Coventry Mystery Plays. Engraved
bronze plate, inlaid into the top of
a curved wall.

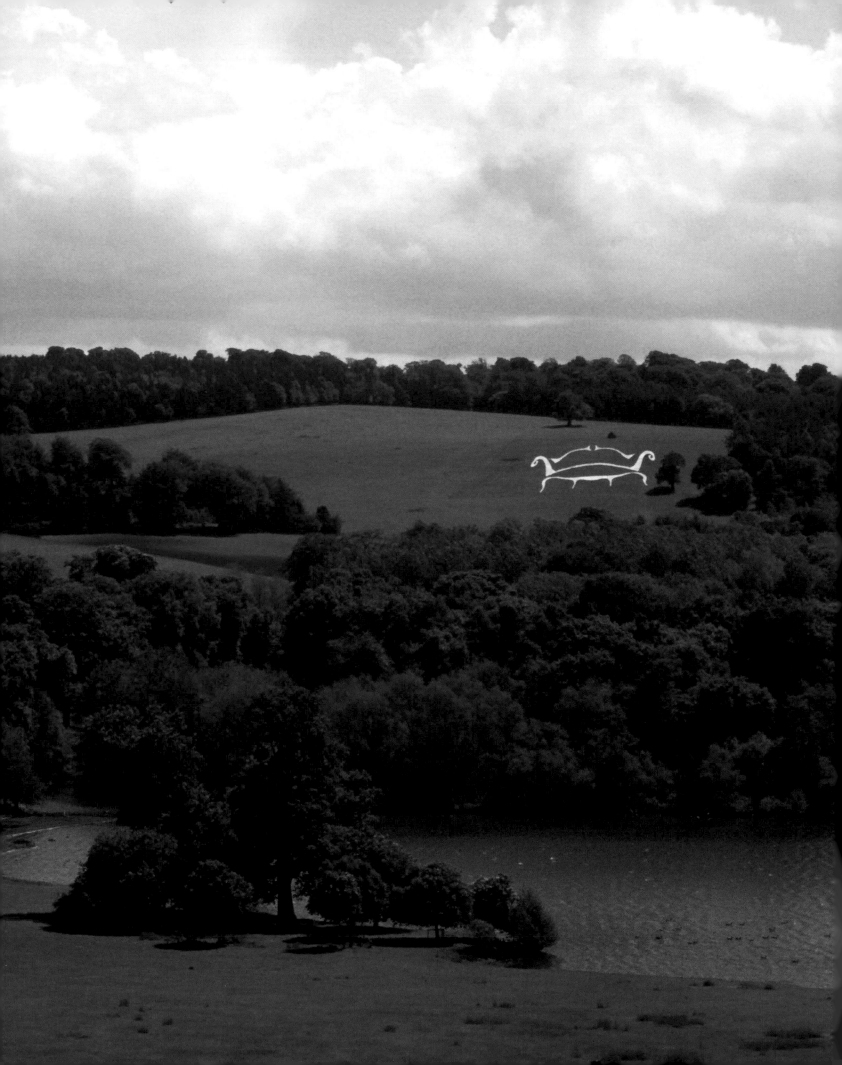

However deeply Whiteford savours the natural world, she also remains keenly aware of the role played by artifice within pastoral settings. Many of the apparently untouched landscapes surrounding the grand country mansions of Britain were, in reality, designed with painstaking deliberation. When invited by Harewood House in Yorkshire to create her response to the building and its multi-faceted history, she lost little time in researching the history of the eighteenth century mansion and its seductive locale. Edwin Lascelles, the immensely wealthy builder of Harewood House, wanted the ideal setting for the secular Palladian temple that became his home. Workaday Yorkshire moorland did not meet with his approval, so he hired Lancelot 'Capability' Brown to fashion a landscape "tailored to his own taste".[28]

Deceptively gentle, and lacking the geometrical formality of earlier garden designs in England, Capability Brown's transformation of the Harewood parkland was thorough-going nonetheless. Lake, foliage and hillside behind were all informed by the serpentine line so widely cherished in late eighteenth century aesthetics. Hogarth had defined it for painting in his influential treatise *The Analysis of Beauty*, published in 1753. And the tireless, prolific Brown popularised the idea by revolutionising the English landscape garden. Nothing pleased Lascelles more than the knowledge that he could gaze from his windows over a setting shaped by what Hogarth described as the "line of beauty".

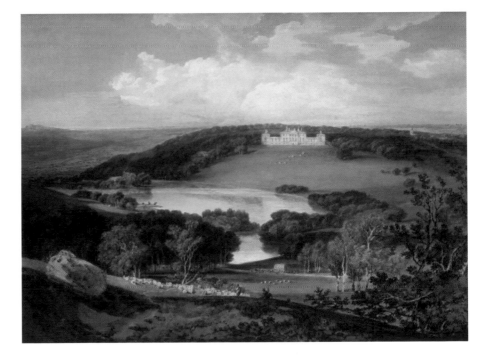

61

Sitelines, Harewood (after Chippendale), 2000
Land drawing on Greystone Hill, Harewood Estate. View from Harewood House across the lake.

ABOVE:
Harewood House from the South, 1798
Watercolour on paper by JMW Turner, 1775–1851.

During the months she spent visiting Harewood and studying its collections, Whiteford came to appreciate the bond between Brown's landscape and the furniture by Thomas Chippendale preserved inside the House. Focusing in particular on a 1775 rose velvet sofa from the Yellow Drawing Room, she realised that it was animated by the same beguiling serpentine line found on Brown's horizon. Whiteford began painting a sequence of watercolours inspired by the curving forms of objects in the Harewood collection, whether Chippendale's furniture or Sèvres porcelain. And gradually, she developed a bold plan to make a land drawing on the panoramic hillside immediately opposite the House. To everyone's surprise, it took the form of what Jane Sellars, the Principal Curator of Harewood, felicitously described as "a sofa *triumphans*, graceful in its artificial curves, made to prance across the equally contrived lines of Brown's faux-classical landscape".[29]

The experience of encountering and pondering Whiteford's *Sitelines* was, however, more complex and ambiguous than Sellars suggested. Glimpsed soon after visitors entered the Harewood estate, its leaping white contours bore an initial resemblance to the great earth drawings of prehistoric Britain. Inscribed on a site as steep and prominent as many of these ancient precedents, it looked at first like a strange double-headed animal. The curved arms were reminiscent of heads, pointing eagerly in opposite directions. This hybrid steed appeared to be caught in a moment of chronic indecision, unable to gallop either to the left or the right.

62

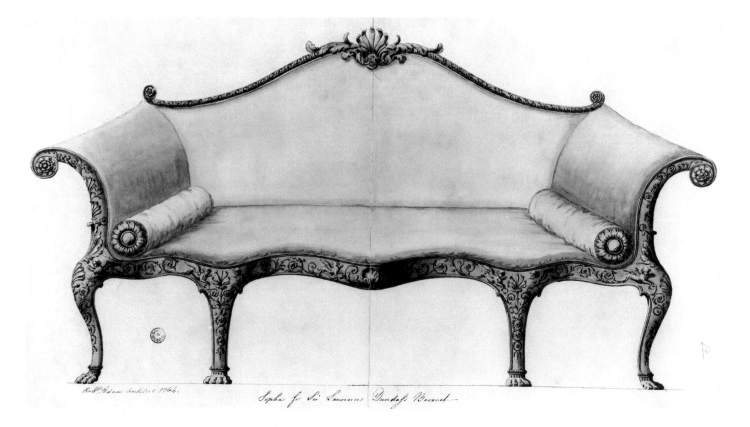

Drawing for a sofa, 1764
Pen and ink drawing by Robert Adam.

After a while, though, viewers appraising *Sitelines* from the Victorian terrace, or the state rooms on the south side of the House, began to appreciate Whiteford's references to a sofa. She did not seek to hide them: indeed, two words added to the work's title pointed us clearly in that direction: *After Chippendale*. And once the connection had been identified, our perception of everything changed. *Sitelines* now became a comment on the thinking fictionalised by Edgar Allan Poe. In his *Tales of Mystery and Imagination*, Poe imagined a visitor entering a home in a picturesque location and, realising that the furniture had "evidently been designed by the same brain which planned 'the grounds'", exclaiming that it would be impossible "to conceive anything more graceful".[30]

In other words, Whiteford wanted *Sitelines* to make everybody aware of just how artificial the Harewood landscape really was. Anyone visiting the Terrace Gallery encountered an exhibition of Chippendale furniture, accompanied by the watercolours she had executed in response. Their evident kinship with the drawing in the grounds outside alerted visitors to the link between *Sitelines* and a sofa. It announced Whiteford's playful determination to destroy the illusion that the Harewood parkland was somehow effortless, and had always looked the way it does today. Yves Abrioux argued that "the visual ease produced by the informality of the serpentine line contributes decisively to constituting nature as a trope for comfort. If this is precisely what we moderns characteristically, but only half-knowingly, celebrate in English parkland, we do so at the cost of

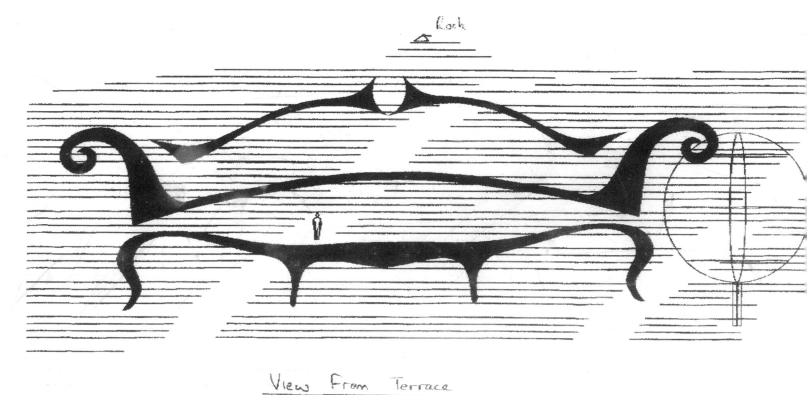

Pen and ink study for land drawing, 2000
CAD scan showing the placement of the sofa in the landscape, with a figure, the 'Greystone' and a tree showing relative sizes. The final drawing required anamorphic correction to achieve the correct perspective when seen from the house.

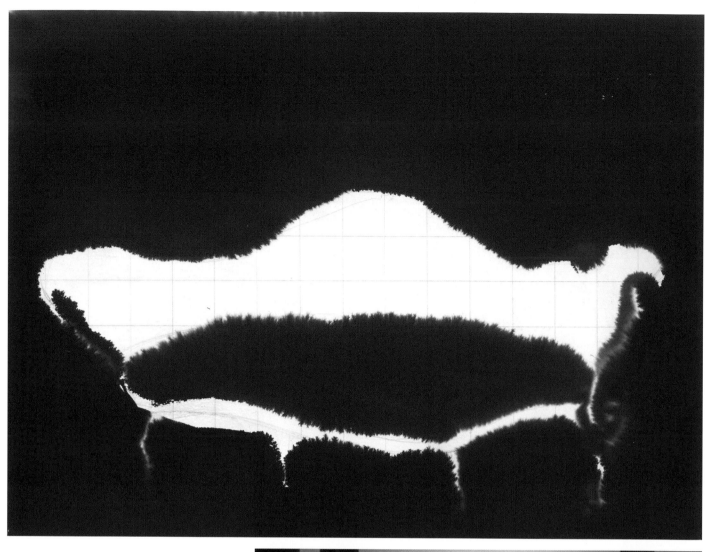

64

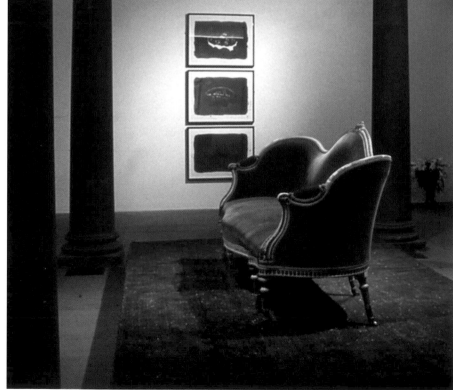

<u>TOP:</u>
Rose Velvet Sofa (after Chippendale), 2000
56 x 76cm. Liquid watercolour on parchment paper.

<u>BOTTOM AND OPPOSITE:</u>
Sitelines, Harewood (after Chippendale), 2000
Astro turf plinth, and seven watercolours on paper. Installation with Rose Velvet Sofa by Thomas Chippendale, 1775. Harewood House, Leeds.

<u>OVERLEAF:</u>
Sitelines, Harewood (after Chippendale), 2000
Land drawing on Greystone Hill. Architectural mesh fabric. View from the Terrace Gallery. Harewood House, Leeds.

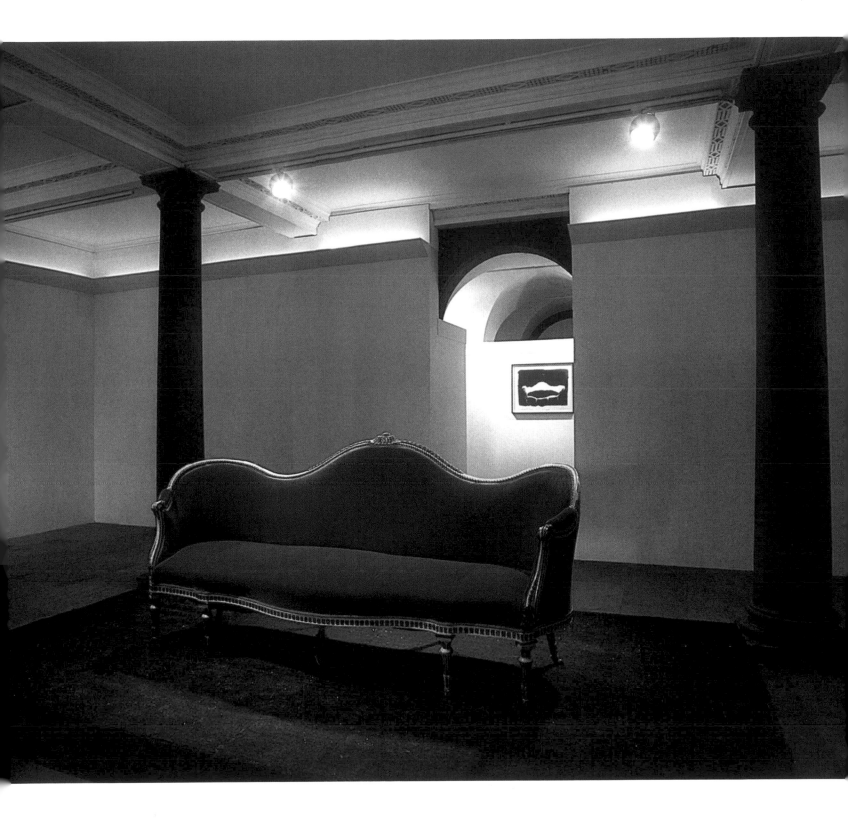

The Rose Velvet Sofa was placed opposite a door leading
onto the terrace, from which one could look across the
lake to the 'sofa' on the hillside. A series of watercolours
traced the faint outlines of objects in the museum.

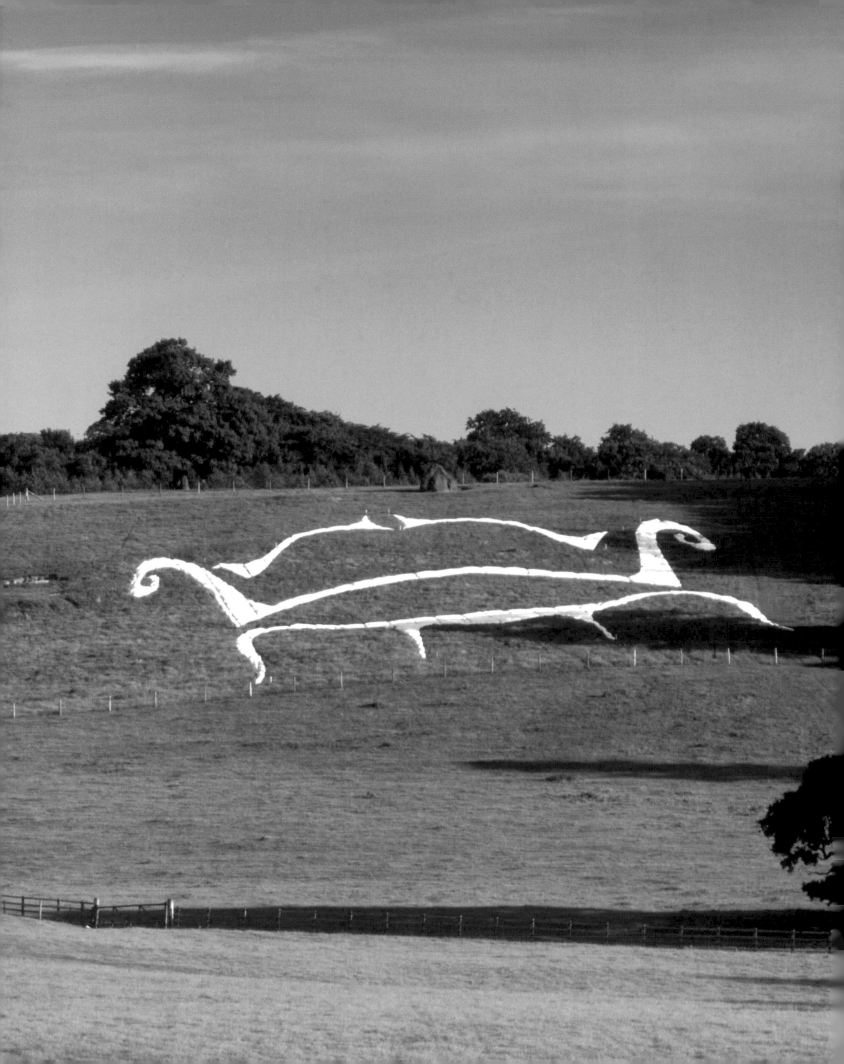

downplaying the historical import of the eighteenth century landscape garden as a peculiarly naturalistic artefact." *Sitelines* opened the viewer's eyes to the truth, as Abrioux went on to explain: "The congenial green carpets that were laid out in estates such as Harewood had the effect of making classical culture potentially more at home in the mellow English countryside than further south, in the scorched landscapes of the Mediterranean whose imposing classical ruins were at that time being rediscovered by aristocratic participants in the Grand Tour. In a process of translation that is at once linguistic and physical, in the root sense of 'transportation' the landscape garden makes classical culture 'speak good English' (to adapt a piece of advice given to the poet Alexander Pope). In so doing, it partakes in the politics of the Augustan imperium: the creation of a modern empire to supplant those of the Ancients."[31]

All the same, the kinship between *Sitelines* and a prehistoric earth drawing refuses to go away. It demonstrates Whiteford's determination to make us think about far older and more enigmatic traditions in British art. *Sitelines* was not an instructional work. It stopped well short of insisting on a single reading, and remained open to radically different interpretations. The undoubted resemblance to a sofa did not oust its other reverberations, and they continued to enliven the Harewood hillside for as long as the land drawing proclaimed its provocative presence in the Yorkshire turf.

68

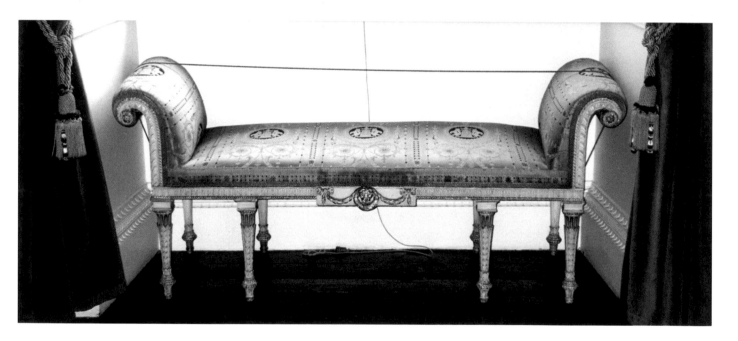

ABOVE:
Eighteenth century window seat by Thomas Chippendale. Harewood House, Leeds.

OPPOSITE TOP AND BOTTOM:
After Chippendale, 2000
56 x 76cm. Series of ten framed works on paper. Liquid watercolour on parchment paper.

This land drawing makes a link between the artifice of Capability Brown's landscape at Harewood and the exquisite furniture of Thomas Chippendale designed for the house. Both men used the concept of the serpentine line in their work, and curving back of the Chippendale sofa seems to echo the curve of the landscape designed by Capability Brown.

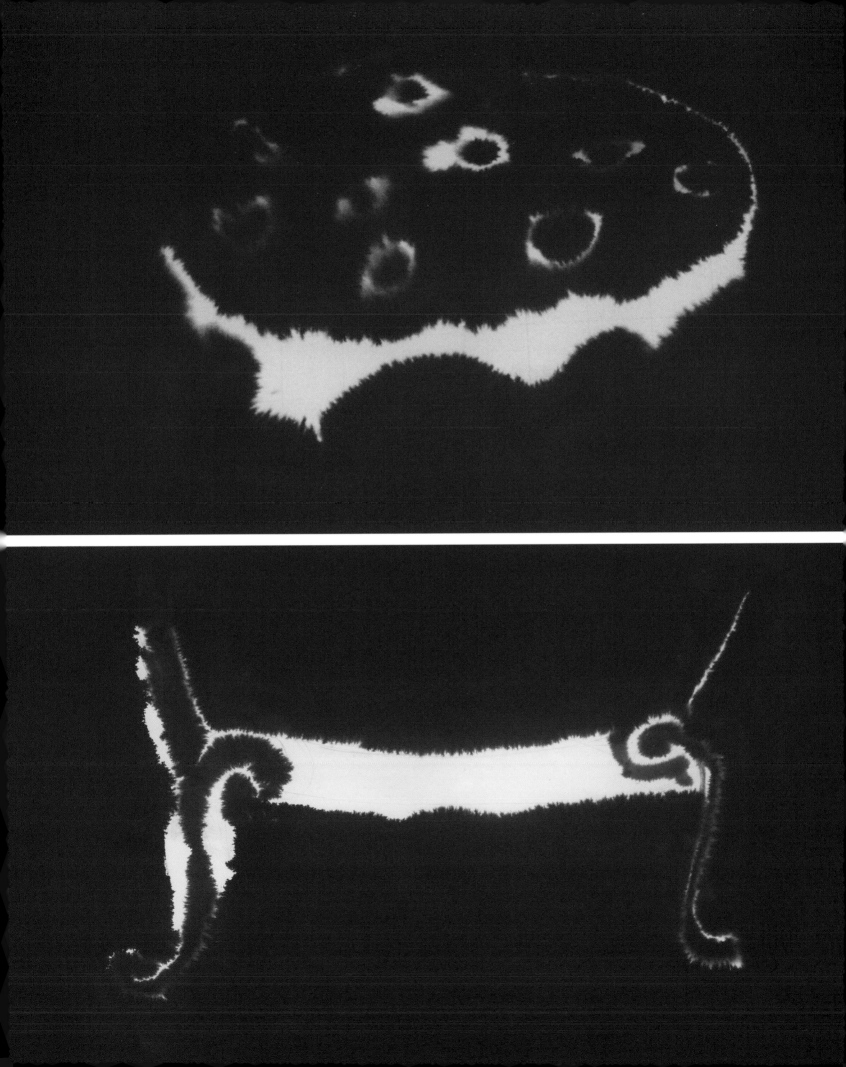

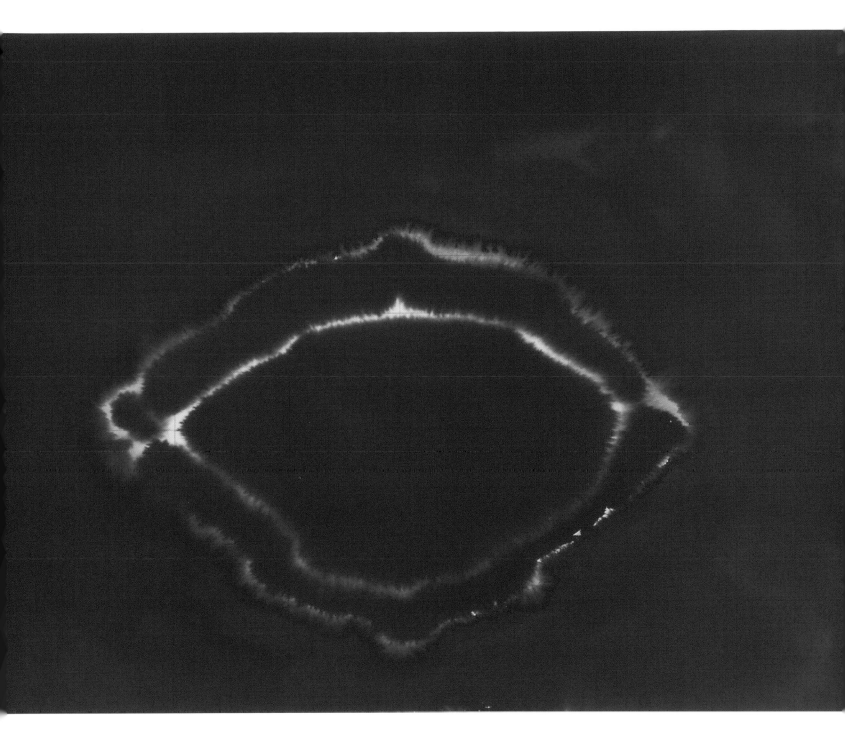

OPPOSITE:
After Sèvres
Each 56 x 76cm. Installation of 20
works on paper. Liquid watercolour
on parchment paper. Agnews,
London, 2001.

ABOVE:
**After Sèvres (Marie-Antoinette
déjeuner), 2000**
56 x 76cm. Liquid watercolour on
parchment paper.

No references to furniture could be detected in the land work Whiteford made a year later for a Scottish island. She drew it with silver sand on the immense front lawn at Mount Stuart, the home of the Bute family. Having met them while preparing her Dovecot tapestry for the Museum of Scotland, she initially accepted an invitation to visit the Isle of Bute and look at Mount Stuart's outstanding tapestry collection. At that time, in 1997, the Butes had never organised a major contemporary art exhibition in their house. But Whiteford, who always remembered her own childhood holidays on the Isle of Bute, suggested that Mount Stuart would be a potent location for contemporary artwork. They agreed, and the original plan centred on displaying the drawings she had made for her *Corryvrechan* tapestry commission. But then, after Whiteford had spent a fruitful amount of time travelling round the island and exploring its history, the venture became infinitely more adventurous.

By the time her exhibition opened in the summer of 2001, inaugurating the new building and gallery at Mount Stuart as well as marking the first year of its contemporary art programme, she had immersed herself in the remains of ancient settlements on the island. She tried to find out as much as possible about the cultural and geographical significance of the stones and burial sites on the island. But when she came across evidence concerning a dramatic discovery on the small, deserted island of Inchmarnock nearby, her curiosity quickened. In 1961 a Bronze Age burial site had been unearthed, harbouring a female skeleton and a necklace made of ignite.[32] Whiteford wanted to find out more about this anonymous, solitary woman. She consulted the archives at Mount Stuart, where to her astonishment the archivist located evidence of a similar discovery in the grounds of the house itself.

72

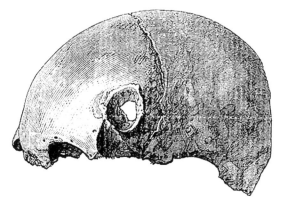

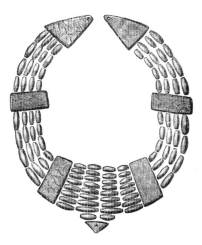

ABOVE:
Illustrations from *Bute in the Older Time*, 1893.
Trepanned skull and jet necklace, discovered by the XIV Marquis of Bute in a Bronze Age burial site at Mount Stuart in the early nineteenth century, and secretly sent to the Society of Antiquities, Edinburgh. Now in the Museum of Scotland.

OPPOSITE TOP:
Shadow of a Necklace, 2001
First snow covering the land drawing. Mount Stuart, Isle of Bute.

OPPOSITE BOTTOM:
Mount Stuart, Isle of Bute, Scotland.

Shadow of a Necklace was installed in May 2001 and remained *in situ* for a year. This photograph was taken in late October after a snowfall, looking across the Firth of Clyde to the mainland. Under the snow, *Shadow of a Necklace* has become a shadow of itself.

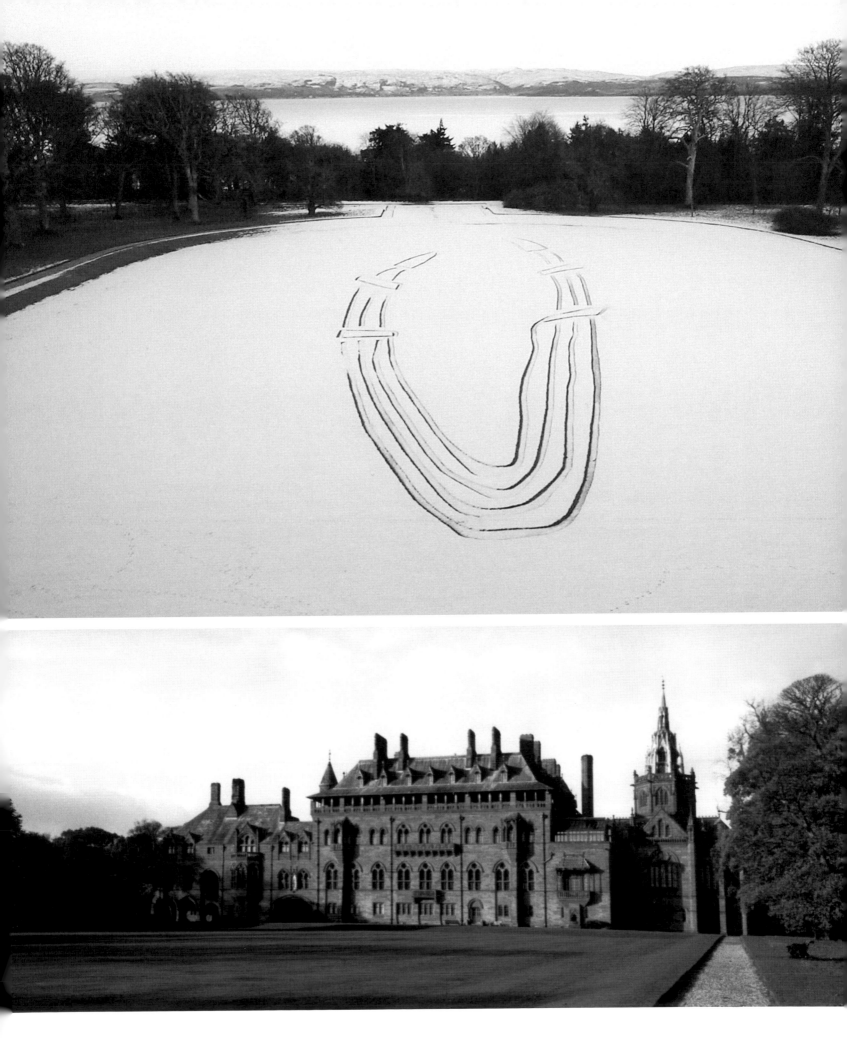

In 1887 the Third Marquess of Bute, whose meeting with William Morris had precipitated so much of the Dovecot Studios' history, uncovered the grave of another solitary woman from the Bronze Age. This time, it contained scattered beads from a jet necklace. But the skull of this female skeleton was trepanned. No conclusive explanation could be found for such an extreme and rare form of prehistoric surgery. The Marquess remained silent about his tantalising archaeological find, and after reconstructing the jet necklace he sent it off to the Society of Antiquities in Edinburgh. The fact that it had been found close to Mount Stuart probably made the Third Marquess determined to treat his discovery with the utmost discretion.

With the help of the archivist at Mount Stuart, Whiteford tracked down the jet necklace to its present home at the Museum of Scotland.[33] Its powerful, elemental structure impressed her so much that she decided to return the necklace metaphorically to the Isle of Bute. Once permission had been granted to carve her land drawing into the front lawn, Whiteford brought the Bronze Age artefact home. The site she transformed with silver sand was uncannily near the grave where the unknown woman had once been immured. *Shadow of a Necklace* was able, therefore, to proclaim on the surface of the earth something that had remained hidden in the island for many centuries. It was as if Whiteford enabled the necklace to rise up from its resting place and, for a while at least, proclaim its existence to the sea and the sky.

Like her Calton Hill sculpture 14 years earlier, it offered a challenge to the buildings nearby. For the previous Mount Stuart had been destroyed only ten years before the Third Marquess discovered the grave. He was responsible for erecting the Victorian Gothic mansion which stands there today, and for growing the lawn over the remains of a formal parterre accompanying the original house. The latter building, a white neo-classical structure, was in turn built on the remains of a half-buried basement — the only surviving segment of the building erected there earlier. This site must have undergone endless transformations over the centuries, stretching back at least as far as the Bronze Age grave.

Whiteford responded to the location's fluctuating character in the linear form she devised for *Shadow of a Necklace*. Its flowing elements were redolent of flux arrested, and implicit within the land drawing's deliberate looseness is the inevitability of future change. Besides, any attempt to comprehend the totality of the image from ground level was bound to end in frustration. The loops and curves were so enormous that they could only be seen as fragments of some ungraspable whole. Unlike *Sitelines*, so precisely visible on the hillside at Harewood, *Shadow of a Necklace* was not viewable from afar. But one vantage did yield an excellent, almost intimate view: the main bedroom on the second floor of Mount Stuart house. From there, all the restless white lines fell into place and assumed the identity of an unclasped

74

OPPOSITE TOP:
Shadow of a Necklace, 2001
Excavated trenches with Hebridean silver sand infill. The principal view of the necklace is from second floor of the house. Mount Stuart, Isle of Bute.

OPPOSITE BOTTOM:
Shadow of a Necklace
Work in progress. Mount Stuart, Isle of Bute.

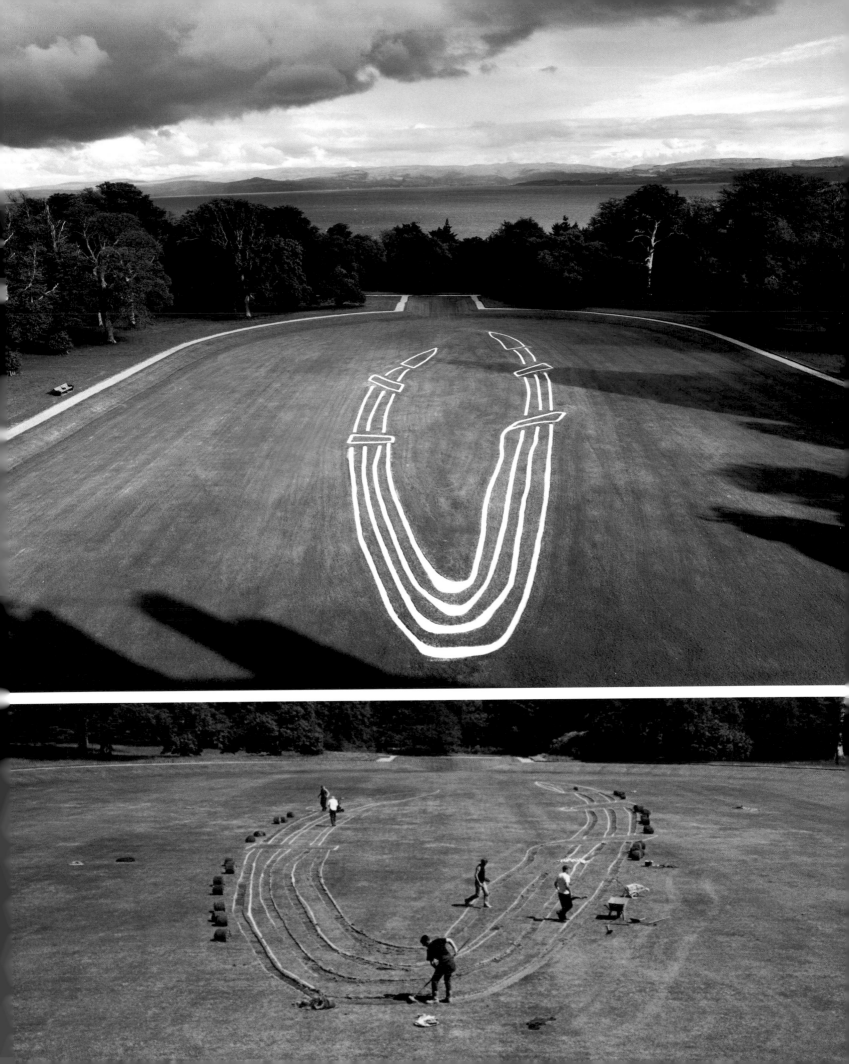

76

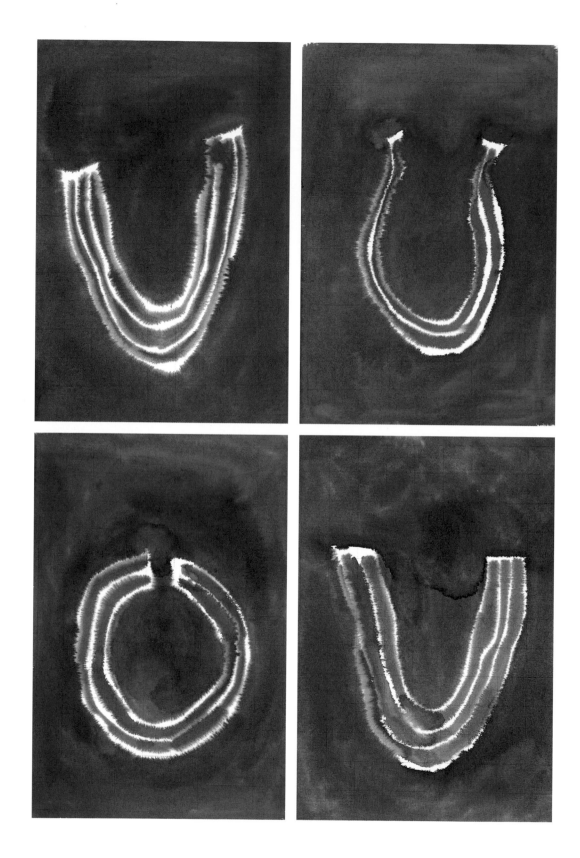

ABOVE AND OPPOSITE:
Archaeological Shadows, 2001
56 x 38cm. Series of six works
on paper. Liquid watercolour
on parchment paper.

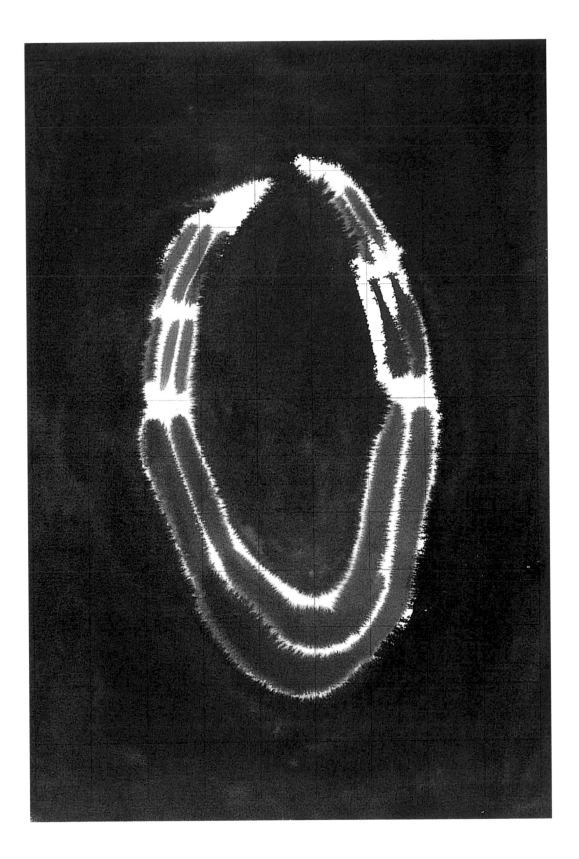

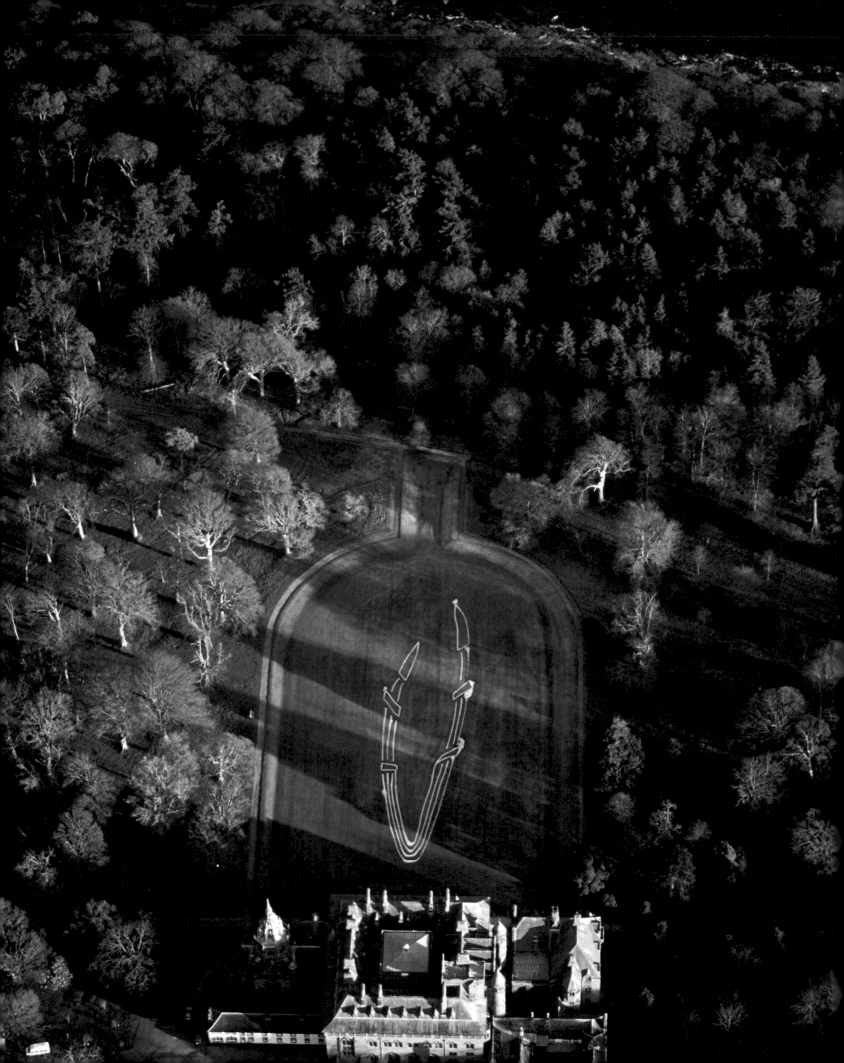

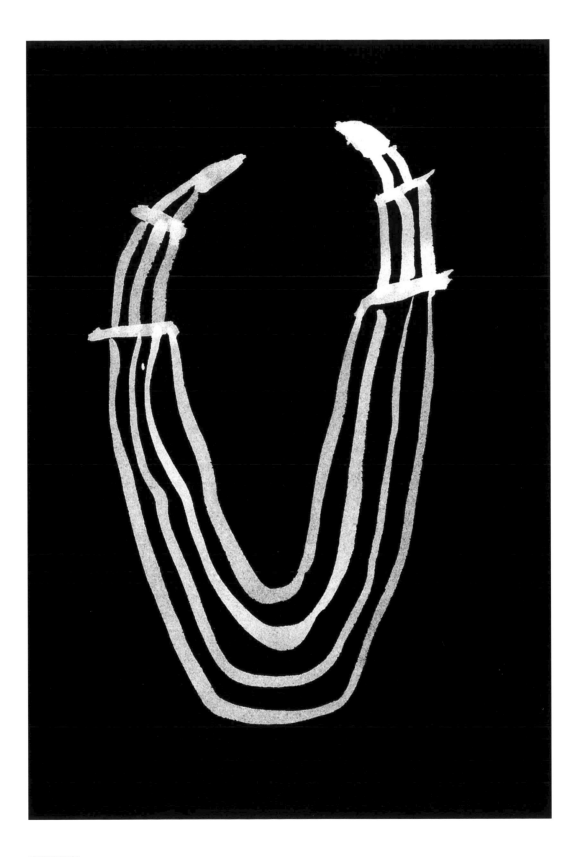

OPPOSITE:
Shadow of a Necklace, 2001
Aerial view of the drawing in front
of Mount Stuart, showing the
anamorphic distortion used to give
the correct reading when seen from
the house. This takes into account a
five metre fall in levels towards the sea.

ABOVE:
Shadow of a Necklace, 2001
Proposal drawing. Brush and ink
on watercolour paper.

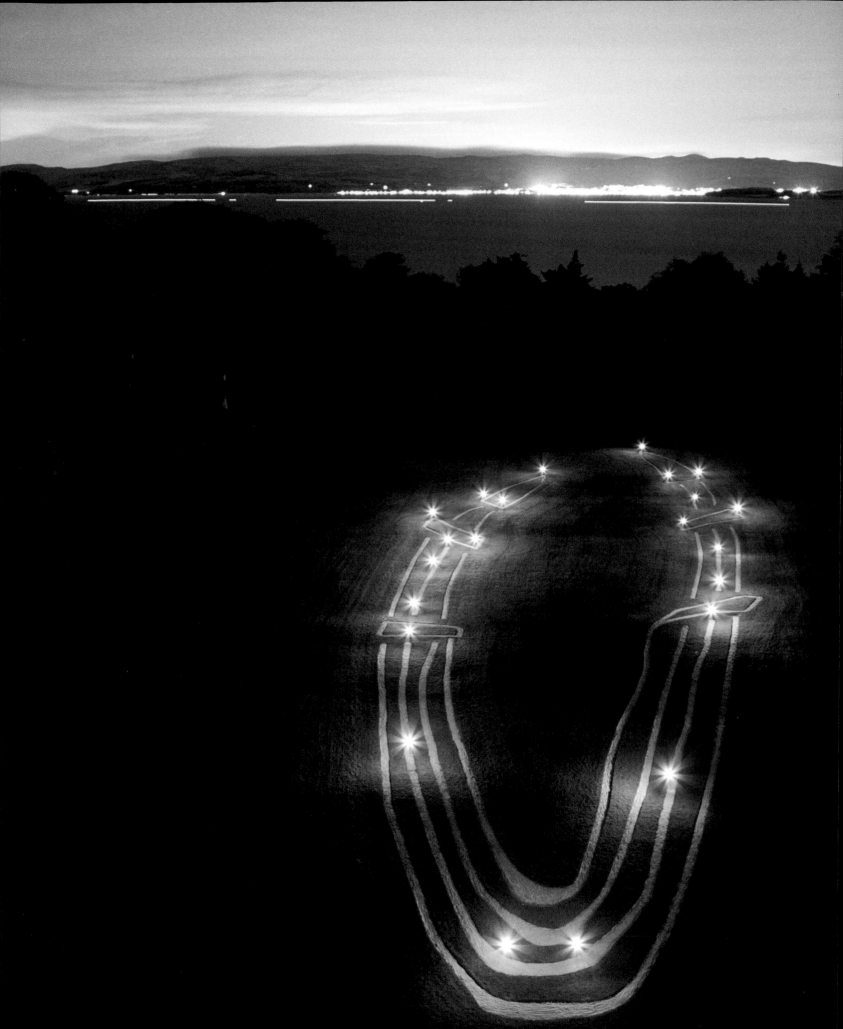

necklace. It was almost as if the owner had flung her jewellery down from the casement to the grass below, where the jet particles inexplicably expanded to fill the generous space at their disposal. Scrutinised from this window, the two tips of the necklace appeared to point towards the sea, whose tidal motion had seemingly infected Whiteford's linear rhythms. And at night, when illuminated at so many points within the lawn's blackness, *Shadow of a Necklace* entered into a nourishing dialogue with the lights on the distant mainland as well as the flaring nocturnal sky.

The Isle of Bute site — open-air, in touch with land and water, changing at so many stages of day and night — could hardly be more opposed to the setting Whiteford found herself confronting at the Kunstverein Goettingen. Its 1991 *Skulptur als Feld* exhibition was held inside the Lokhalle, a vast industrial space which used to be a locomotive shed. As the organisers explained, the survey aimed at "calling attention to a work form that, despite its importance for art in the second half of the twentieth century, has up to now hardly been noted as a phenomenon — the flat, extended floor sculpture. The extremely spatially-rapacious and spatially-demanding form of art makes us conscious in a particular way of the time-based relationship between the artwork, space/place and the viewer."[34]

81

Shadow of a Necklace, 2001
Night view with flares, looking
towards the mainland.

The show encompassed a wide range of nine practitioners, from pioneers as senior as Carl Andre to younger artists like Whiteford who had made most of their work outside the gallery's boundaries.[35] But she was fascinated by the Lokhalle during her first visit on a fiercely cold February weekend. Snow had just fallen, and an extraordinary white light suffused what she described as "a monumental structure stretching out parallel to the railway track, as long as a train itself.... It had obviously been recently renovated and was completely empty except for the massive steel columns and network of girders, gantries and cranes."[36]

Realising that it was a far from neutral space, Whiteford knew she would have to deal with this tough industrial architecture and the equally strong shadows scything across walls and floor alike. She did not, however, enter this negotiation by confining herself to the Lokhalle. It made her eager to discover more about the history of Goettingen as a whole. And after walking through the walled Medieval city, with its half-timbered houses and Brothers Grimm manuscripts preserved in the old library, she focused on the Saline Luisenhall where salt crystals are produced.

Whiteford found the process of transformation quite magical. The Saline draws salt water from a well almost one kilometre deep. After surfacing at a temperature of 38 degrees and containing as much salt as the Dead Sea, the water is heated in immense pans and evaporated. Only the salt crystals are left, and their incandescent whiteness impressed Whiteford on a visceral level. So did the opposing blackness of the coal used to heat the pans. This extreme contrast persuaded her that she had found the right way to deal with the potent presence of the Lokhalle's industrial setting. "The vapour from the vast salt pans fills the air", she recalled, describing how the Saline interior "seems to assail the senses — the taste, the smell, the touch of the salt stays with you. It is an unforgettable place. I knew that I had found the material for the artwork. It was so particular, so special to Goettingen."[37]

82

OPPOSITE TOP:
Saltworks, 2001
Salt drawing in progress. *Skulptur als Feld*, The Lokhalle, Goettingen, Germany.

OPPOSITE BOTTOM:
Six tonnes of salt crystals from the Saline Luisenhall, Goettingen used to make the installation.

The Lokhalle was a former train shed, a huge industrial space with its gantries for lifting engines still in place. Whiteford was commissioned to make a floor work for this space as part of an International Exhibition *Skulptur als Feld*.

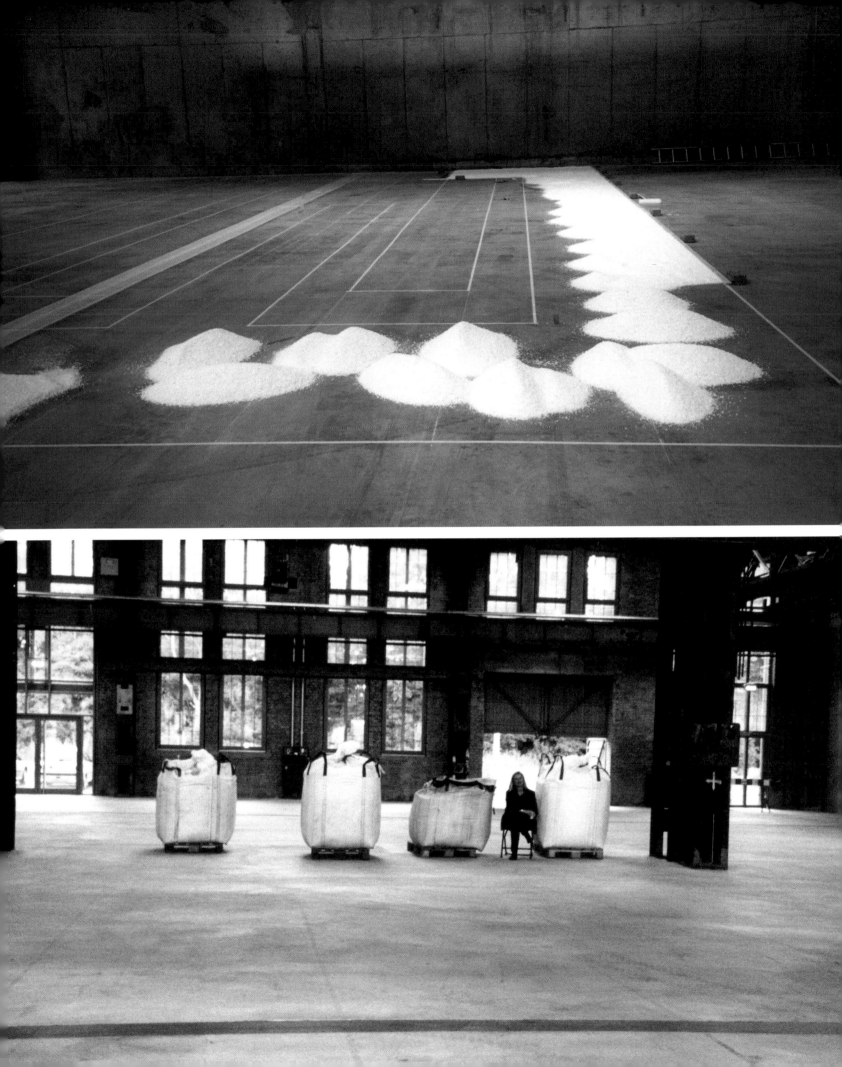

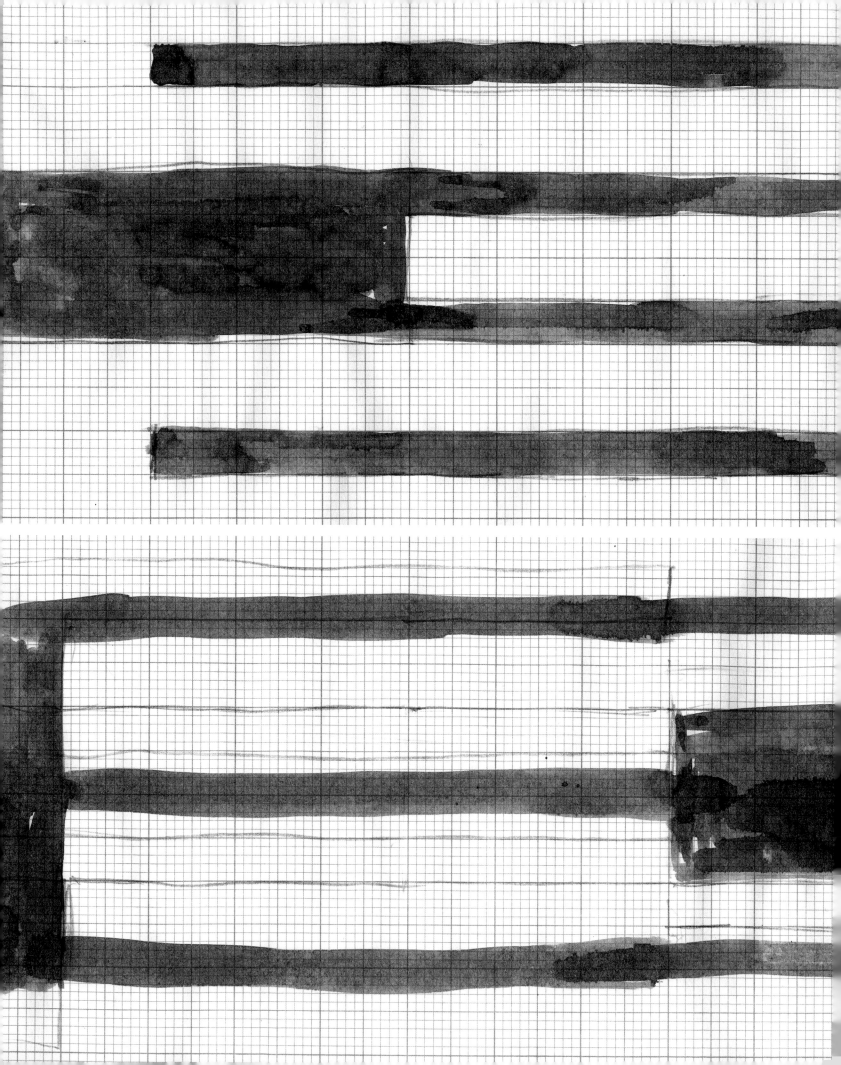

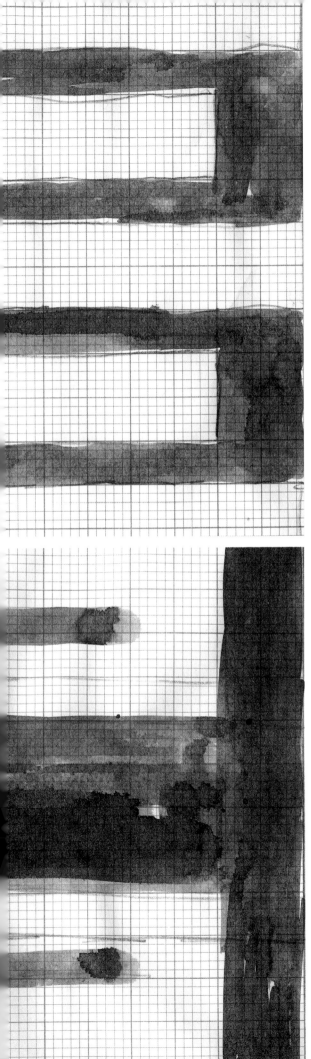

<u>LEFT TOP AND BOTTOM</u>:
Saltworks, 2001
Studies for the installation at
the Lokhalle.

<u>ABOVE</u>:
Architectural model of the
hypocaust system at the Saline
Luisenhall, Goettingen.

The salt came from the Saline Luisenhall, a renowned
saltworks in Goettingen. The salt is drawn from lakes one
kilometre underground and evaporated on the surface
in large pans. The drawing makes reference to the coal-
fired hypocaust system and the contrasting elements
of salt and coal.

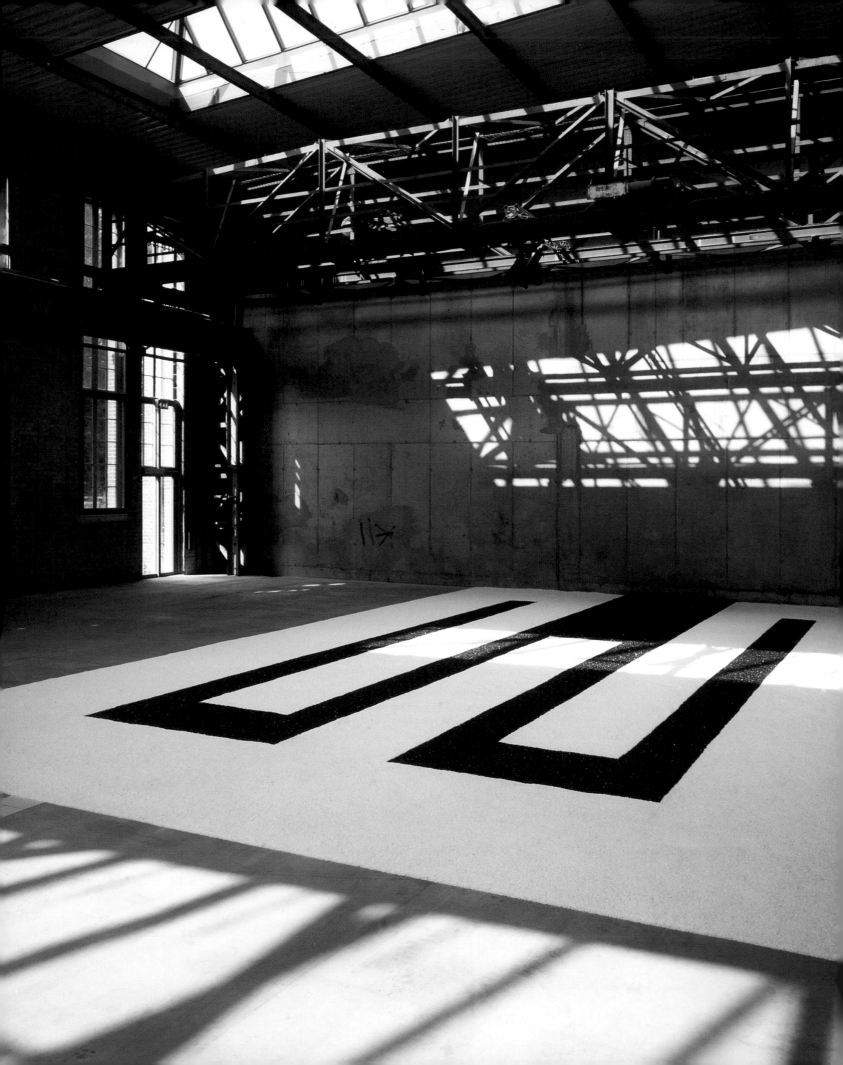

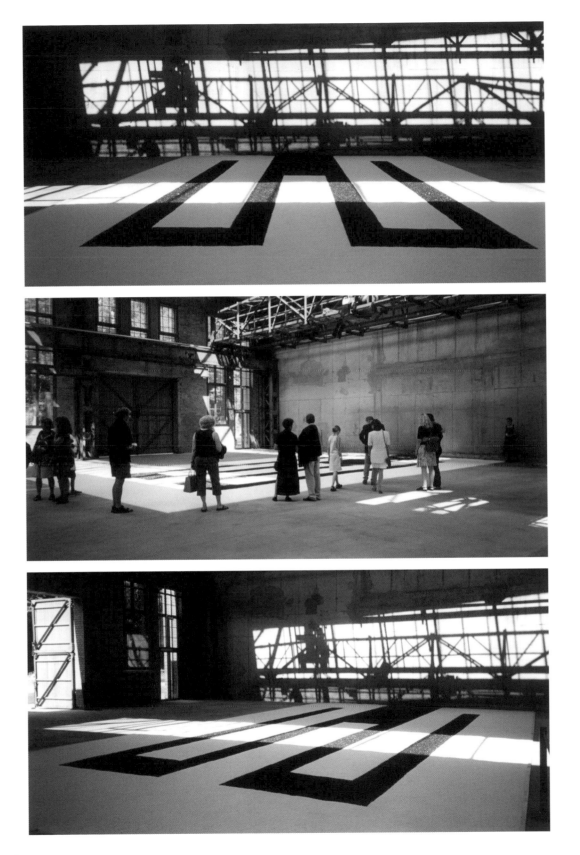

OPPOSITE AND ABOVE:
Saltworks, 2001
1,500 x 800cm. Ground drawing
using salt crystals and coal from
the Saline Luisenhall.

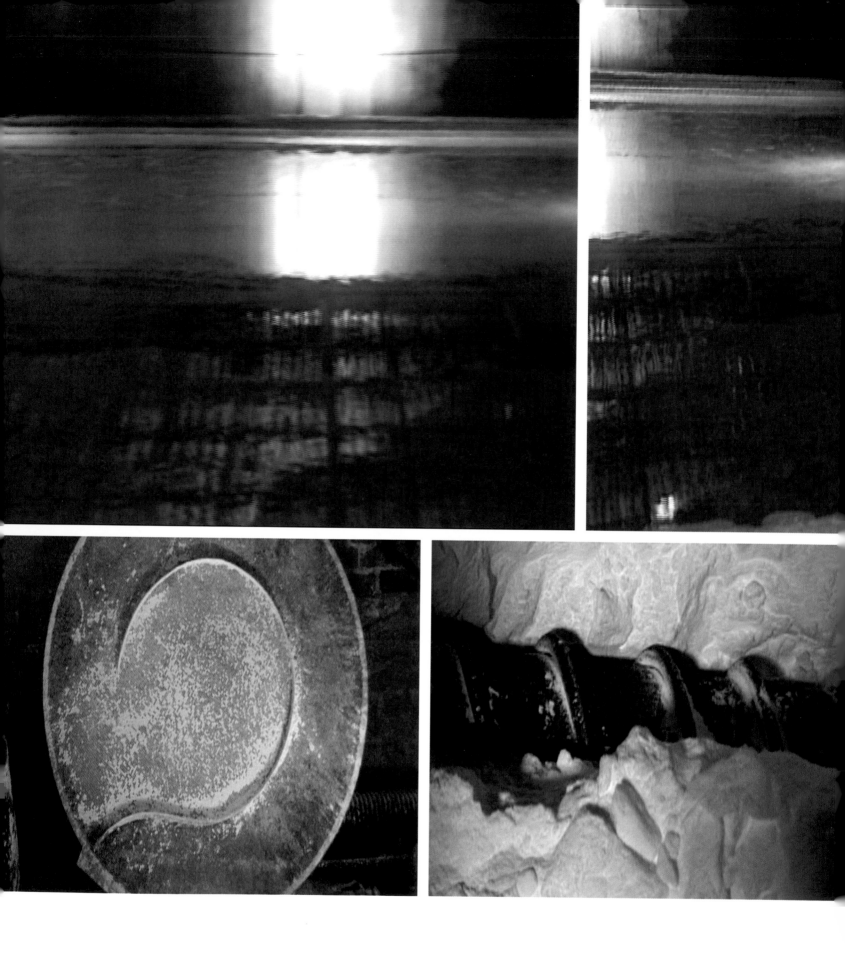

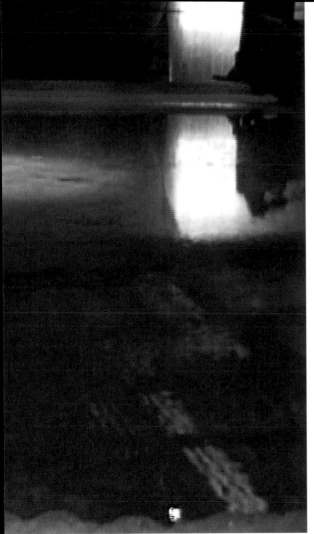

But Whiteford did not want the meaning of her *Saltworks* to be limited to the Saline alone. She hoped it would refer to the geology of the region as a whole. Travelling through the area, where salt mines still abound, she was astounded by the spectacle of a mountain of salt announcing its whiteness for miles across the plain. Moreover, the *Saltworks* she installed on the Lokhalle floor referred in its stripped, rectilinear forms to the system of horizontal brick-built channels carrying hot air to the Saline pans from the coal furnace beneath. This structure seemed strikingly similar to the Roman hypocaust system of heating — a system she had previously encountered not only during her Italian travels but also at Bath, on a memorable trip in the late 1970s to England's best preserved Roman spa city.

Many visitors would have no knowledge of hypotherms and water pans when they gazed down at her minimal expanses of salt and coal laid out on the Lokhalle floor. But her installation's stark, unyielding, black and white severity was intended above all to resonate with the space at Whiteford's command. She wanted the work to remain as open as possible, so that it could take on an independent life even as she layered the piece with memories drawn from the context it inhabited.

89

Saline, 2001
Video, 4.40 minutes. Six video stills.

The degree of slippage between different meanings in her work reached perhaps its most unnerving point when Whiteford addressed herself to the Chapel Court at Jesus College, Cambridge. During the summer of 2005 she caused intense debate among the fellows and undergraduates by presuming to conduct an *Excavation* in an ample area normally cherished for its uninterrupted expanse of grass. Working in association with the Cambridge Archaeological Unit under the direction of Chris Evans, Whiteford found an aerial photograph of Jesus College taken by the Luftwaffe on a reconnaissance mission at an early stage in the Second World War.

Whiteford's involvement with aerial photography had been growing ever since 1994, when she displayed in the British School at Rome a *Palimpsest Series* of watercolours based on air reconnaissance photographs of Italy preserved in the BSR archive. Taken by the Royal Air Force during the Second World War, they subsequently provided archaeologists with an invaluable wealth of information. Used for research purposes, the images altered in meaning and prompted fresh ways of reading marks in the landscape. Colin Renfrew, an archaeologist always admirably responsive to contemporary art, was impressed by the watercolours she produced, declaring that "Kate Whiteford has rediscovered the romance of aerial photography." After deploring his fellow archaeologists' inability to fully assimilate "the wonder and the fascination of the process itself", he argued that Whiteford had "caught the texture of these images: the sense of coherent structure imperfectly perceived, of signal intermingled with noise so that intuition is needed to decide which is which. She successfully conveys their nature as much as their content."[38]

90

TOP LEFT:
Evidence, 2005
Ink jet print/documentation. Engraving by David Loggan dated 1675 from the collection of Jesus College, Cambridge with fictional archaeological shadow added to Chapel Court.

BOTTOM LEFT:
Excavation (Circle and Arch), 2005
Cut turf drawing. Chapel Court, Jesus College Cambridge.

RIGHT AND OPPOSITE:
Evidence, 2005
Ink jet print/documentation. Aerial reconnaissance photograph taken by the German Luftwaffe in the 1940s, showing Jesus College with the 'archaeological' site outlined.

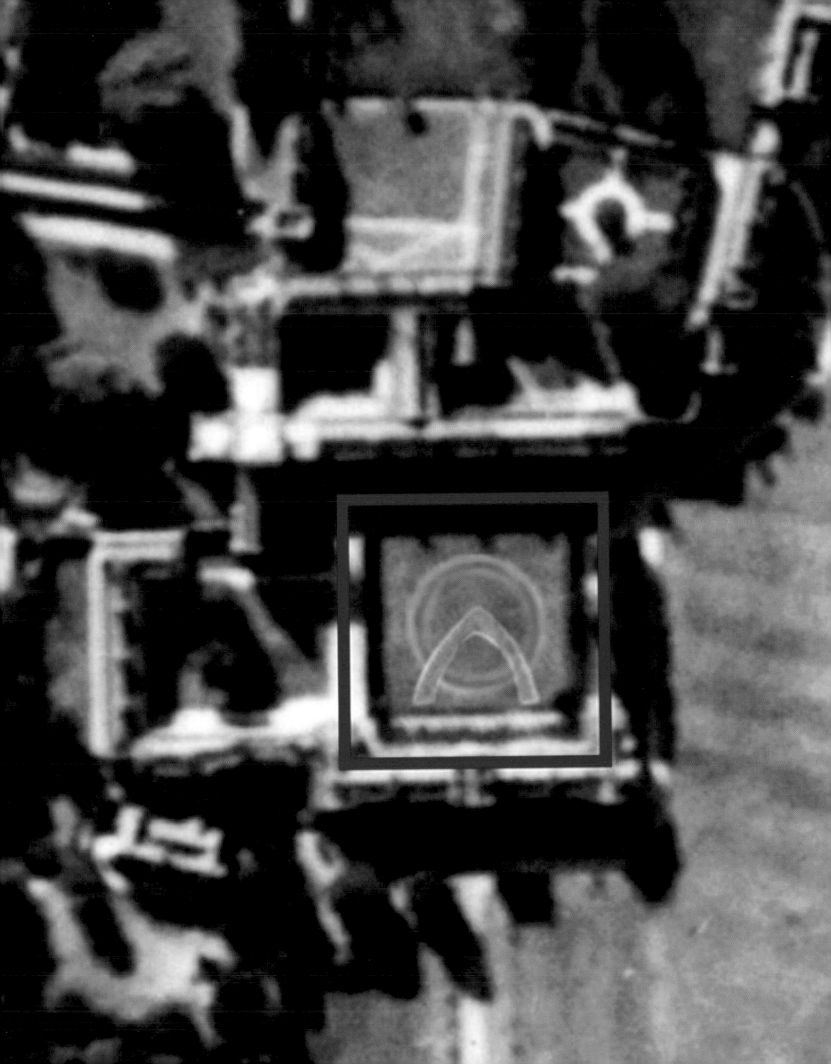

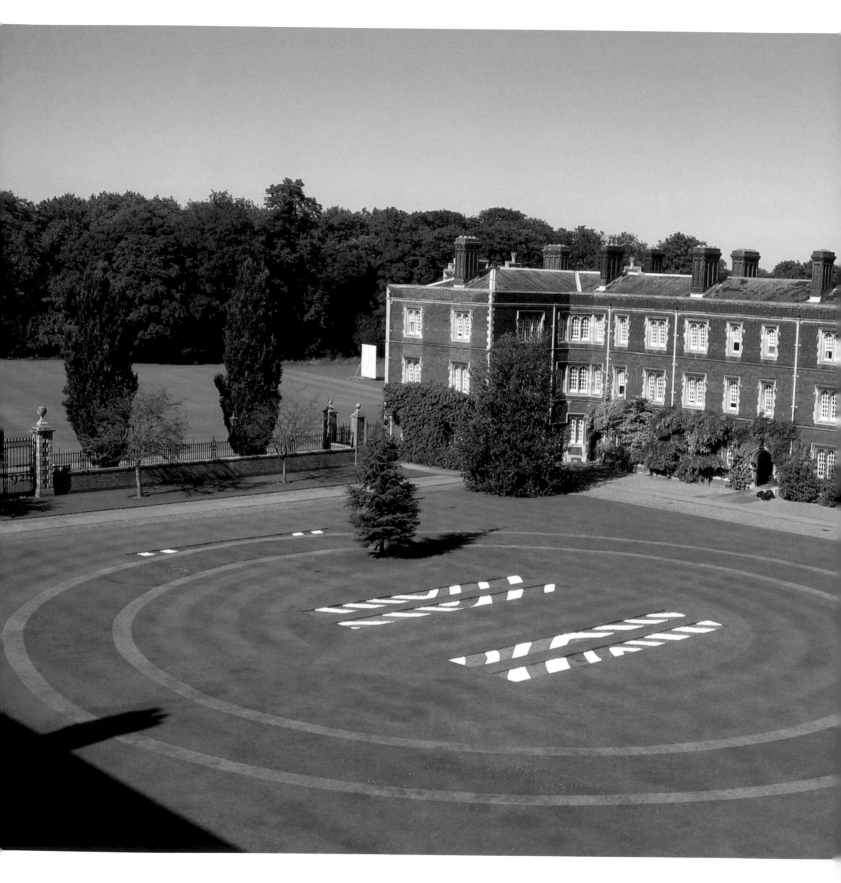

ABOVE:
Excavation (Circle and Arch), 2005
Excavated trenches with Cambridgeshire
chalk infill and turf drawing. View to the
northeast from Jesus College's Chapel Tower.

Renfrew concluded that the term "remote sensing", used by archaeologists to describe discovery techniques which, like aerial photography, do not disrupt the earth with excavation, could also be applied to Whiteford's preoccupation "with the processes of aerial prospection of structures and with the transformations which bring them to us".[39] His words also illuminate the work Whiteford went on to make at Jesus College, where Renfrew himself was for many years the enlightened Master. Taking the Luftwaffe photograph as her unlikely springboard, she treated it with the spectral outlines of a circle and an arch. The circle was in reality evocative of the earth globe found in the heraldic personal emblem invented by the College's founder Bishop Alcock. As for the arch, it referred to the Gothic architecture deployed in the College's original buildings of 1496, and to the nunnery of St Rhadegund which stood on the same land before the College was founded.

Once again, Whiteford wanted to suggest that the multi-layered meanings embedded in the site had somehow fought their way up to the surface. And when her fictional archaeology was finally imposed on the Chapel Court itself, she made different levels of growth create a double circle on the grass. Inside its encompassing lines, four test trenches were allowed to transect the circle. As well as referring to the Gothic arch, these chalk deposits raised the possibility of a prehistoric drawing on the landscape. It would originally have been made long before Jesus College and the nunnery were conceived.

93

RIGHT:
Excavation (Circle and Arch), 2005
Documentation of 'archaeological excavation' in Chapel Court, Jesus College, Cambridge.

This project was developed in collaboration with the archaeologists at Jesus College, who regularly use aerial photography in their work to identify sites of archaeological interest. Using their methodolgy a fictional site on Chapel Court, Jesus College, was 'identified' from an aerial photograph taken by the Luftwaffe during the Second World War.

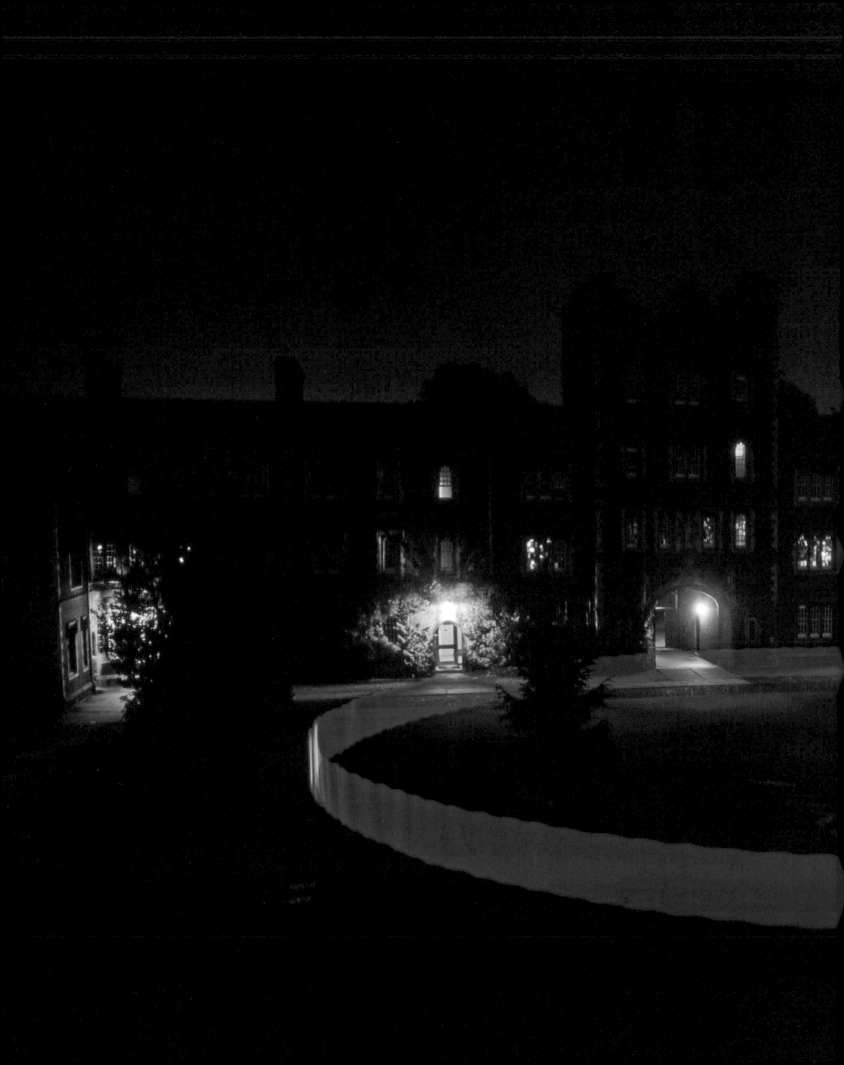

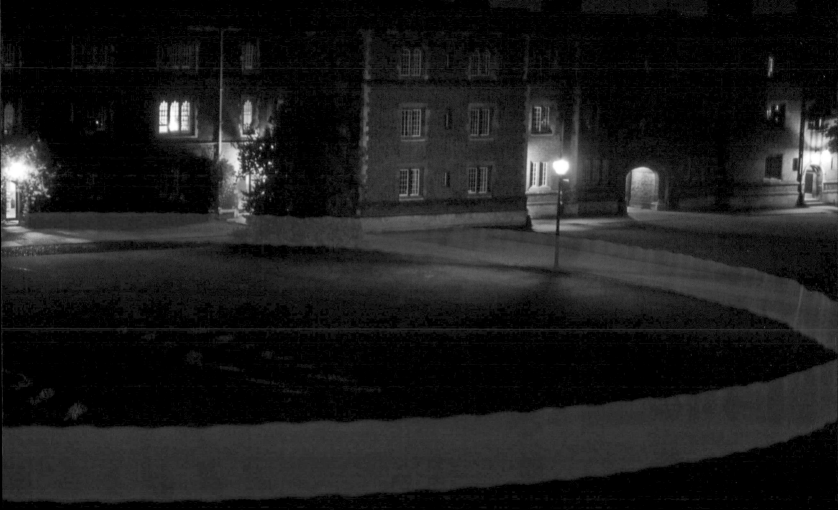

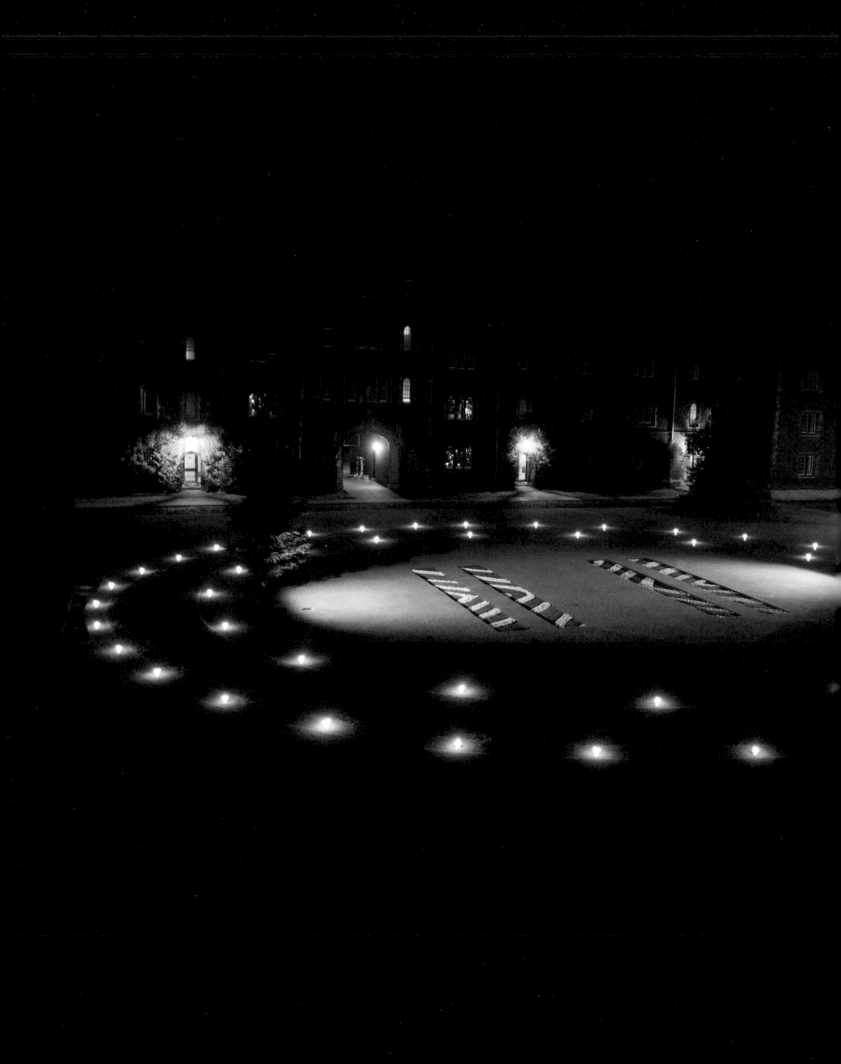

Nobody, however, can have encountered *Excavation (Circle and Arch)* or its predecessors in Whiteford's art without sensing that she is supremely alive to contextual resonances of many different kinds. Whether geographical, cultural or religious, they find their way into the deceptively pared-down forms favoured throughout her work. Yet it would be a mistake to conclude that she is obsessed by history at the expense of an involvement with our own time. Her work is, at heart, resolutely modern, insisting on a radical language of forms and playful conceits which often subvert the architectural setting. Although Whiteford believes that the past impacts upon the appearance of things and can never be ignored, she remains committed to ensuring that her work functions wholeheartedly in the present. The research underpinning her art is intended to open up manifold possibilities, trigger reinterpretations and, above all, engender new meanings.

97

PREVIOUS PAGES:
Excavation (Circle and Arch), 2005
Night view with light installation,
Chapel Court, Jesus College,
Cambridge.

LEFT:
Excavation (Circle and Arch), 2005
Night view with flares, Chapel
Court, Jesus College, Cambridge.

1. Lingwood, James, Tony Foster and Jonathan Harvey, "Introduction", *TSWA 3D*, Bristol, 1987, p. 3.

2. The other artists were Edward Allington, Hannah Collins, Mark Dunhill/John Joekes/Jennie Norman, Judith Goddard, Antony Gormley, Ron Haselden, Miranda Housden, Sharon Kivland, Holly Warburton, Richard Wilson and George Wyllie.

3. See Richard Cork, "Beyond the Tyranny of the Predictable", *TSWA 3D*, pp. 6–13. The author's review of the entire *TSWA 3D* event in *The Listener*, 14 May 1987, is reprinted in Richard Cork, *New Spirit, New Sculpture, New Money: Art in the 1980s,* New Haven and London, 2003, pp. 420–423.

4. Kate Whiteford, statement, *TSWA 3D*, p. 14.

5. Kate Whiteford, interview with the author, 29 June 2006.

6. Kate Whiteford, interview with the author, 19 July 2006.

7. Kemp, Martin, "Works on Sight", *Kate Whiteford Sitelines*, Edinburgh, 1992, p. 7.

8. Since 1982, many of these stones have been removed from their sites and replaced in the landscape by casts. They can now be found in the Museum of Scotland.

9. Whiteford, Kate, "Artist's Statement", *Votives and Libations in Summons of the Oracle: New Work by Kate Whiteford, Artist in Residence, University of St Andrews,* St Andrews, 1983, p. 6.

10. Oliver, Cordelia, "Kate Whiteford", *The Guardian*, 12 April 1983.

11. Archer, Michael, "Rites of Passage", *Kate Whiteford: Rites of Passage*, Glasgow, 1984, pp. 7 and 8.

12. Kate Whiteford, quoted by Martin Kemp, "Works on Sight", p. 9.

13. The other artists whom I commissioned for this set of six prints, subsidised by the King's Fund, were Helen Chadwick, Anish Kapoor, Richard Long, Bruce McLean and Therese Oulton. See Richard Cork, "Pictures of Health", *Telegraph Weekend Magazine*, 21 October 1989.

14. In particular, the Scottish exhibition celebrated Glasgow's position as the 1990 European City of Culutre. The other artists were David Mach and Arthur Watson.

15. Sammartini subsequently published a book called *The Pavements of Venice* as well.

16. Henry, Clare, "Tre Scultori Scozzesi", *La Biennale di Venezia XLIV, I & II*, Venice, 1990, p. 101.

17. Kemp, "Works on Sight", p. 18.

18. W Vivian Davies, "Foreword", *Time Machine: Ancient Egypt and Contemporary Art*, London, 1994, p. 3.

19. Putnam, James, "Introduction", *Time Machine*, p. 8.

20. Putnam, "Introduction", p. 8.

21. Kate Whiteford, statement, *Time Machine* p. 18.

22. Henry Moore, quoted by W Vivian Davies, p. 3.

23. See *Phoenix: Architecture/Art/Regeneration*, London, 2004, for a comprehensive account of the Phoenix initiative.

24. Richard MacCormac and Vivien Lovell, "Introduction", *Phoenix*, p. 12.

25. Whiteford, Kate, "Priory Maze", *Phoenix*, p. 78.

26. Whiteford, "Priory Maze", p. 78.

27. From "Processional", *Phoenix*, p. 81.

28. Sellars, Jane, "Introduction", *Kate Whiteford: Sitelines, Harewood: After Chippendale*, Harewood, 2000, n.p.

29. Sellars, "Introduction", n.p.

30. Poe, Edgar Allan, *Landor's Cottage*, 1850, in *Tales of Mystery and Imagination*, ed., London, 1968, p. 55.

31. Abrioux, Yves, "A Furnished Landscape", *Kate Whiteford: Sitelines, Harewood*, n.p.

32. The ignite necklace is now preserved in the Museum at Rothesay.

33. The jet necklace was subsequently removed from the Society of Antiquities to the Museum of Scotland, where it is now displayed.

34. von Figura, Kurt, and Joachim Kummer, "Foreword", *Skulptur als Feld*, Ostfildern-Ruit, 2001, p. 8.

35. The other eight artists were Carl Andre, Polly Apfelbaum, Leni Hoffmann, Mariella Mosler, David Rabinowitch, Raffael Rheinsberg, Adrian Schiess and Heike Weber.

36. "Kate Whiteford: Tracing the Site", interview with Anja Marrack, *Skulptur als Feld*, p. 104.

37. "Kate Whiteford: Tracing the Site", p. 105.

38. Renfrew, Colin, "Remote Sensing", *Remote Sensing: Drawings from the British School at Rome*, London, 1997, p. 2.

39. Renfrew, "Remote Sensing", p. 2.

40. Rod Mengham, "Kate Whiteford", *Sculpture in the Close 2005: Jesus College, Cambridge*, Cambridge, 2005, p. 21.

THREE TREES

RICHARD NIGHTINGALE **THREE TREES**

In a small village in Northern Mozambique there is a big tree. It is a mango tree but its role in the local community goes far beyond the supply of fruit in season. Set in the middle of a cluster of low-built thatched houses it is the largest thing in the village — visible from all around, it marks an important place. Under its branches is a wide sheltered space where the whole village can gather. As any passer-by can witness this space acts as town hall, market, general meeting area, school and playground but I am also sure that the tree and its huge shadow has a myriad of more personal and private significance in the lives of individual villagers.

Though remote and exotic this tree also seems curiously relevant to my understanding of Kate Whiteford's work. All over Africa significant places are made by natural forms — a particular tree, the placing of stones, the shape of a rock — and these places have an importance in the lives of people which may be difficult to explain or interpret but is nevertheless very real and meaningful. I believe that Whiteford's work in the examining, recording and testing of nature and the imprint of man on the natural world is somehow akin to this identification of the special power of a place.

And trees, in particular have figured large in the work that I, as an architect, have done with Whiteford. I am neither artist nor art critic and can only explain an appreciation for her work through analogy with the process of making architecture and through examples of concerns that we have discovered in common.

Kate Whiteford was commissioned by the Foreign and Commonwealth Office to work with my practice when we were designing the new High Commission for Nairobi in Kenya. Just as we were aiming to produce a building which made the most of local materials and techniques in a way which was relevant to the locality as well as serving as an efficient modern office, Whiteford's approach, too, was to take Africa seriously. She travelled the length and breadth of Kenya from the Islamic island of Lamu on the coast to the lakes of the Great Rift Valley and the highlands observing and recording material, pattern and form.

The new building is clad in local stone which was prepared on site by teams of workmen — generally sitting on the ground gripping the stones between their feet and chiselling by hand with great skill. Whiteford visited the quarries, selected and experimented with textures, colours and chiselling techniques and worked up a design for the main forecourt paving. The patterned paving, executed in the same stone as the building,

PREVIOUS PAGES:
Mango tree, Northern Mozambique.

OPPOSITE:
London plane tree outside the artist's studio. The tree was central to the architectural layout of house and studio.

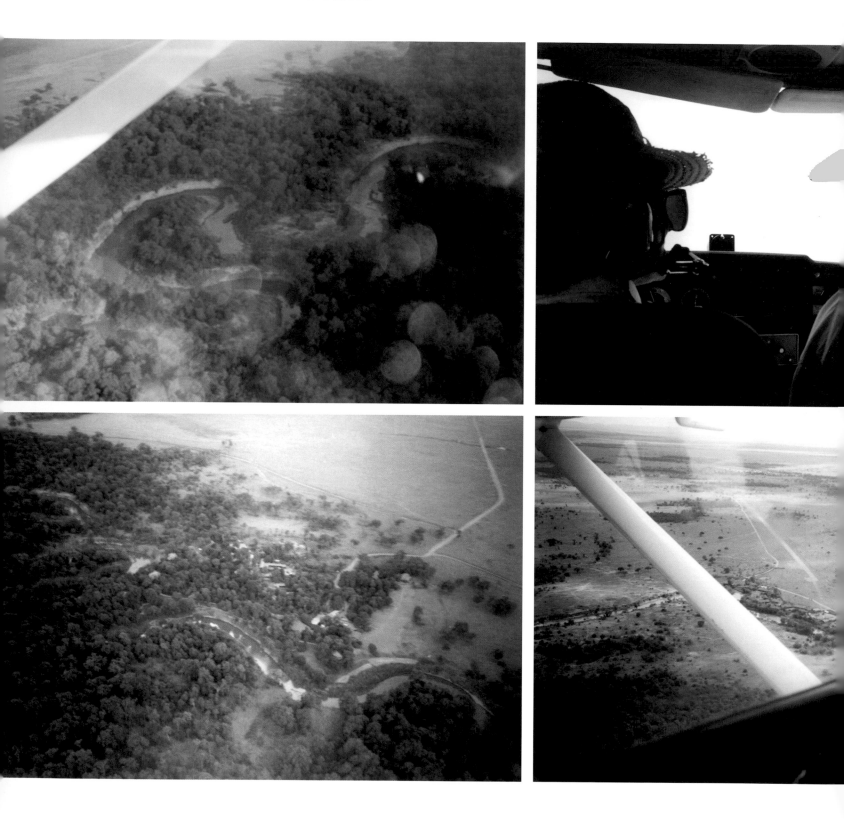

Flying over Masai Mara Game
Reserve, Kenya, 1995.

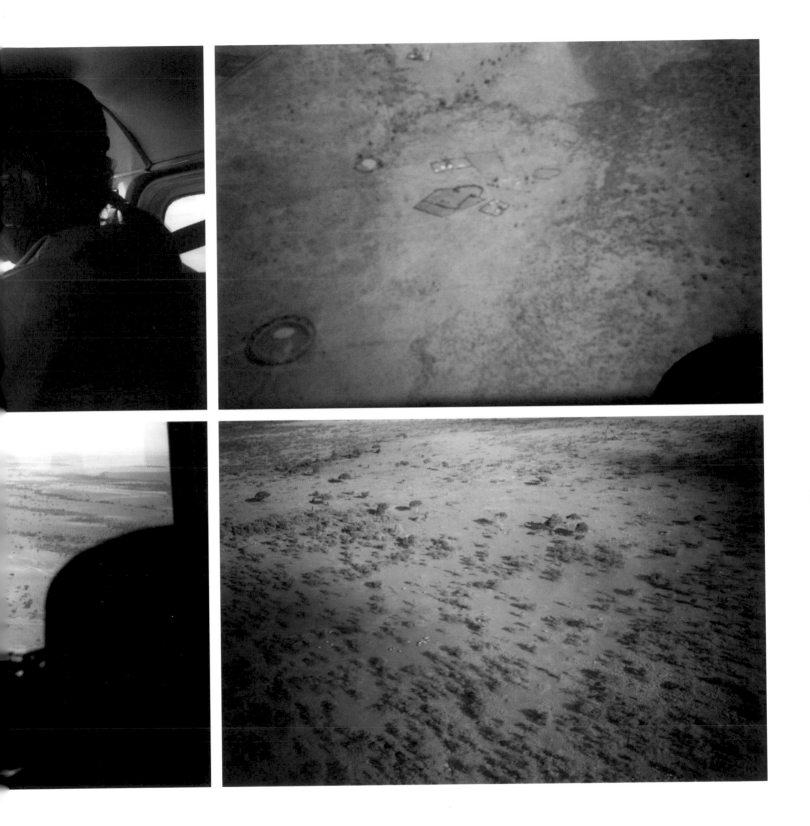

takes the observer beyond the immediate realm of architecture — making reference not only to rock engravings Whiteford observed and sketched in the National Museum in Nairobi but also to echoes of tracks and dwellings seen from the air flying over the Maasai Mara. The result, weathered with equatorial rain and driven over by Landrovers, is an integral part of the building and yet is significantly apart (not quite at odds with the general composition but adding, as it were, a layer to its complexity).

The form of the main building is keyed to the presence of an old Mugumo (wild fig) tree on the site. These trees are sacred to the local Kikuyu people (and indeed to many African tribes) and the main entrance hall, at the junction of the two main wings of the embassy, is wrapped around the tree so that the visitor ascending the staircase to the High Commissioner's office climbs as if through its branches. Whiteford's two other works for the building, a marble relief and a large painting adjacent to the staircase are thus enmeshed with the natural world, the branches of the Mugumo and the views through it to the city of Nairobi beyond — nature and man's interference with nature being recurring themes in her work.

In the related series of pieces designed for the High Commission the Whiteford palette and forms are as recognisable as ever but are, I think, subtly transformed by the power of Africa in general and the immediate locality and material in particular. Unlike others of her land works which reflect light (Calton Hill, Edinburgh and Priory Maze, Coventry) in the Nairobi courtyard the natural materials blend in a quiet way under the glare

106

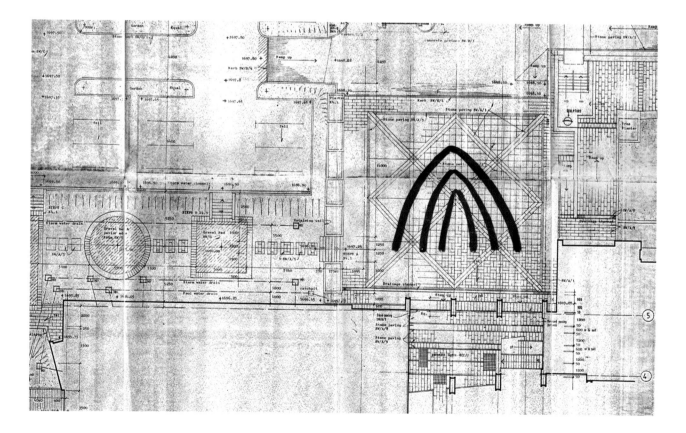

ABOVE:
Working drawing for the courtyard of the British High Commission, Nairobi, Kenya, 1994–1996.

OPPOSITE TOP AND BOTTOM:
Work in progress for the British High Commission, 1994–1996. African granite set into local sandstone.

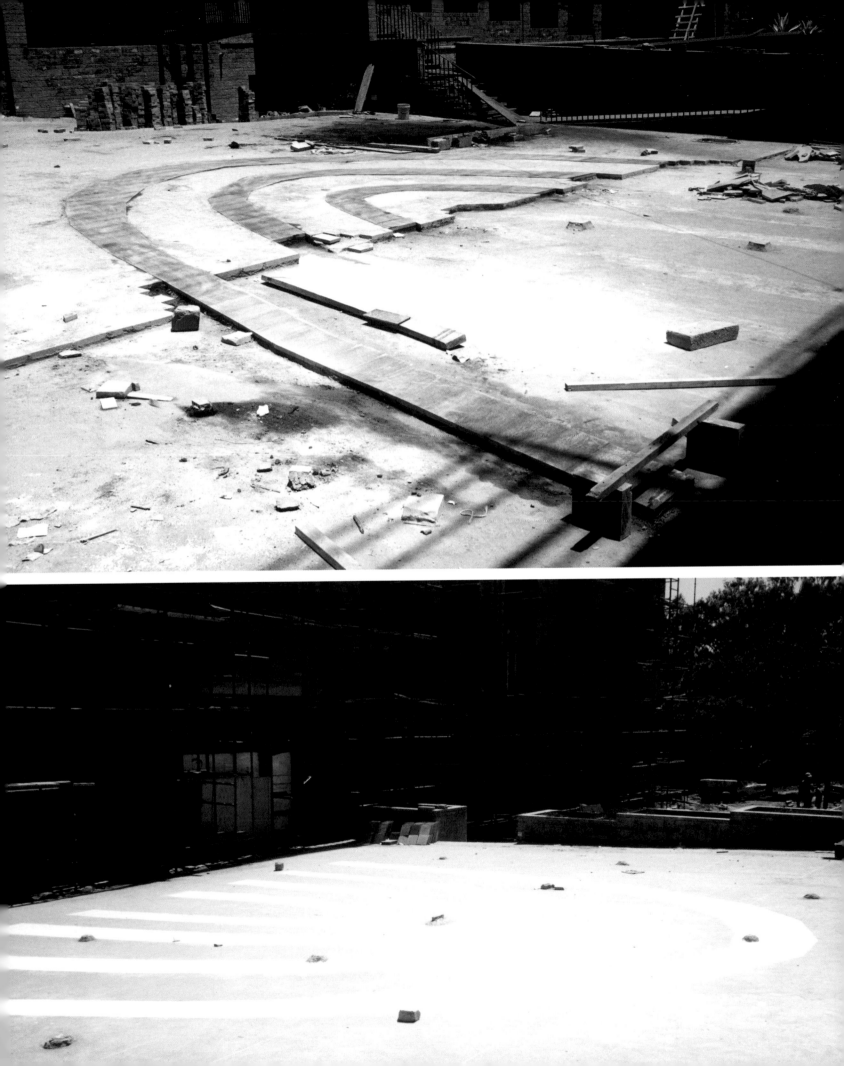

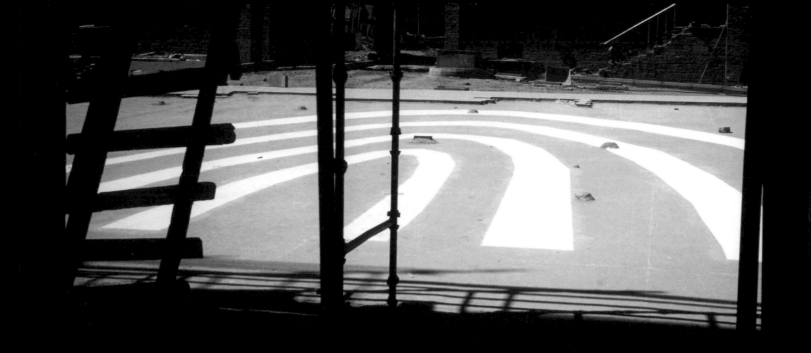

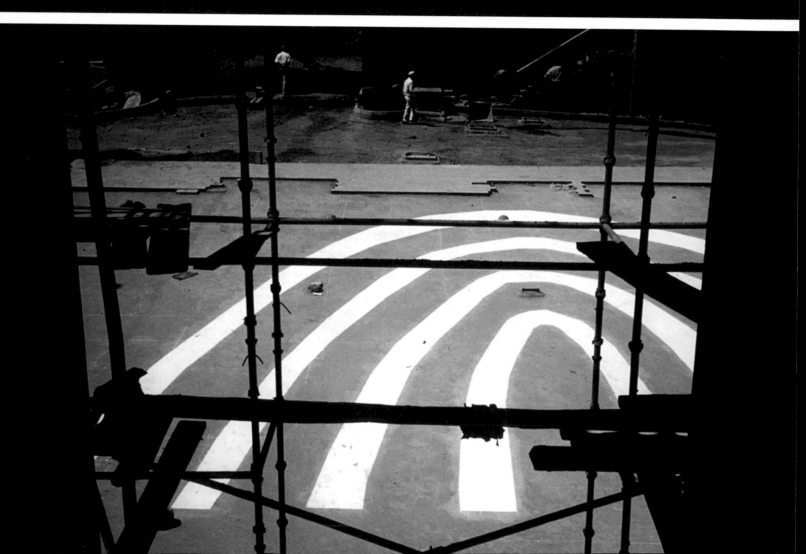

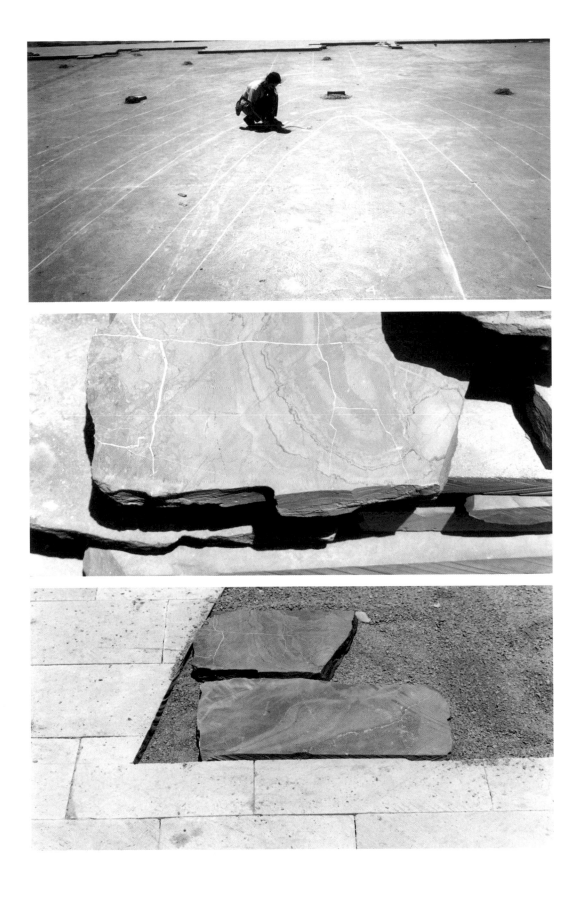

OPPOSITE TOP AND BOTTOM:
Work in progress at the British High
Commission, 1994–1996.

TOP TO BOTTOM:
Work in progress at the British
High Commission, with details
of stone samples.

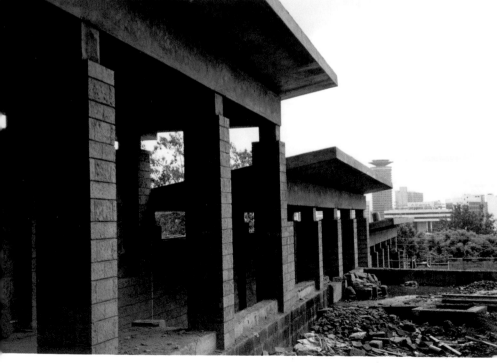

TOP:
Detail of the courtyard shadowed by the entrance canopy.

BOTTOM LEFT:
British High Commission, Nairobi, under construction. Cullum and Nightingale Architects, 1998. The exterior of the building is clad in Nairobi Blue stone.

of the sun. Inside the building, however, the colour and heat of Africa seemed to be reflected in the contrasting colour of the painting and the rhythms of the black marble drawing which extends upwards through the double-height volume of the entrance hall.

Back in England we have worked with Whiteford on the design of her studio in Dulwich and on a house for her and Alex Graham on the same site. This has been a long and stimulating process with much discussion and model-making and some trial and error. What I find rewarding about working with Kate is the way that she will hook into an idea that I, as an architect, might have — the form of a window, say, or the detail of a door frame — and see significance in it which then transforms my thinking about the way the design might develop and makes it richer. It is not so much a conversation between artists (which suggests some secret language) but a sparking off of individual and, we hope, complementary ideas.

When we were working on the design of the studio my concerns were largely to do with practicalities — how to achieve an even distribution of natural light, how to create a large open space without the form or structure becoming a visual encumbrance, how to fit a large volume onto a tight and restrictive site and how to make the place safe and secure. But somehow in the process (and much to do with Whiteford's comments and interventions) the building has acquired a whole other life. The flush closing doors and shutters not only mean that the building can be shut off from the outside world but, along with the copper mansard roof pulled down to low eaves, give it the air of being some form of reliquary — a casket for the safekeeping of precious things. The only south-facing window (placed in the middle of

III

BOTTOM CENTRE AND RIGHT:
The black marble for the wall drawing and green granite for the land drawing came from local quarries.

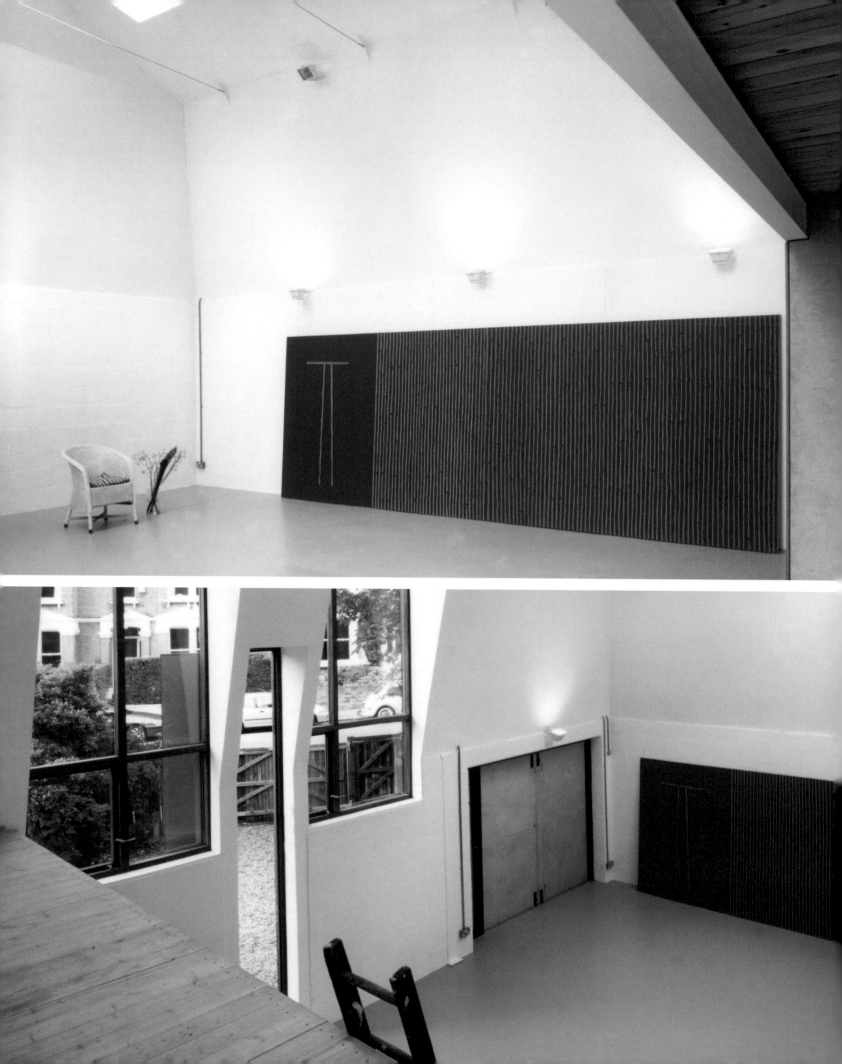

the sloping mansard roof to light the mezzanine) becomes a formal frame focussed on a particular view into the branches of a huge plane tree in the neighbour's garden. The halogen lights recessed into the sloping surfaces of the ceiling around this framed image have become a constellation of stars. And so the studio, which can be perceived from the outside as a simple dumb box, is somehow transformed into a world in itself, full of references to nature, the firmament and with celestial reverberations.

The design of the house adjacent to the studio has evolved, through a long process of development (both before and after the start of construction) into something which combines relatively straightforward physical form with nature, illusion, and reference… a setting for comings and goings and stories and dreaming. I no longer know who is responsible for what in the design — the roles of architect and client having been so intertwined. The original brief was for a house that was like a shed or a barn and, in essence, the large oversailing copper roof encloses a single volume. But this volume has been distorted both by the conditions of the site and by the circumstances of the design process. Whereas the studio is closed up to make a world of its own the house breaks down the barriers between inside and outside. There is a large double-height volume in the middle of the house which is, as it were, the centre of the village, the space under the tree. Off this space are a variety of places both inside and outside — an enclosed garden to the north, an open courtyard to the south under the dappled shade of the large plane tree (the one framed in the studio window), a living room, a kitchen etc..

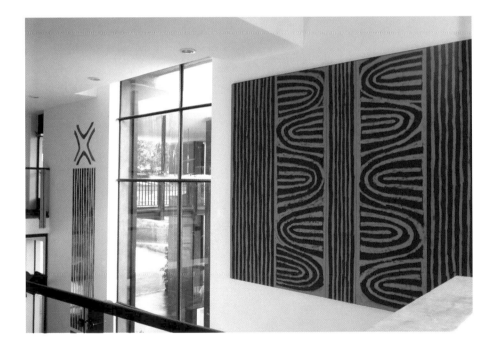

OPPOSITE TOP AND BOTTOM:
The artist's studio, London, designed by Cullum and Nightingale Architects, 1998.

OPPOSITE AND RIGHT:
Nairobi, 1996
Four panels, each 275 x 80cm and one panel, 275 x 40cm. Oil on gesso on linen. Installation view, interior of the British High Commission, Nairobi, Kenya.

The final plan for the house is keyed to the site in a very particular way, its shape responding to the site and engaging with the spaces around. Though the plan was never conceived as possessing any formal value of its own it does, in the end, have some of the qualities of a Whiteford land drawing (which, in turn, can sometimes read like the ground plan of lost structures). The plan focuses on the plane tree and particularly on the space under the tree which may, in time, become the site of a further land drawing — an opportunity for art and architecture to be further entangled.

The precise and scientific working methods and the references to history and symbols and myth are all, of course, very important in Whiteford's art but, for me, her pieces often work at a much more basic and physical level. The enjoyment of architecture can often be to do with the simple beauty of stuff — the grain of wood or the texture and weight of a piece of stone — and this is an important quality of Whiteford's work. The drawings produced at the British School in Rome — *Remote Sensing* — are the result of careful research and acute observation (surely the engine of good art) but end up as images that are simply luscious in their texture and depth. It is as if nature and artifice have collaborated in some process that is both visceral and cerebral. I don't know how they are made but they make my mouth water.

And for me this physical lusciousness has nothing to do with aesthetics — with the intellectual appreciation of matters artistic — but is something much more direct and earthy. It is also, for me, more African. We don't know much about the significance of the prehistoric stone engravings Whiteford sketched in the Nairobi museum but we can be pretty sure that they were not gallery art. They were, I am confident, executed with a definite purpose in mind and, though we may not now be able to interpret it, it is this which gives them their power. The big mango tree in Mozambique impresses us with its size, extraordinary structure and natural beauty but that is not the half of it. It is the life, the myriad lives, past present and future, lived in its shadow that really count. It is this meaning beyond the immediately observable which Whiteford's work addresses and makes physical again.

OPPOSITE:
Magumo Tree (wild fig tree), sacred to the local Kikuyu people on site at the new British High Commission, Nairobi, Kenya. The tree was central to the architectural scheme.

REMOTE SENSING

COLIN RENFREW **REMOTE SENSING**

Kate Whiteford has rediscovered the romance of aerial photography. The wonder of this technique — its remarkable ability to recover the plans of buried buildings and structures from the remote past by astounding feats of aeronautical detection — astonished the archaeological world of the 1920s, not least the British School at Rome. Naturally enough, among archaeologists the significant advance was seen to be the wealth of new information about the early past — the Roman field systems, the prehistoric villages — which became available for the first time.

Yet somehow, among all the photogrammetry and the air photographic interpretation, many archaeologists, while greatly valuing the new information which is still abundantly provided in this way, have not fully assimilated the wonder and fascination of the process itself. Kate Whiteford has caught the texture of these images: the sense of coherent structure imperfectly perceived, of signal intermingled with noise so that intuition is needed to decide which is which. She successfully conveys their nature as much as their content.

These images are, in a literal sense, metaphors. They are subtle transpositions between media. Nearly every activity within the landscape leaves its trace upon that landscape: fields, roads, houses, ditches, monuments — all become part of a complex palimpsest. The built feature is reduced to soil; soil to crop mark; crop mark to aerial photographic negative; negative to print; print to reproduction in the published volume — not to mention the series of mappings and plottings needed to produce a measured diagram. Kate Whiteford has understood the subtleties of these transformations and their visual richness in a way that few archaeologists have. She is interested in what they look like as much as in their contribution towards the restoration of ancient structures.

She holds these delicate images up for our inspection and contemplation, and in so doing makes them into works of art as well as the tools of scientific research. And, of course, her scrutiny carries its own resonances. We are used now to the concept of 'landscape art' in the monuments of modern sculptors: she herself has been active in this area. And we have begun to see some of the great prehistoric monuments — the earthworks of Wessex, for instance — as artworks in that sense. But the whole landscape is a palimpsest of human activities: lines which experience has etched on the ageing face of the past. Landscape history. Where does history stop and art begin?

118

PREVIOUS PAGES:
Detail of an RAF aerial reconnaissance photographs of Italy, 1939–1945. Near Civitella S Paolo, RAF 4082, 25/4/1944.

OPPOSITE:
Cassino
From the *Palimpsest Series*, 1994, 56 x 38cm. Liquid watercolour on parchment paper.

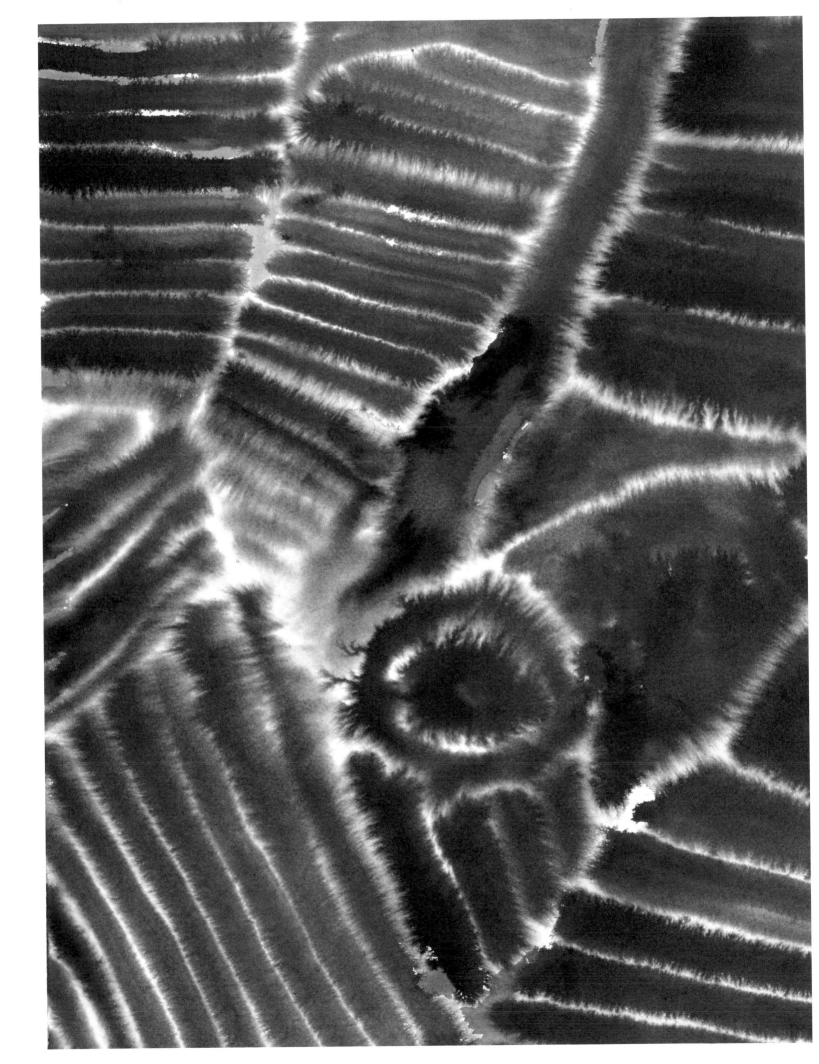

The British School at Rome is an appropriate place to ask such a question.[1] Among cultural institutions it is notable for the juxtaposition of archaeologists, historians and other research scholars on the one hand, and contemporary artists and architects on the other. Sometimes the different groups go their own ways and about their own work in peace. But more often there are fruitful interactions which can serve to open the eyes of historians and archaeologists to the modern world, and those of modern artists to the variety and richness of the past. The present volume, deliberately presented in the traditional format of the Papers of the British School at Rome, is a witness to these interactions. Above all, it is a witness to the sensibility of Kate Whiteford, an artist who has for many years found source and stimulus in the relics of the remote past. "Remote sensing" is the term often assigned by archaeologists to those discovery techniques, including aerial photography, which do not entail the disturbance of the earth through excavation. Another metaphor, the expression serves well to indicate here the preoccupation in the works illustrated with the process of aerial prospection of structures and with the transformation which brings them to us, the readers of this volume. Remote sensing involves here the knowledgeable and receptive use of our eyes, those most sensitive of sensors, and of our imaginations. It is here that Kate Whiteford, flying solo, sets a pioneering course.

First published in Kate Whiteford, *Remote Sensing: Drawings from the British School at Rome,* 1997.

1. Kate Whiteford was Sargant Fellow at the British School at Rome 1993/1994. The *Palimpsest* series of paintings derived from studying wartime aerial reconnaissance photographs found in the School library, remnants of a once extensive collection. In the immediate aftermath of the Second World War the School's Director, John Ward-Perkins, recognised the potential for archaeology of the detailed aerial documentation of Italy made by the RAF during the war. He rescued from destruction the enormous collection of photographs, now in the National Italian Photographic Archive (ICCD).

OPPOSITE:
The Palimpsest Series, 1994
(Tusculum, Cerveteri, Paestum, Ostia)
Each 76 x 56cm. Liquid
watercolour on parchment paper.

I was surprised to find that the Library at the British School at Rome still contains some of the wartime archive of aerial photographs of Italy taken by the Royal Air Force during the Second World War.

The topographical detail revealed in these photographs has been used subsequently by archaeologists for research purposes, thereby changing both the meaning and the reading of marks in the landscape.

As an artist the same marks, patterns and rhythms were of interest to me as visual documentation of time and experience, a graphic landscape open to new interpretations.

The use of both aerial and microscopic photographs in archaeology suggested a parallel interpretation whereby, once freed of any strategic need, the scale of the marks could be seen simultaneously as either monumental or minute.

This publication attempts to cross the boundaries of these readings with parallel texts in art, archaeology and criticism.

"Landmarks", from *Remote Sensing: Drawings from the British School at Rome*.

TOP AND OPPOSITE:
RAF aerial reconnaissance photographs of Italy, 1939–1945. The RAF aerial survey of the Italian mainland during the Second World War was acquired by the British School at Rome after the war to be used for research. The photographs proved to be an invaluable resource for identifying the traces of sites of archaeological interest.

LEFT:
Rieti, RAF 5022, 2/4/1945.

RIGHT:
North of Viterbo, RAF 3074, 15/5/1944.

OPPOSITE:
S.E. of Sutri, RAF 4036, 21/8/1943.

23S 29.3 P.G. AUG 21 1943.0945.F/24".21,500:

6

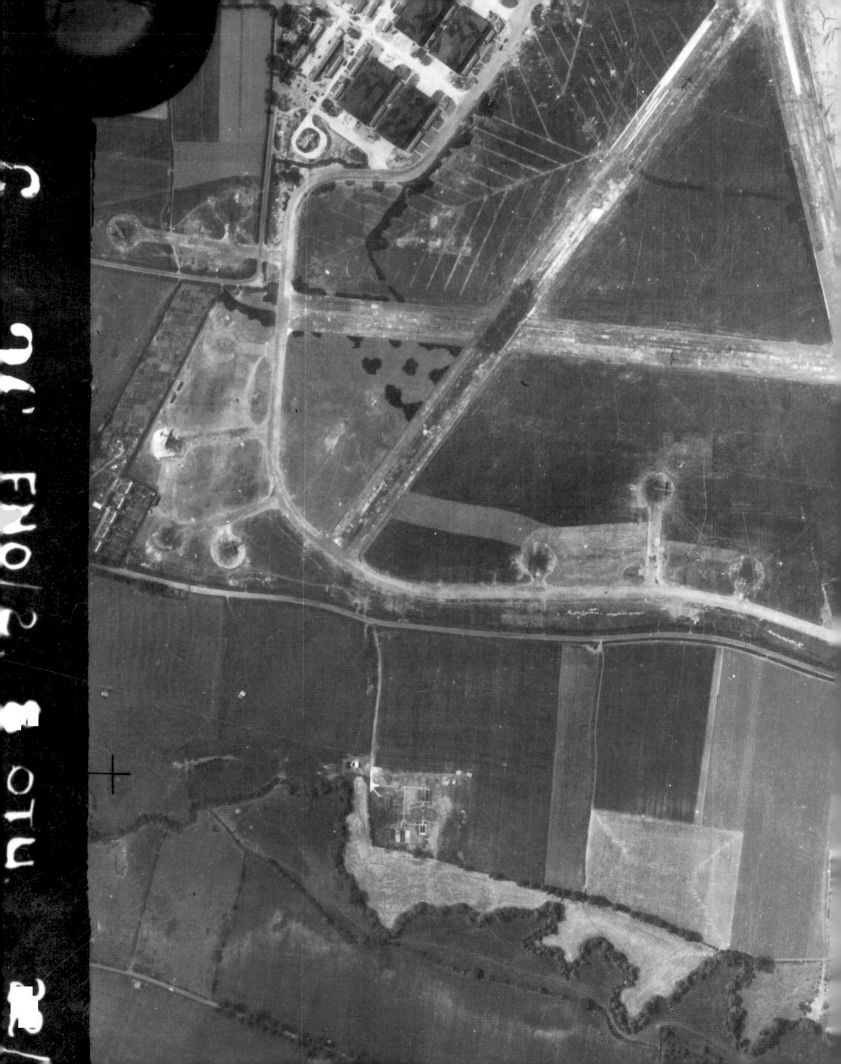

AIRFIELD

KATE WHITEFORD **AIRFIELD**

The starting point for *Airfield* at Compton Verney was the plan view dated 1818 and a wartime aerial photograph of nearby Wellesbourne Airport with the runway camouflaged in 1942.

The 1918 plan by Pedley analyses the main components of the eighteenth century 'Capability' Brown landscape and reveals a powerful underlying geometry to Brown's design. It belies the notion of informality and natural groupings which we have come to associate with his landscapes and reveals how the 'natural' topography is arranged and shaped by a strong pattern of imaginary lines. These invisible sight lines or 'vistas' cross vast tracts of land, lakes and forests as if flying overhead and illustrate the spatial command of Brown's imagination. The idea of flying began to take off.

Much has happened to change the landscape since Brown's day. Stands of trees, planted to obscure the public road, cut off the long vistas down through the series of serpentine lakes.

PREVIOUS PAGES:
Aerial photograph of Wellesbourne Mountford airfield, c. 1942, showing overpainted camouflage and dispersal units.

ABOVE:
Airfield, 2007
Compton Verney, Warwickshire. Line marker paint on turf. Land drawing, with false perspective, along the original eighteenth century vista from the house towards a series of lakes, now hidden by trees.

OPPOSITE:
Plan of the Compton Verney estate, 1818, showing sight lines and vistas according to the designs by Lancelot 'Capability' Brown.

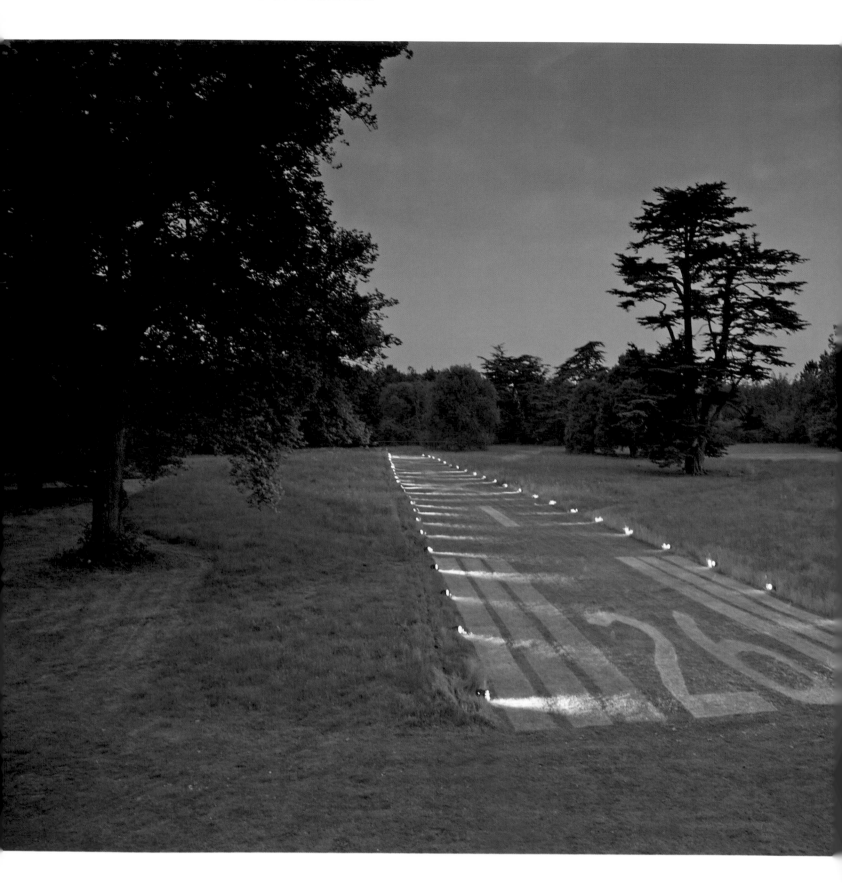

Airfield, 2007
Night view of land drawing with
'landing lights'.

During the Second World War the house was requisitioned by the Army and used as a camouflage research station. The former military airport of Wellesbourne Mountford is only five minutes flying time away and there are reports of planes landing on the main lawns in the 1940s on their way back to base. The vertical reconnaissance photograph shows the layout of the airfield with wartime camouflage on the runways, taken in 1942. After the war Wellesbourne Airfield became a base for the School of Aerial Photography. Thousands of wartime reconnaissance photographs reveal marks on the land which cannot be seen at ground level — in peacetime they became an invaluable resource used by archaeologists.

All these stories contribute to an understanding of the landscape at Compton Verney as it is to-day — a palimpsest of hidden lines, manipulations and interventions made over several centuries and still being uncovered. On my first trip to Compton Verney archaeologists were on site, trying to uncover Brown's original winding paths threaded throughout the parkland. After seeing the fresh excavation marks on site, and visiting the nearby airfield to look at the site from the air I sensed that this terrain was like a secret document — a coded landscape that we are still trying to decipher.

The two land works *Point Blank* and *Airfield*, sited on the east and west fronts of the house respectively, are aligned along the original eighteenth century vistas. By conflating different aspects of the history of the site these works have multiple readings. Could *Airfield* be a decoy left over from the period of wartime camouflage? Or was the extensive eighteenth century vista indeed transformed in the twentieth century into a runway? *Airfield* implicitly makes reference to the extraordinary spatial dynamics of Brown's designs and contrasts them with the layout of early twentieth century airfields which also have meandering paths — the dispersal units — growing out of dynamic diagonals.

Point Blank is positioned, at a distance, directly in front of the main entrance of the house on its east facade. It draws attention to the vista created by Brown and references his use of 'point blank', or the position dead — ahead, to manipulate space and direct the viewer's line of sight. The image for *Point Blank*, red and amber vertical stripes, is one of the ground signals used in aviation. It means: 'Do Not Land Except in an Emergency'.

On the other side of the house, the west front, *Airfield* is laid out along Brown's original long view to the lakes, skirting the giant cedar that Brown positioned at 'point blank' to created two symmetrical but dissimilar outlooks. As John Phibbs points out, this was a device borrowed from the pairing of landscape paintings by artists like Claude Lorrain. The runway heads towards the far lake, now obscured by trees but, undeterred, the imaginary plane soars overhead toward the village of Combrook, with a side view of the temple on the left providing a landmark, as Brown intended two and a half centuries ago.

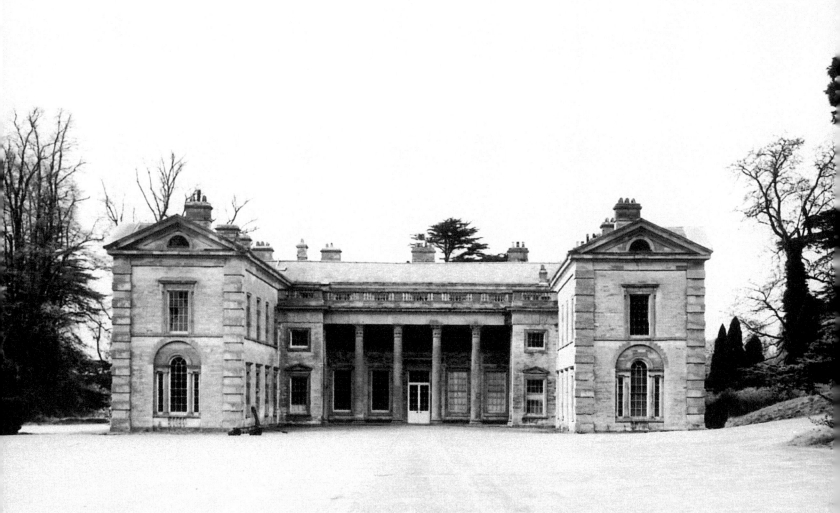

ABOVE:
Compton Verney East Front, the
viewing position for *Point Blank*.

OPPOSITE:
Point Blank, 2007
View along the eighteenth century
vista from the East Front showing
the position of *Point Blank*. Printed
mesh fabric on site, photomontage.

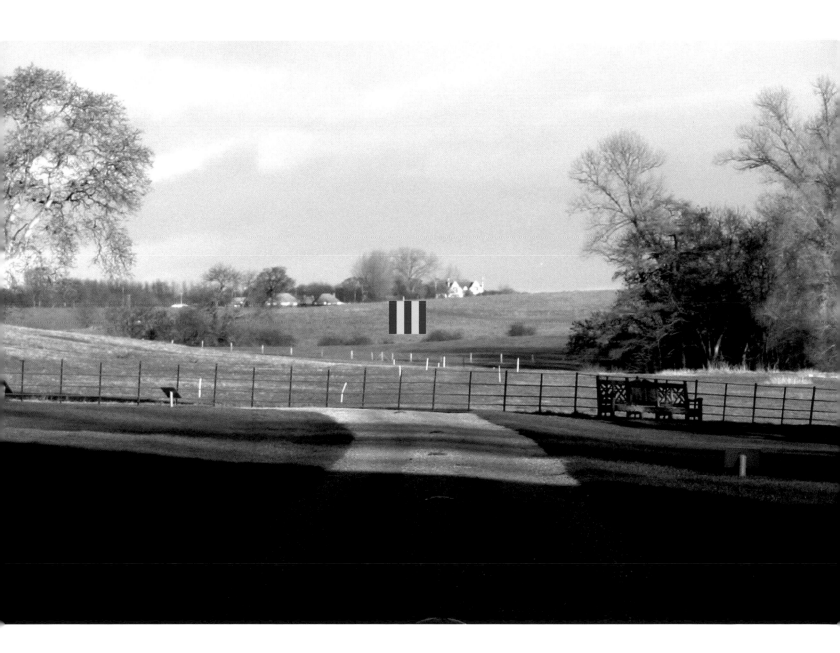

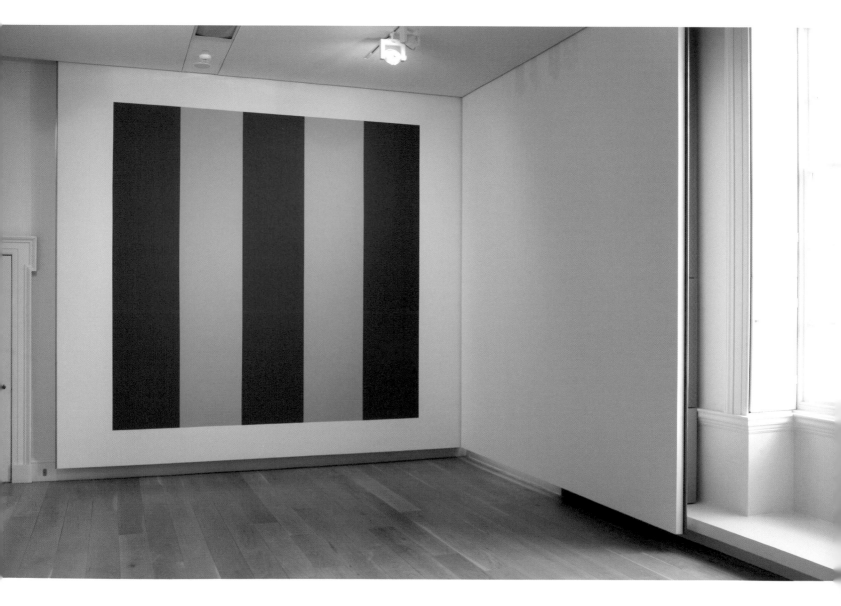

Ground to Air Signal: 'Land in
an Emergency Only', 2007
350 x 400cm. Wall painting.

This fictional runway has white 'threshold' lines and bears the correct code (26) which indicates its position relative to due north; white crosses throughout its length indicate that it is no longer in use; and a false perspective deceives the eye and leads into the far distance.

The uncanny resemblance between the criss-cross dynamics of Brown's vistas and the layout of early twentieth century airfields, such as Wellesbourne Mountford nearby, is explored further in a series of images on canvas shown in the gallery. Other wall paintings derive from airfield codes signifying: 'Land in an Emergency Only' and 'Due to the state of the manoeuvring area, pilots should exercise special care when landing'.

Finally, the film *Compton Pools* completes the aerial dynamic, literally re-enacting the journey that Brown made in his imagination, circling in an endless loop over the great plan — the original starting point.

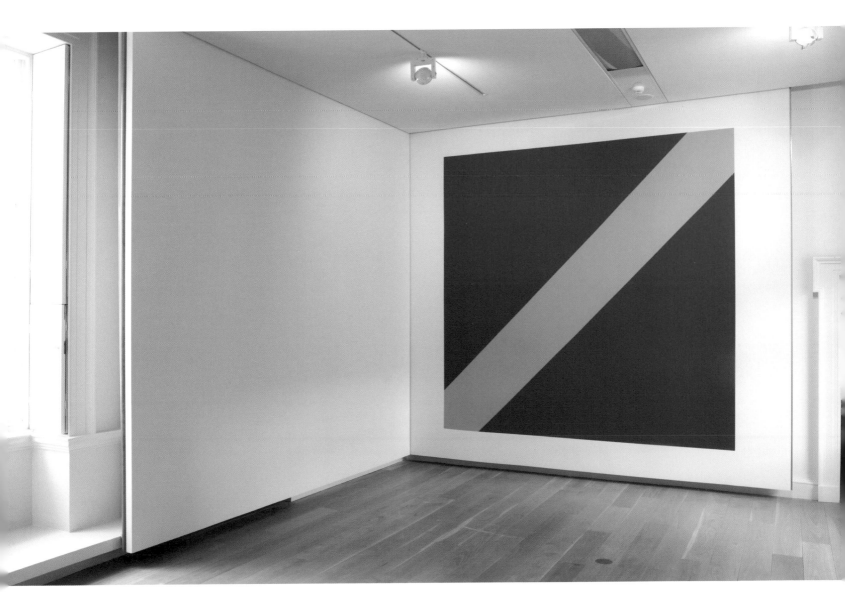

Ground to Air Signal: 'Due to the state of the manoeuvring area, pilots should exercise special care when landing', 2007
350 x 400cm. Wall painting.

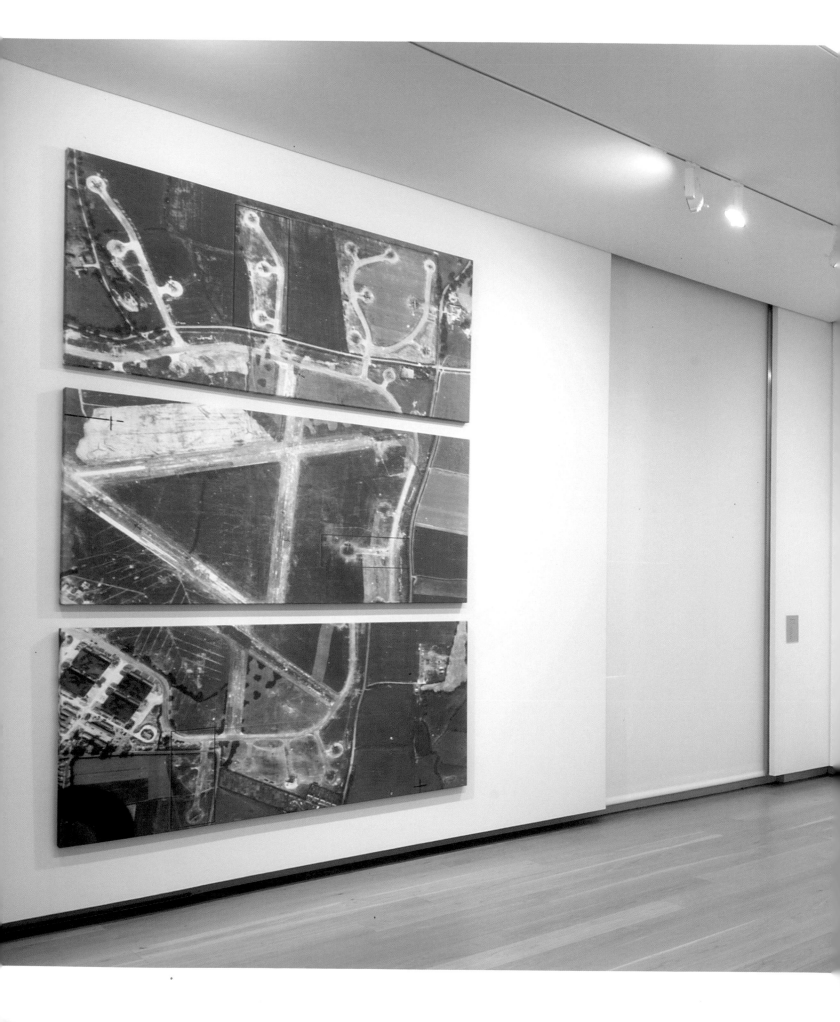

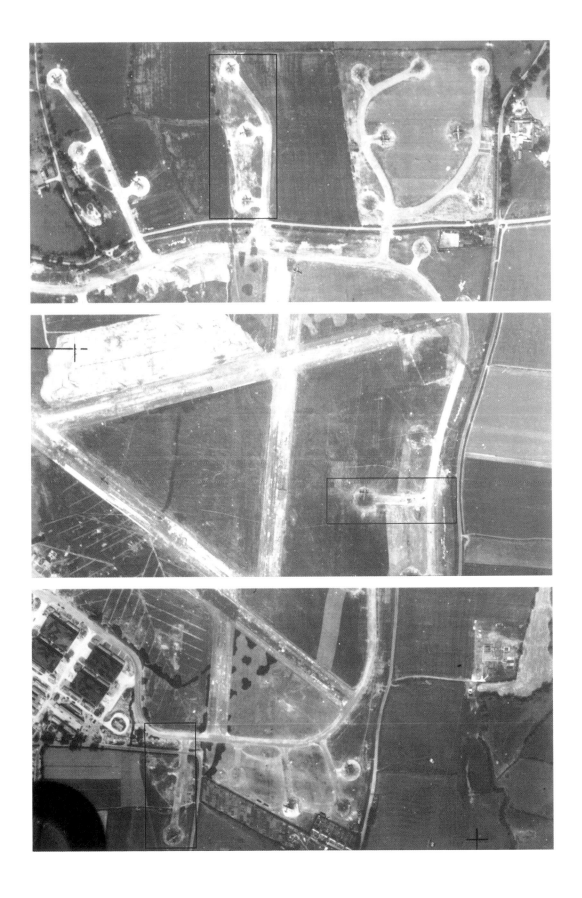

OPPOSITE:
Viewfinder, 2007 (Wellesbourne
Mountford Airfield)
Installation view.

TOP TO BOTTOM:
Viewfinder, 2007 (Wellesbourne
Mountford Airfield)
Each 120 x 250cm. Triptych. Ink jet
print on canvas.

JOHN PHIBBS THE GREAT OUTLINE

It might be said that the whole surface of the Western world has been shaped by one or other of two great traditions of landscape design. These two traditions are dominated by two men, who tower above all others despite the fact that neither of them wrote anything worth reading. André Le Nôtre, 1613–1700, gardener to Louis XIV, made Versailles a world of order, of avenues and canals, statues and topiary, and meticulously kept parterres, to show that even nature would do the bidding of a man as powerful as his master the king. In England by contrast, what is known as the English Landscape Movement was led by Lancelot 'Capability' Brown, 1716–1783, who set aside the power of man and built parks and gardens made up of sinuous sweeps of water, flowing lawns and apparently casual groups of trees, places that harmonised with nature and were shaped by natural forms, places where king and commoner might meet as equals.

COMPTON VERNEY
The house at Compton Verney is a building with three symmetrical fronts (east, west, and south), and Brown's first task was to make views from the main windows on each. These views were not to interrupt the overall coherence of the landscape, but at the same time each was to be somehow distinct from the others.

Arrival of Aeneas in Italy, the Dawn of the Roman Empire
Claude Gellée (le Lorrain), 1600–1682.
Oil on canvas.

136

Furthermore each was to be composed according to the established canons of landscape painting, and (ironically, given the anti-French bias of the English landscape style), each was the more valued the more it looked like a painting by the Frenchman Claude Lorrain.

When Brown arrived, Compton Verney already had a grand layout of avenues, which radiated from the house in the French style, and attempted to impose the central importance of the house on the somewhat intractable topography of the place.

POINT BLANK

Taking the west, park, view first, while Brown may have appeared to remove much of the early formality, in practice he retained a geometric symmetry in his design. First he planted trees close to the house, at "point blank", as it was called, that is directly in front of the central door. Of these the large cedar on the lawn survives. This trick gave him two views (one for each of the two windows on either side of the door) instead of one rather useless view from the front door itself.

Then he made much use of four structures, all of which he may have designed himself: the Temple (on the north edge of the woodland known as The Rides) and the Orangery, another building at the west end of the Lower Pool, above Combrook, the 'ruin', survived by its foundations, and a fourth set on a knoll on the northwest side of West Park, surrounded by apple trees, and probably a temporary structure, like a tent, that could be taken down in winter. These structures were related, for they make two pairs (Temple and Orangery; ruin and apple knoll) each of which is bisected by point blank (a straight line running straight out from the middle of the

Morning
Claude Gellée (le Lorrain), 1600–1682.
Oil on canvas.

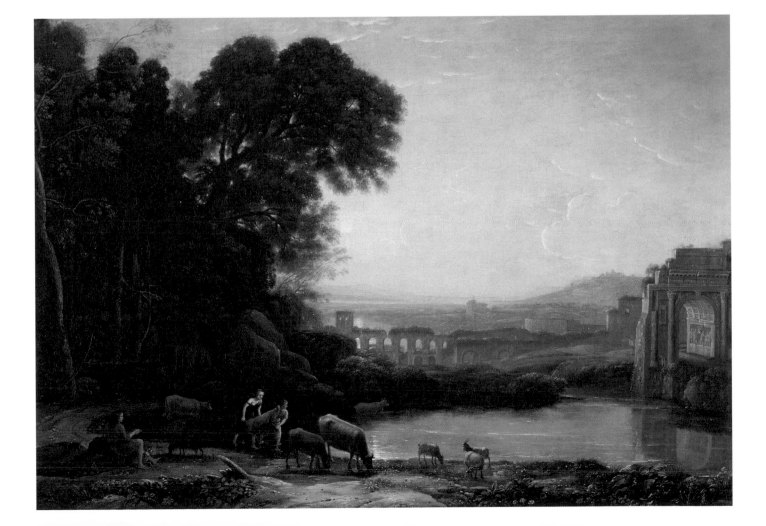

house). This gave Brown the structural beginnings of two views so composed that each mirrored the other and between them they made a single landscape centred on the middle of the west front. At the same time they were quite different in style and character. In Brown's day the view to the west would have been described as feminine with a fore-ground of flowers and orange blossom rising up to the Orangery only a short step from the house, and a longer view across the B4086 towards the apple knoll.

The complementary view, to the south, was more distant and grand, running down the full distance of the valley to Combrook and stopped by the large square 'ruin', with a shorter side view to the Temple.

This arrangement (a pair of paintings, each asymmetric, but making a completely symmetrical composition when hung next to each other) was one

138

ABOVE AND OPPOSITE:
Compton Pools, 2007
Super 8 film, B/W and colour, 4.40
minutes. Eight film stills.

that Claude himself used. He painted and sold his pictures in complementary pairs, or pendants. No doubt he intended them to be hung in a formal room where they would reinforce the architecture, and he gave each quite distinct subjects, to prevent their imposing a single character on the room.

What is remarkable about Brown's use of the same trick of design is that although the idea was more or less current in Britain, there was no single pair of Claudes in the country for him to look at.

Turning to the east front, in North Park, Brown had a less tractable problem. This was the entrance front and entrance fronts were noise, dusty, public places from which it was difficult to enjoy the view even if one wanted to. Furthermore all the width had been taken out of the view by the extending wings of the house.

While Brown did cut down trees in the formal avenue, this was only to make views back to the house. The views out would not have changed so much. What he does seem to have done however is build an ornamental cottage or farm at point blank. It is still there today but so far from the house as to be scarcely noticed. What are we to make of this? It cannot possibly have been an accident, and the house could have been put up anywhere else on the estate. Yet one does come across odd tricks like this in Brown's work, apparently at odds with the informality that is associated with him. When he left a piece of landscape largely alone, he still liked to put a signature on it to show all who cared that he had deigned to approve it as it was, and had deliberately left it unchanged.

AN AERIAL PERSPECTIVE

Having worked out what to do with his main views, Brown could go on to set out similar views from less important buildings, such as the structures I have already mentioned, and by combining all together he created his 'great outline'. This may be said to have been derived from geometry and at this point in the process it is worth stopping to note that Le Nôtre must have begun his design with a similar geometric exercise, and that Brown's reputation for 'informality' is based more on the relaxed look of his finished work than on the rigour with which it was designed.

He could then turn to the line of the approaches to the house, and to the drives and walks that traversed the landscape. These could be laid out wherever he pleased so as to link the various follies, and also to take advantage of the incidental views that happened to have been created as a by-product of the 'great outline'. However, they also had to accommodate fixed elements such as the public road, and the dam that divides the Middle and Upper Pools, concealed by the Adam Bridge. Always, he had variety in his mind — the drives and walks in particular had to take in the greatest variety of scenery, wild and polished, small and large scale.

Finally he could start to think of planting, using leaf colour in particular to heighten the chiaroscuro and add the illusion of aerial perspective to his views.

OPPOSITE TOP AND BOTTOM:
Compton Pools, 2007
Super 8 film, B/W and colour, 4.40 minutes. Two film stills.

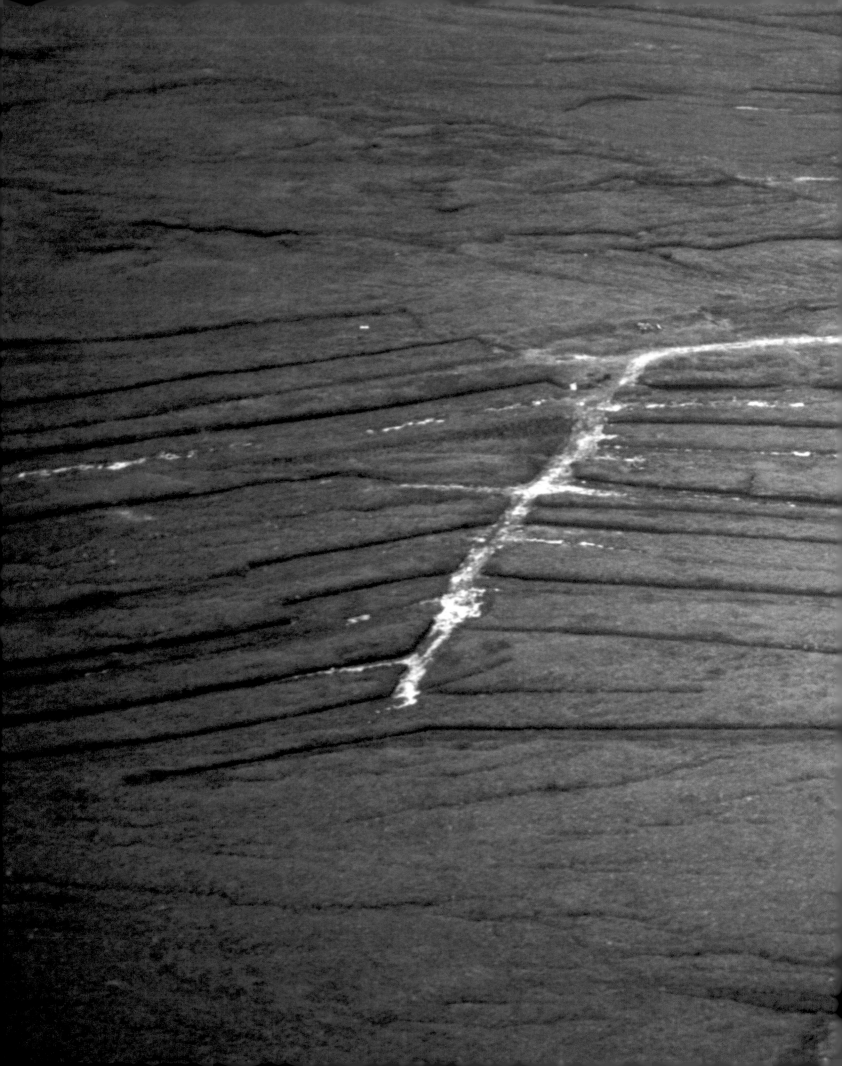

LEWIS, AN AERIAL VIEW

KATE WHITEFORD **LEWIS, AN AERIAL VIEW**

From the air the landscape of Lewis has the appearance of an artist's drawing with distinct marks and cuts and even the rubbings out of successive generations. Archaeologists have known for some time that at certain times and in some conditions aerial photography can reveal marks and signs which cannot be seen at ground level. However, the landscape of Lewis reveals much more: it is a living document — a palimpsest of lines which criss-cross the land forming distinctive patterns, both ancient and modern. This unique hand-drawn landscape has brought me back to the island again and again.

In 2001 I was sent a bundle of Gaelic poems, recently translated into English, with an invitation to contribute to a book of poetry and images to be called *An Leabhar Mor, The Great Book of Gaelic*.[1] This was an ambitious project to bring together one hundred artists with poets writing in Gaelic to generate new visual responses to the written word. It persuaded me to visit the Outer Hebrides to find out more about the poetry and culture of the islands. What began as research for a book became a much more intense and complex project.

For *An Leabhar Mor* I chose a work by a Lewis poet, Murdo MacFarlane. *Chunnaic mi uam a Bheinn* describes flying into Stornoway after living in Canada for many years, and the memories that this landscape provoked for the poet.[2] It is a meditation on time, memory and mortality and, like much Gaelic poetry, it has a profound sense of place. I wanted to see this place for myself. On my first trip I sat with the pilot as we came in to land at Stornoway. As the plane turned to cross Broad Bay I could see the hills described in the poem, low lying and sombre against the vast flat moorland. This was my first glimpse of an extraordinary island. It is difficult terrain of peat bogs and rough ground with few roads. Hidden from the road are hundreds of pools that lie scattered like jewels across the moor reflecting the sky and dazzling with their beauty when seen at a distance from the air.

From above it is also possible to see many of the ancient runrigs, cultivation systems carved into the land, even on rocky headlands. Many of theses are only visible after a light fall of snow or in the early evening when the sun is low and the light casts long shadows. Over Broad Bay, the plane sometimes would pass over a headland at East Roisnish, which looked as if it had been sculpted from the rock. I recognised this extraordinary site from an archive photograph I had seen in National Monuments Record in Edinburgh. At ground level and it was equally dramatic, with the runrigs shoulder high.

PREVIOUS PAGES:
A'Mhointeach: The Moor,
Isle of Lewis
Aerial photograph, colour, 2006.

OPPOSITE:
East Roisnish, 2007
Liquid watercolour on
parchment paper.

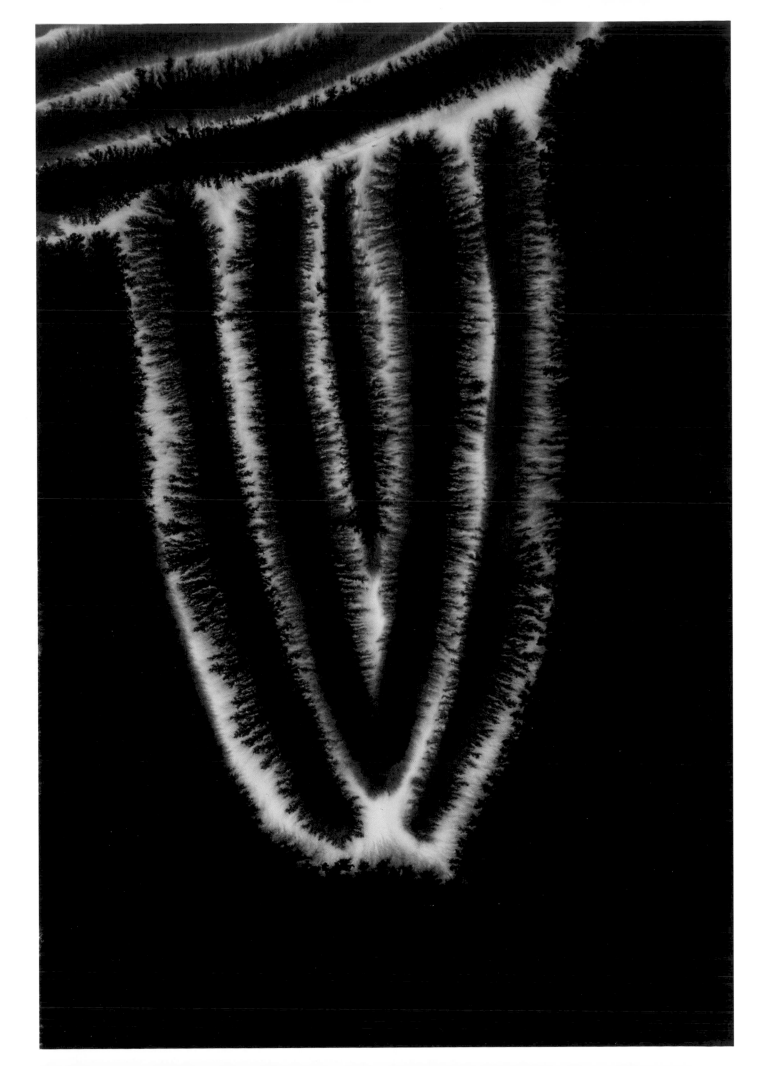

It had been my intention to make a land drawing which related to the poem but having seen the terrain I decided instead to record this dramatic landscape from the air. The result is a Super 8 film, *A'Mhointeach: The Moor*, with images of the land layered with the sound of the wind, the droning noise of the engine, and fragments of spoken and sung Gaelic. This film, together with new works on paper and photo images on canvas, were first shown at An Lanntair Gallery in Stornoway in 2007.

1. *An Leabhar Mor, The Great Book of Gaelic,* ed. Malcolm MacLean, Edinburgh: Canongate 2002.

> Chunnaic miuam a b'bheinn
> 'S mi siubhal air astar speur,
> 'S an aois a mhallachadh rinn,
> Oir mhiannaich mi rithist bhith òg,
> Sa bheinn gun bhonaid,gun bhròg-
> Miann riamh nach do shealbhaich mac mnaoi,
> 'S oirnn fear-trusaidh gach linn an tòir.

2. *Chunnaic miuam a B'bheinn* (I saw at a Distance the Hill), Murdo MacFarlane, 1901–1982.

OPPOSITE TOP:
Viewfinder (Bragar) Isle of Lewis, 2007
120 x 250cm. Ink jet print on canvas.

OPPOSITE BOTTOM:
Viewfinder (East Roisnish)
Isle of Lewis, 2007
120 x 250cm. Ink jet print on canvas.

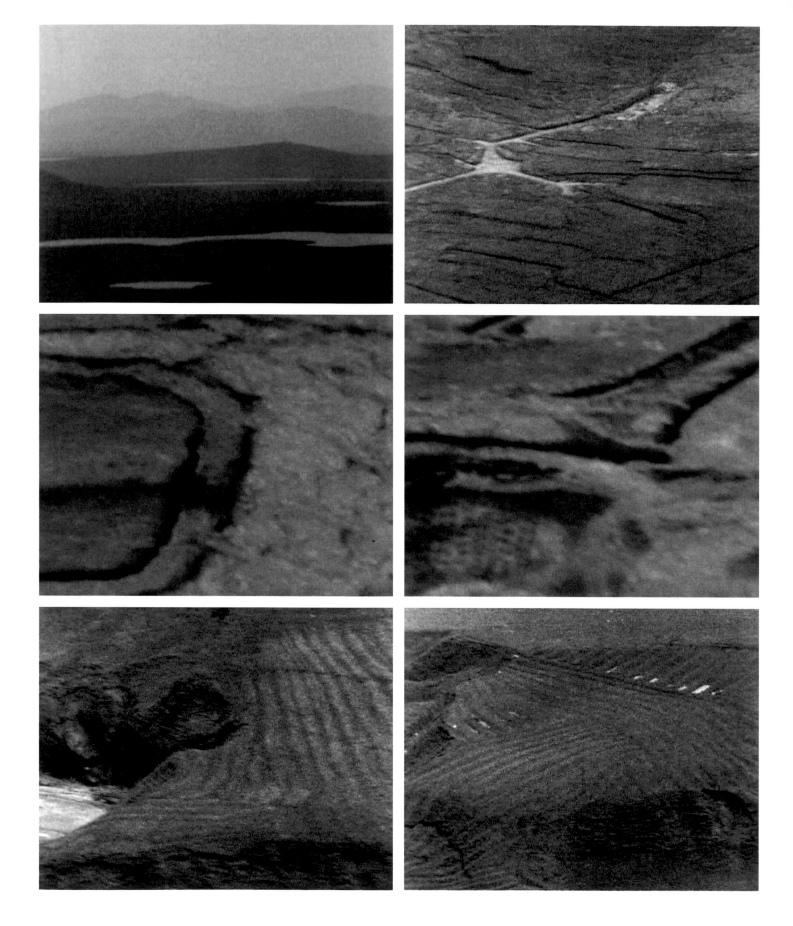

148

A'Mhointeach: The Moor, 2007
Super 8 film, B/W and colour,
7 minutes. 12 film stills.

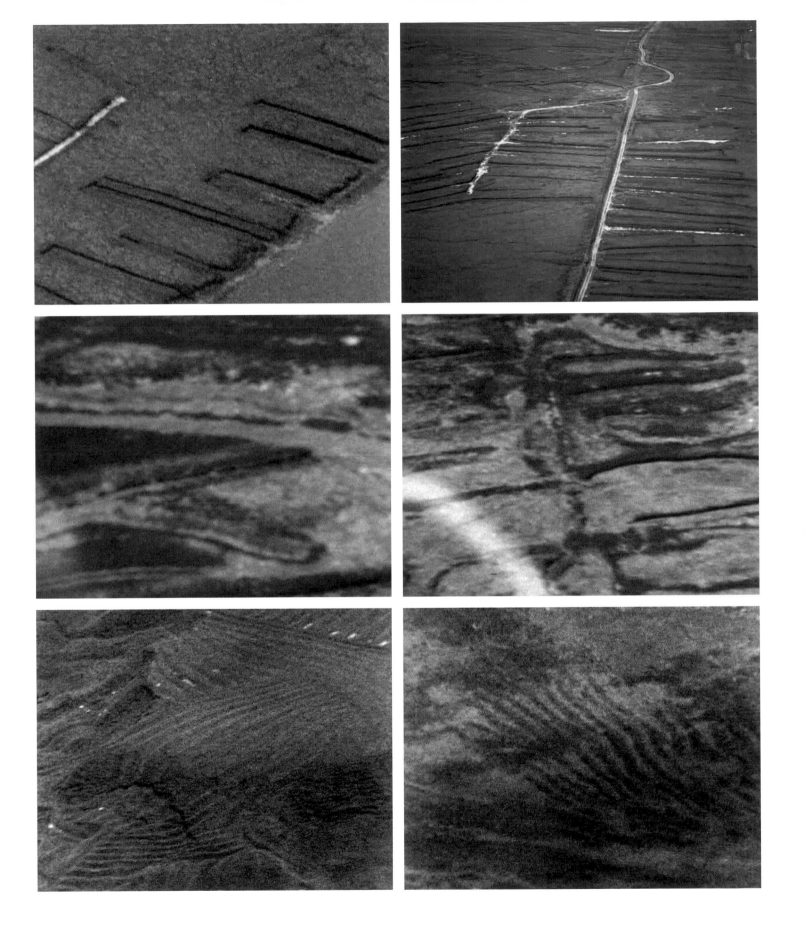

A FICTIONAL ARCHAEOLOGY

YVES ABRIOUX # A FICTIONAL ARCHAEOLOGY

Situated south of Paris, near Versailles, the Domaine de Coubertin was occupied by the family of the same name from the sixteenth century until it became an arts foundation in 1973. Its most famous scion was Baron Pierre de Coubertin who founded the modern International Olympics Committee, and organised the first modern Olympics in Athens in 1896.

The Chateau de Coubertin is set in extensive grounds which have been redesigned several times over the centuries. The formal French garden and the woodland behind the manor house were recast as a landscape park in the English style in the 1860s.

A significant feature is the island set in a small pond at the far end of the lawn. To the educated eye, the plan of the pond and its islet recalls a classical prototype: the island (temple) in the gardens of the Villa Adriana at Tivoli known as the Teatro Marittimo, Emperor Hadrian's most private retreat. That this island too may have housed a temple is an irresistible hypothesis.

For the exhibition *The Spectre of Gardens* investigations were carried out on the island at Coubertin under the direction of Kate Whiteford, an artist well known for her archaeologically-inspired land drawings in landscaped gardens such as those at Harewood in England and Mount Stuart in Scotland.

A few architectural fragments were uncovered making it possible to sketch out the layout of a circular temple. The most exciting find was that of the remnants of a hearth at the very centre of the island temple. Is it really possible that the sacred flame at Coubertin could have been recycled as the Olympic torch?

Whiteford's archaeological find has been recorded on an explanatory plaque on the edge of the pond at Coubertin. Documentation has been placed in the archives of the Coubertin Foundation and archaeologists from the University of Cambridge have recreated a digital model of the temple.

From an article published in *La Gazette des Antiquités* de la Vallée de Chevreuse, Autumn 2006.

La Gazette des Antiquités is in reality an enabling fiction. After showing a journalist around the house and gardens in the Coubertin estate, Mme Pascale Grémont, curator of collections at the Coubertin Foundation was surprised to see that, in the draft of the piece that she received prior to publication, Kate Whiteford's archeological notice describing the island temple at Coubertin was taken as purely factual. Other visitors similarly failed to discern the fictional quality of Whiteford's installation and Mme Grémont took great pleasure in playing along with them before revealing the truth.

PREVIOUS PAGES:
Domaine de Coubertin, Saint-Rémy-lès-Chevreuse, France.

OPPOSITE TOP AND BOTTOM:
L'Île au Temple, 2006
Domaine de Coubertin, France.

A recent excavation has revealed a ground plan (left) similar to that of the island at Villa Adriana, Tivoli. The plan suggests that this was the site of a small circular temple. At the centre of the island there is evidence of a hearth. This is where a sacred flame would have burned.

L'Île au Temple

Jardin anglais, Domaine de Coubertin.

Des fouilles récentes ont mis à jour un plan au sol (à gauche) qui rappelle celui de l'îlot dans l'enceinte de la Villa Adriana, Tivoli. Ce plan indique l'emplacement de ce qui était sans doute un petit temple circulaire. Les traces d'un foyer demeurent visibles au coeur de l'îlot. C'est là où aurait brûlé une flamme sacrée.

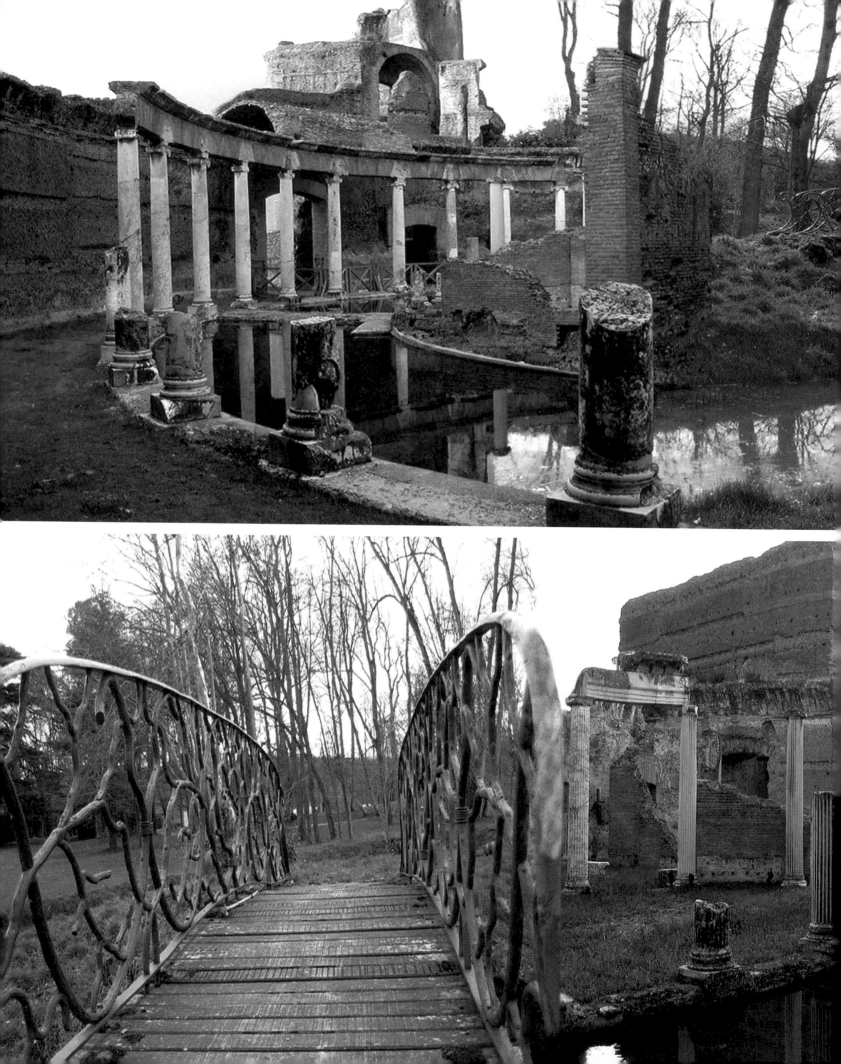

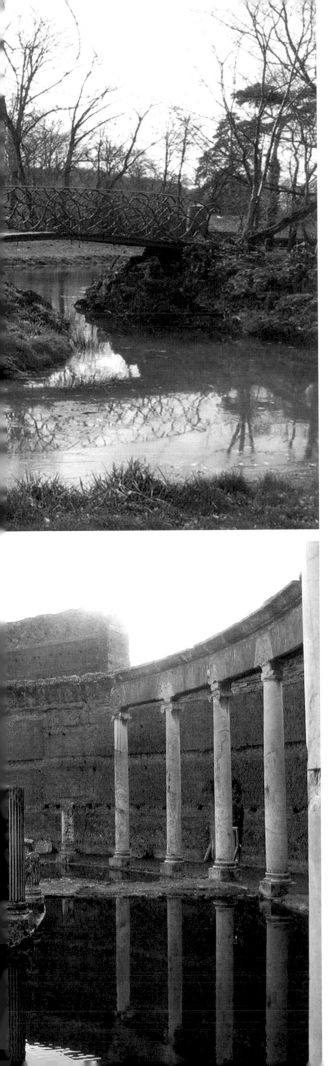

OPPOSITE TOP AND BOTTOM:
L'Île au Temple, 2006
Isola Maritima, Villa Adriana and the
English Garden at Domaine de
Coubertin. Digital photomontage.

With its carefully constructed 'evidence' and meticulous 'documentary' apparatus as well as its appearance in the context of a park or a landscape, Kate Whiteford's *L'Île au Temple* relates to works such as Ian Hamilton Finlay and Ian Gardner's *The Atlantic Wall: William Gilpin*, 1984, which juxtaposes contemporary watercolours and eighteenth century citations; or the Spanish artist Juan Fontcuberta's *Sirens*, 2000, which combines a museum installation with fabricated fossil traces situated 'on site' in the southern French countryside. What distinguishes the Coubertin installation from both of these predecessors and Whiteford's own land drawings at, for example, Harewood or Mount Stuart — which both comprise an archeological dimension — is that *L'Île au Temple* is an extremely realistic piece of archeological fiction.

It recalls the surge in amateur antiquarianism that coincided with the establishment of the English landscape garden in the eighteenth century, and it notes the elaborately fictional qualities with which these gardens were imbued.

As an archeological fiction, *L'Île au Temple* keeps to the scale of its supposed original. The outline of the emblematical garden temple never fully appears, other than in the imagination of the visitor, stimulated by a fictional interpretation panel, a very small number of stone fragments and a few ashes. Here, the lines of the temple are not so much traced in space as drawn out in time — the time of association and imagination; the time of motivated fiction.

Whiteford's land drawings excavate aspects of the history of a particular site, often taking the form of large scale incisions. Since the representational nature of these lines can only be properly observed from a specific vantage point, the appearance and disappearance of the motif in the eyes of visitors enacts the problematic quality of cultural continuity through association.

RIGHT:
Plan drawing of the 'excavation' on the island in the English Garden.

OPPOSITE:
Reconstruction of *L'Île au Temple* from the plan drawing of the 'excavation'. CGI imaging.

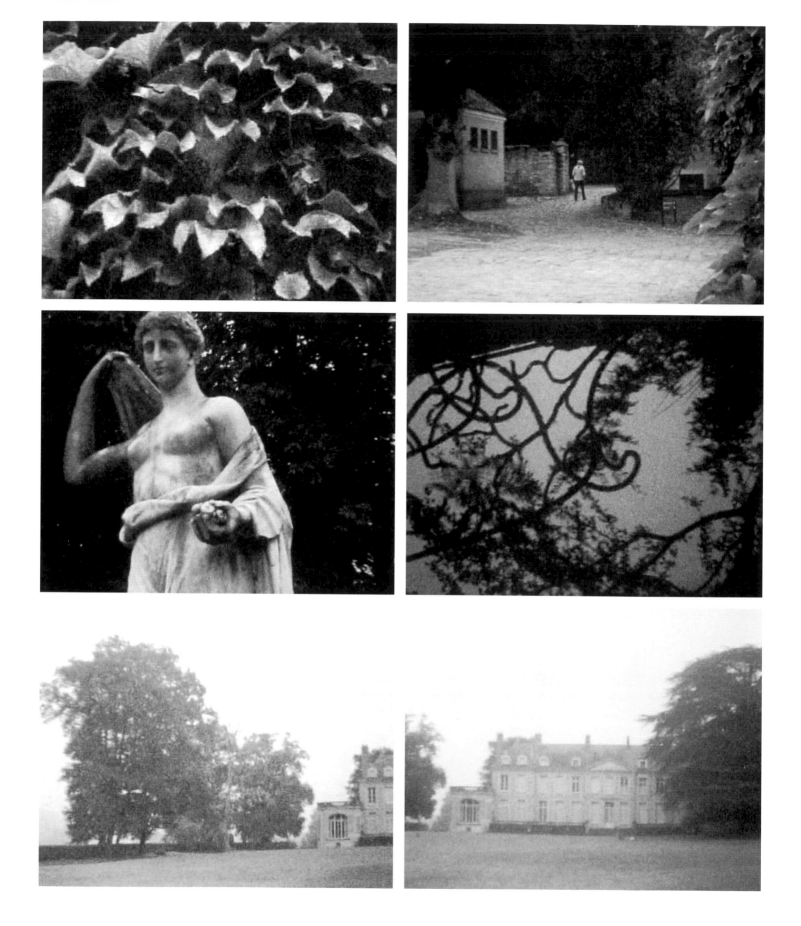

158

L'Île au Temple, 2006
Super 8 film, B/W, 5 minutes.
12 film stills.

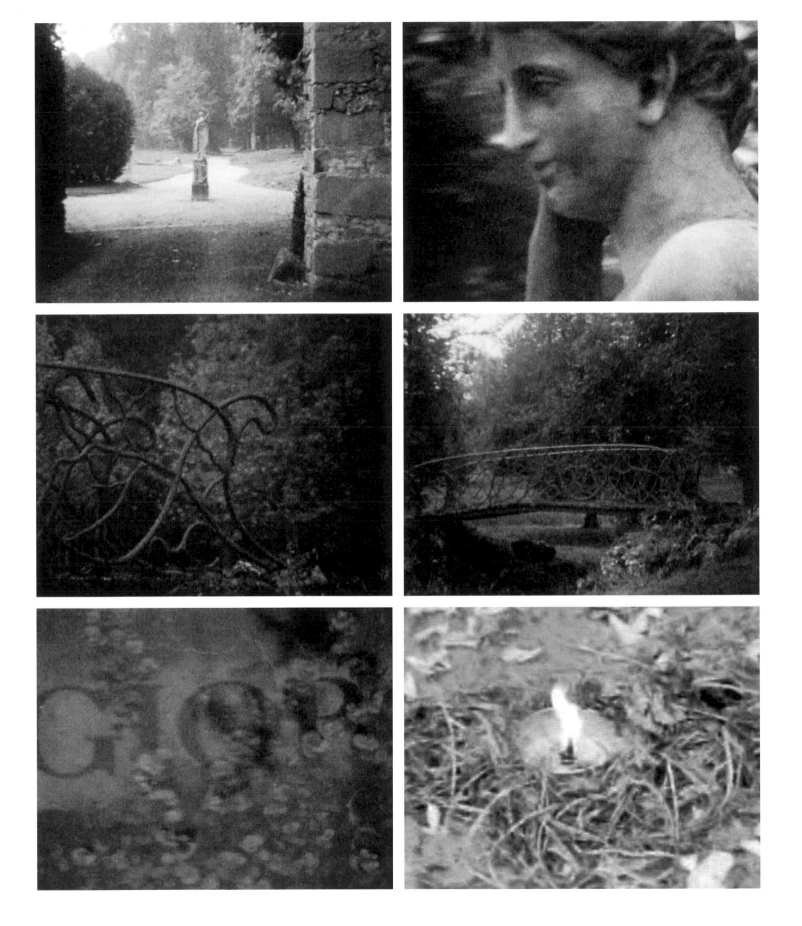

EXCAVATION

KATE WHITEFORD **EXCAVATION (DOUBLE DISC AND SERPENT)**

In 2005 I was invited to propose a land drawing for the grounds of Eden Court Theatre, Inverness, which was undergoing an extensive refurbishment.[1] The location was the former garden of the restored Bishop Eden's Palace and is overlooked by the newly restored theatre building. This provides a perfect situation for a land drawing as there is an elevated view of the site. *Excavation* is made to be viewed from the second floor of the theatre, with the perspective of the drawing manipulated at ground level.

As the main path to the theatre cuts across the site I incorporated the path into the work by making it follow the curved lines of the drawing. Where the path crosses the drawing it becomes a granite causeway, at which point the land drawing can be viewed at close range, similar to the viewing paths which traverse archaeological sites.

The concept of the work is that of a fictional 'excavation' in the grounds of Bishop Eden's Palace. The drawing of 'archaeological remains which have been uncovered during the building works is based on the incised images on the reverse of the carved stone at Glamis Manse.[2] At ground level, the sinuous curves of the serpent are elegantly distorted and exaggerated to be viewed from above.

To reach the theatre one follows the path until the granite causeway crosses the white drawing and black mondo grass, creating a significant moment of transition: crossing the drawing signifies leaving the real world behind and entering the world of dreams and imagination.

1. Commissioned by Eden Court Theatre in association with Page \ Park Architects and Ian White Associates, landscape architects.

2. Pictish symbol stone (see p. 11). Sculpture for Calton Hill, Edinburgh, 1987, also makes reference to the incised images on this stone.

PREVIOUS PAGES:
Excavation
(Double Disc and Serpent), 2007
Excavated trenches with black mondo grass (*Ophiopogon planiscapus 'nigrescens'*) and bonded white spar, with granite causeway. Eden Court Theatre, Inverness.

OPPOSITE:
Excavation
(Double Disc and Serpent), 2007
Setting out the drawing on site.

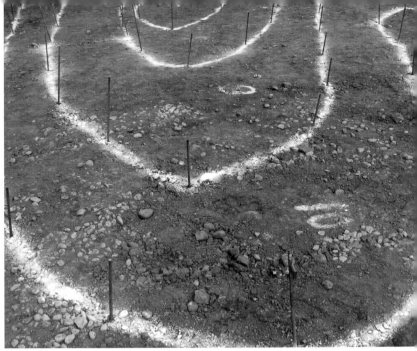
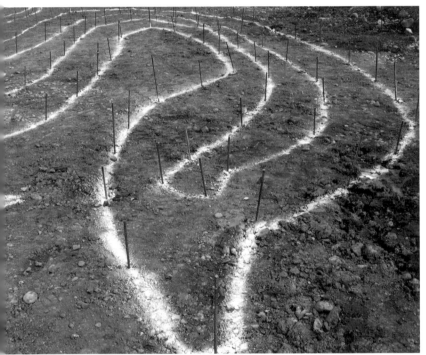
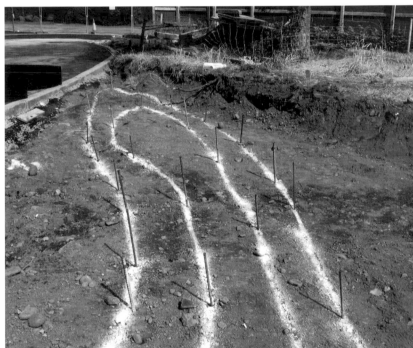
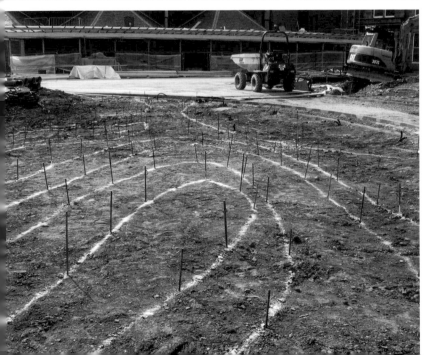
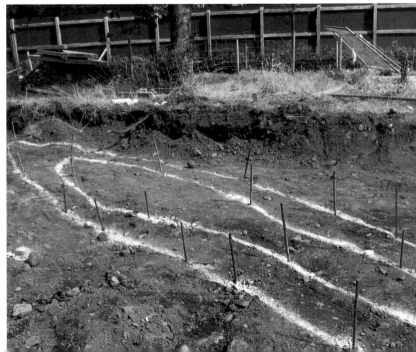

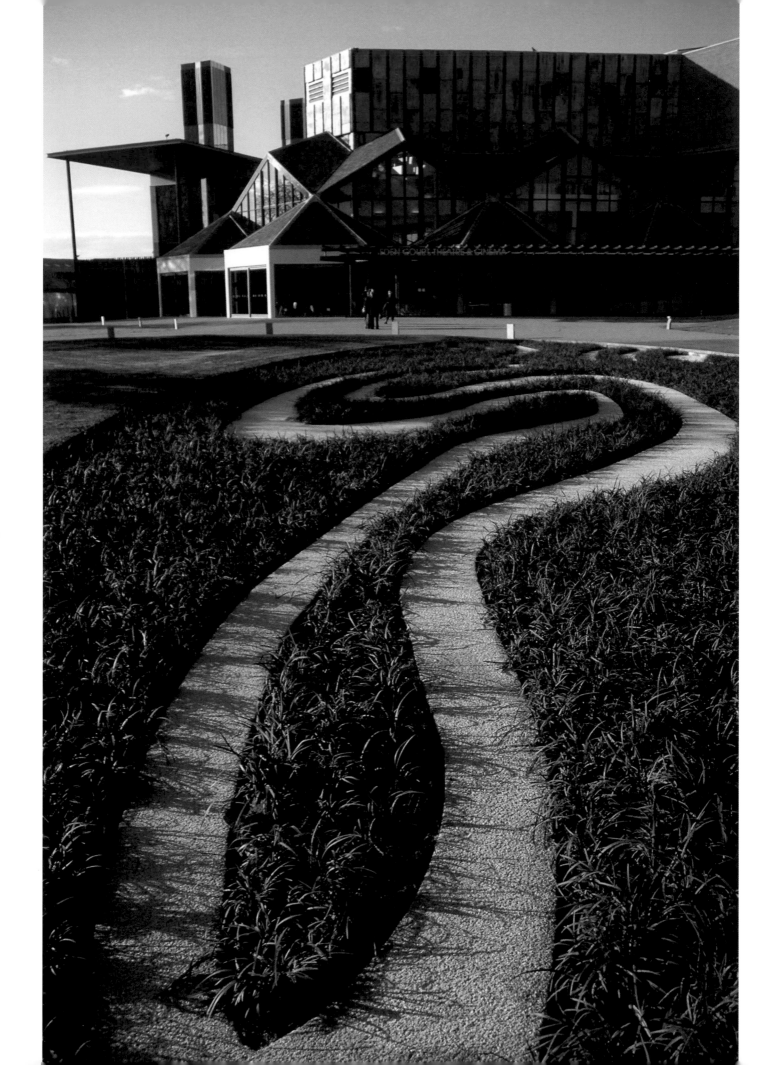

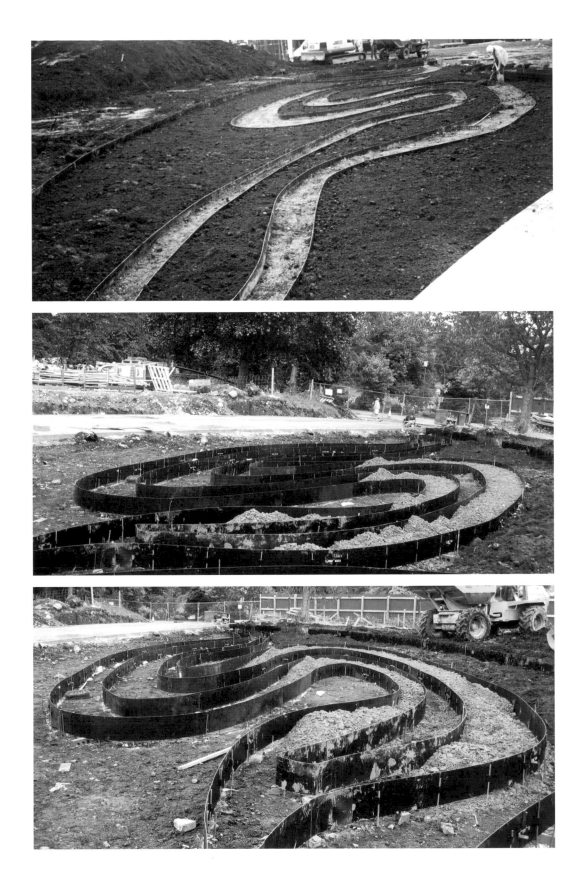

OPPOSITE:
**Excavation
(Double Disc and Serpent), 2007**
Ground level view towards the Eden
Court Theatre.

TOP TO BOTTOM:
**Excavation
(Double Disc and Serpent), 2007**
Work in progress.

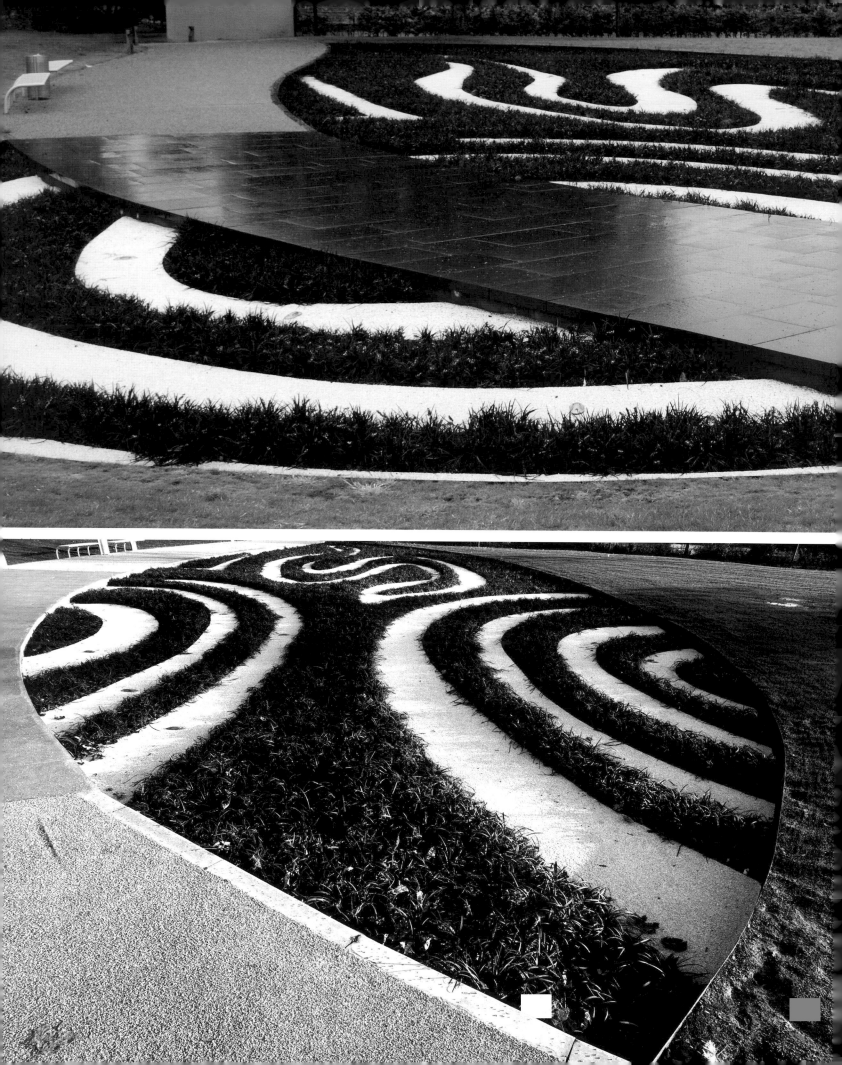

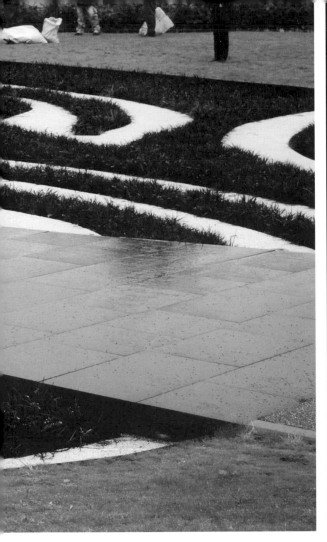

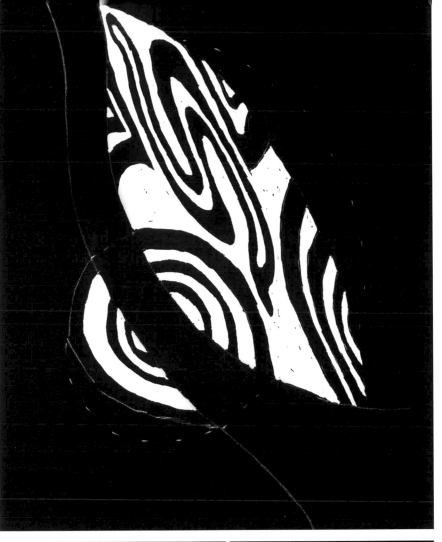

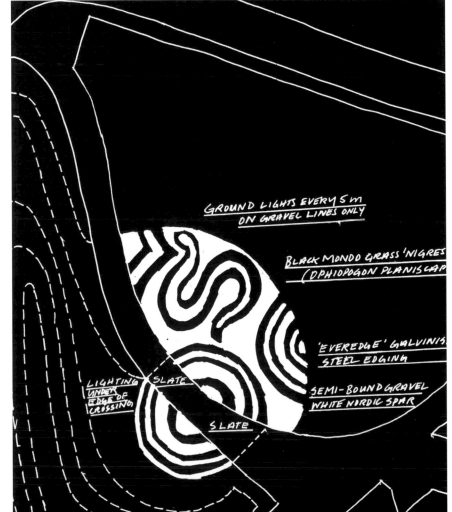

OPPOSITE TOP AND BOTTOM:
Excavation
(Double Disc and Serpent), 2007

TOP:
Excavation
(Double Disc and Serpent), 2007
Anamorphic scale drawing.

BOTTOM:
Excavation
(Double Disc and Serpent), 2007
Scale drawing, without manipulation.

GROUND LIGHTS EVERY 5m
ON GRAVEL LINES ONLY

BLACK MONDO GRASS 'NIGRES
(OPHIOPOGON PLANISCAP

'EVEREDGE' GALVINIS
STEEL EDGING

SEMI-BOUND GRAVEL
WHITE NORDIC SPAR

LIGHTING
UNDER
EDGE OF
CROSSING

SLATE

SLATE

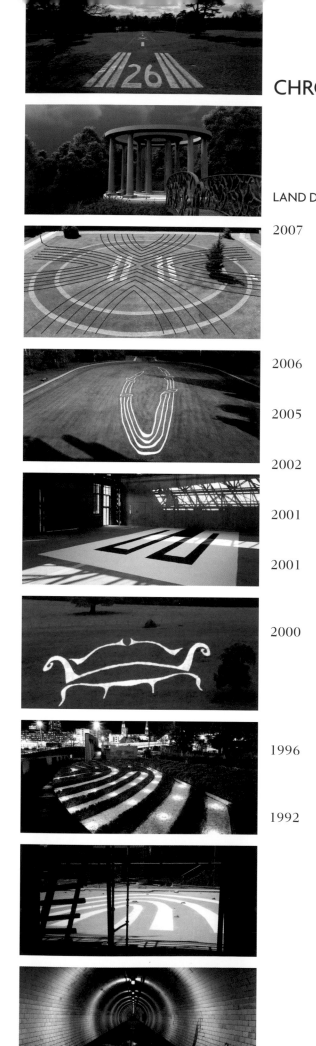

CHRONOLOGY

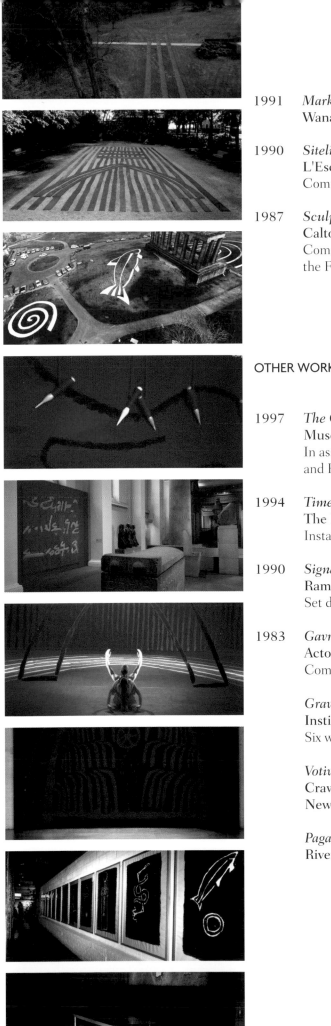

1991 *Marklinjer, Wanås*
Wanås Sculpture Foundation, Sweden

1990 *Sitelines: Venice*
L'Escedra, Giardini Biennale, Venice
Commissioned by the 44th Venice Biennale

1987 *Sculpture for Calton Hill*
Calton Hill, Edinburgh
Commissioned by TWSA 3D, Bristol, in association with
the Fruit Market Gallery, Edinburgh

OTHER WORKS IN SITU

1997 *The Corryvrechan Tapestry*
Museum of Scotland, Edinburgh
In association with Dovecot Studios, Edinburgh
and Benson + Forsyth Architects

1994 *Time Machine*
The British Museum, London
Installation for the Egyptian Sculpture Galleries

1990 *Signature*
Rambert Dance Company, London
Set design in collaboration with Siobhan Davies and Kevin Volans

1983 *Gavrini*
Actors' Institute, New York
Commissioned wall painting

 Graven Images
Institute of Contemporary Art, London
Six wall paintings

 Votives and Libations in Summons of the Oracle
Crawford Centre, University of St Andrews
New 57 Gallery, Edinburgh

 Pagan Echoes
Riverside Studios, London

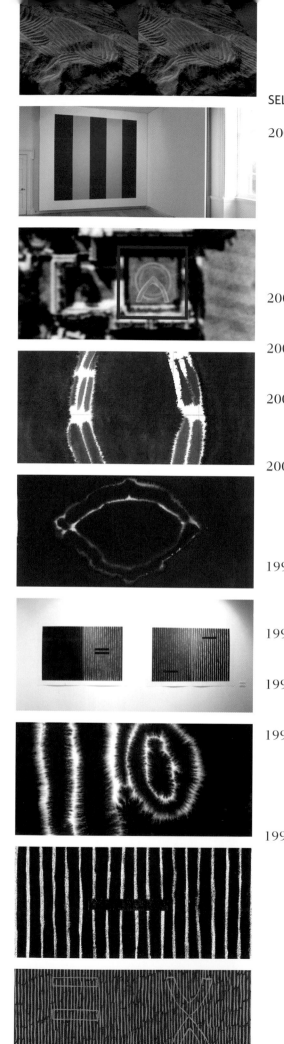

SELECTED GALLERY EXHIBITIONS 2007–1976

2007 *A'Mhòinteach: Sgrìobhte air an Talamh (The Moor: Drawing on the Land)*
An Lanntair Gallery, Isle of Lewis, Outer Hebrides
Prints and film installation, Lewis, Super 8 film, B/W, 7 minutes

 Airfield
Compton Verney, Warwickshire
Wall paintings and film installation, Compton Pools, Super 8 film, B/W and colour, 4.40 minutes

2006 *Le Spectre des Jardins*
Fondation de Coubertin, Paris

2005 *Sculpture in the Court*
Jesus College, Cambridge

2002 *An Leabhar Mòr*
City Art Centre Edinburgh, V&A London and Smithsonian Institute, Washington USA and tour

2001 *Archaeological Shadows*
The Gallery, Mount Stuart, Isle of Bute

 Kate Whiteford: Cabinet
Agnew's, London

1997 *Sitelines*
The Stripe Gallery
Osaka, Japan

1994 *Remote Sensing: Drawings from the British School at Rome*
British School at Rome

1993 *Graven Images*
ICA, London

1991 *From Art to Archaeology*
South Bank Centre, London

 Kate Whitefor
Frith Street Gallery, London (also 1990 and 1989)

1990 *British Art Now: A Subjective View*
Setagaya Art Museum, Nagoya City Art Museum, and tour of Japan

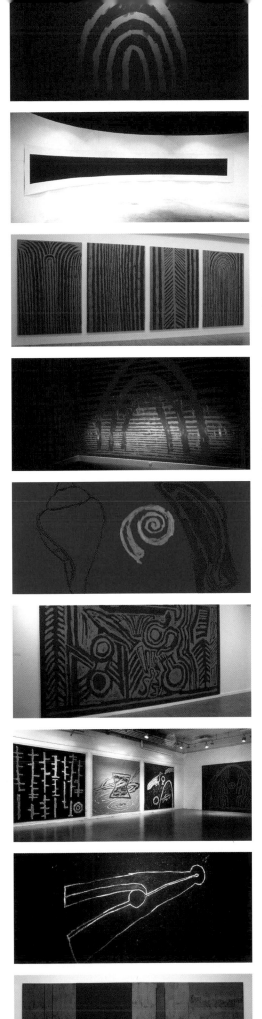

1988 *Kate Whiteford: Paintings*
Diane Brown Gallery, New York

Internationale Triennale der Zeichnung 4
Kunsthalle, Nuremberg

Excavations
John Hansard Gallery, University of Southampton

Echo Series
Whitechapel Art Gallery, London

1987 *The Vigorous Imagination*
Scottish National Gallery of Modern Art, Edinburgh

John Moores Liverpool Exhibition 15
Walker Art Gallery, Liverpool

1986 *Britain in Vienna: 12 British Artists*
Kunstlerhaus, Vienna

1985 *Kate Whiteford: Paintings and Wall Works 1983–1985*
Ikon Gallery, Birmingham

John Moores Liverpool Exhibition 14
Walker Art Gallery, Liverpool

1984 *Rites of Passage*
Third Eye Centre, Glasgow

1982 *Pagan Paintings*
The Gallery, 52 Acre Lane, London

1981 *Seven Scottish Artists*
Third Eye Centre, Glasgow

1980 *Archives*
The Gallery, 52 Acre Lane, London

1978 *Painters in Parallel*
Scottish Arts Council Gallery, Edinburgh

Kate Whiteford
The Stirling Gallery, Stirling (also 1975)

1976 *GLA and the New 57 Gallery*
Fruitmarket Gallery, Edinburgh

BIOGRAPHY

Born Glasgow, lives and works in London
Appointed OBE 2001

Kate Whiteford studied Fine Art (Painting) at Glasgow School of Art and History of Art at the University of Glasgow. A British Council Scholarship took her to Italy to study fresco painting *in situ* in Florence and Rome before moving to London in 1980.

She first exhibited direct wall paintings in *Graven Images*, at the ICA, London, 1983. *Sculpture for Calton Hill*, Edinburgh, 1987 was the first of a series of monumental land drawings made *in situ* in Britain and Europe, including *Sitelines* at the Venice Biennale, 1990. *Signature*, a collaboration with Ballet Rambert, London opened the same year, while the survey exhibition *British Art Now* toured Japan.

In 1993, Whiteford returned to Italy as Sargant Fellow at the British School at Rome and published *Remote Sensing*, on aerial photography and archaeology in 1997. In the same year *The Corryvrechan Tapestry* was commissioned for the new Museum of Scotland, Edinburgh.

Architectural installations include works for the British High Commission, Nairobi, Kenya, 1996, the Garden of International Friendship, Coventry, 2000 and Eden Court Theatre, Inverness, 2007. The land drawings form part of a body of work which includes wall painting, drawing and installation, with new work on super 8 film first shown in *Airfield*, Compton Verney, Warwickshire, 2007.

Elected to the RSA in 2006, the aerial film *A'Mhointeach: The Moor*, 2007, filmed over the Outer Hebrides was shown at the RSA, National Gallery Complex, Edinburgh in January 2009.

Her work is included in private and public collections including Tate Gallery, the British Council, the Government Art Collection, Glasgow Museum and Art Gallery and the Scottish National Gallery of Modern Art.

BIBLIOGRAPHY

2007 Phibbs, John and Augusto Pieroni, *Kate Whiteford: Airfield*, Exhibition Catalogue, Compton Verney.

Abrioux, Yves, *Le Spectre des Jardins*, Exhibition Catalogue, Domaine de Coubertin, 2007, pp. 152–155.

2005 Mengham, Rod, *Sculpture in the Close*, Exhibition Catalogue, Jesus College, Cambridge.

2004 Wachmeister, Marika and Anna Johansson, eds., *Wanås Historia*, Knislinge: Wanås Foundation, p. 97.

2003 Renfrew, Colin, *Figuring it Out*, London: Thames & Hudson, pp. 46–47.

2002 Maclean, Malcom and Theo Dorgan, eds., *An Leabhar Mòr*, Edinburgh: Canongate Books, pp. 220–221.

2001 Abrioux, Yves, *Kate Whiteford : Archaeological Shadows*, Exhibition Catalogue, Mount Stuart, Isle of Bute.

Otto, Julia, *Skulptur als Feld*, Exhibition Catalogue, Hatje Cantz Verlag, pp. 104–113 and p. 121.

Abrioux, Yves, *Kate Whiteford: Cabinet*, Exhibition Catalogue, London: Agnew's.

Wachtmeister, Marika, *Konsten Pa Wanås / Art at Wanås*, Stockholm: Byggförlaget, p. 278.

Wallace-Hadrill, Andrew, *The British School at Rome: One Hundred Years*, The British School at Rome at The British Academy, London, pp. 102–103.

2000 Abrioux, Yves and Jane, Sellars, *Sitelines, Harewood (after Chippendale)*, Exhibition Catalogue, Harewood House, Leeds.

Cork, Richard, Vivien Lovell and Hugh Pearman, *Phoenix: Architecture/Art/Regeneration*, London: Black Dog Publishing, 2004.

Macdonald, Murdo, *Scottish Art*, London: Thames & Hudson, pp. 204–205.

1997 Renfrew, Colin, Richard Hodges, and Augusto Pieroni, *Kate Whiteford, Remote Sensing: Drawings from the British School at Rome*, The British School at Rome, c/o The British Academy, London.

1994 Putnam, James and Vivian Davies, *Time Machine*, Exhibition Catalogue, London: The British Museum, pp. 18–21.

Wachtmeister, Marika, *Wanas Kunsten Parken Slottet*, Wanås Foundation, Knislinge.

MacMillan, Duncan, *Scottish Art in the 20th Century*, Edinburgh: Mainstream Publishers, pp. 153–154 and p. 156.

1992 Kemp, Martin, *Kate Whiteford: Sitelines*, Edinburgh: Graeme Murray.

Hare, Bill, *Contemporary Painting in Scotland*, Sydney: Craftsman House, pp. 206–209.

1990 *The Venice Bienale XLIV*, General Catalogue I, pp. 120–121 and General Catalogue II, pp. 102–103, Simonetta Rasponi, ed., Milan: Gruppo Editoriale Fabbri.

Henry, Clare, *Tre Scultori Scozzesi*, pp. 117–118.

MacDonald, Patricia, *Shadow of Heaven, Scotland from Above*, London: Aurum.

Gooding, Mel, *Britain in Vienna;12 British Artists*, Exhibition Catalogue, London: The Contemporary Art Society.

1987 Cork, Richard, *TSWA 3D*, Exhibition Catalogue, Bristol: Television South West Arts, pp. 14–17.

1984 Archer, Michael, *Rites of Passage*, Exhibition Catalogue,, Glasgow: Third Eye Centre.

1983 Kemp, Martin, *Votives and Libations in Summons of the Oracle*, Exhibition Catalogue, Crawford Centre, St Andrews University.

1982 Oliver, Cordelia, *Seven Scottish Artists,*, Glasgow: Third Eye Centre.

CREDITS

p. 9, 32, pp. 34–35 Sean Hudson; p. 10, 13, 44, 46, 48 Prudence Cumming Assoc; pp. 14–15, p. 78 Patricia and Angus Macdonald/Aerographica; p. 16 St Andrews University; pp. 6–7, p. 17, 18, 21, pp. 22–23, p. 38, 39, 43, 68, 73, 75, 85, 108, 110, 111, pp. 138–143, 148–149, p. 163, 165 the artist; p. 19 George Oliver; p. 20 Steve White; p. 24 Antonia Reeve; p. 25, 50, 55, 65, 69, 71, 76, 77, 145 John Jones; pp. 27–29 David Buckland; pp. 36–37 Whitworth Art Gallery; p. 40 Evelyn Thomasson; p. 47 British Museum Images; p. 51, 55 Museum of Scotland; p. 52, 58, 59, 103, pp. 104–105, p. 153, 157, pp. 158–159, p. 161, 166 Alex Graham; p. 53 Edinburgh Tapestry Workshop; p. 56, 75 top, 81 Mischa Haller; p. 60 Simon Ryder/Guzelian; p. 61 The Earl and Countess of Harewood and the Trustees of the Harewood House Trust; p. 62 The Trustees of the Sir John Soane Museum; p. 63 Architen; p. 66 Jerry Hardman-Jones; pp. 66–67 Jeremy Young; p. 70 Rodney Todd-White & Son; p. 73 top Graeme Alcorn; p. 83, 87 Julia Otto; p. 86 Michael Wiedemann; p. 90, 91, 93 Marcus Abbott/Cambridge Archaeological Unit; pp. 94–97 Adam Scott; pp. 100–101, p. 115 Richard Nightingale/Cullum and Nightingale Architects; pp. 107–109 Bhagwant Grewal; p. 110 top Humphrey Ocean; p. 112 Charlotte Wood; p. 113 Peter Cook; p. 117, pp. 122–125, 146–147 National Monuments Record; p. 119, 121 Mimmo Capone; p. 126, pp. 132–133 Johnathan Shaw; p. 128, pp. 134–135 Jamie Woodley; p. 131 Compton Verney; pp. 136–137 Bridgeman Art Library; p. 151 Domaine de Coubertin; p. 157 top Marcus Abbott/Cartographic Antiquity; p. 164 Brian Clark/Page \ Park Architects.

pp. 50–55 *Corryvrechan Tapestry, 1997* in association with the Edinburgh Tapestry workshop and Benson + Forsyth Architects; pp. 57–59 *Priory Maze, Garden of International Friendship, Coventry, 2000* in association with Phoenix Initiative and MacCormac Jamieson Pritchard Architects; pp. 101–115 *Siteworks, Nairobi, 1997* in association with Cullum and Nightingale Architects; pp. 161–167 *Excavation (Double Disc and Serpent), 2007* in association with Ian White Associates and Page \ Park Architects; *Saline, 2001, L'Île au Temple, 2006, Compton Pools, 2007, A'Mhointeach, 2008,* in collaboration with Alex Graham.

ACKNOWLEDGEMENTS

Special thanks are due to Richard Cork, Lord Colin Renfrew, Richard Nightingale, Yves Abrioux and John Phibbs for the essays that they have contributed to this book. The large scale-projects, often sited in protected or unusual environments, would not have been possible without the curatorial courage and tenacity of my many collaborators. I am grateful to Sophie Crichton-Stuart and Johnny Bute, Kathleen Soriano and John Leslie, Jane Sellars, Charles and Marika Wachtmeister, Mark Jones, Julia Otto and Kurt Figura, Vivienne Lovell, Siobhan Davies, Catherine Lampert, Clare Henry, James Putnam, Iwona Blazwick, Sandy Nairne; James Lingwood, Jonathan Harvey and Mark Francis for the first land drawing at Calton Hill in Edinburgh; Martin Kemp for his support over many years; Richard Hodges and Valerie Scott and Cassy Payne at the British School at Rome; Graeme Murray, Jennifer Wilson and Ruari McNeill, Malcolm MacLean, Roddy Murray, Will MacLean; Stan Bell and the Glasgow League of Artists; Mike Shaw for his consistently elegant engineering solutions; Angela Weight for help with this book; and Alex Graham for being there throughout.

Black Dog Publishing Limited t. +44 (0)207 713 5097
10A Acton Street f. +44 (0)207 713 8682
London WC1X 9NG e. info@blackdogonline.com

175

British Library Cataloguing-in-Publication Data.
A CIP record for this book is available from the British Library.

ISBN 978 1 904772 68 2

architecture art design
fashion history photography
theory and things

black dog publishing

www.blackdogonline.com london uk